The Art of

II

CHIMERA PUBLISHING

HAMILTON, NEW JERSEY
2005

The Art of Amy Brown II

Art: Copyright © Amy Brown 2005
Introduction: Copyright © Tamora Pierce 2005
First Edition: Copyright ©Chimera Publishing, 2005. All Rights Reserved

Editors: Norman Hood and E. Leta Davis
Design and Layout: McNabb Studios for
Chikara Entertainment, Inc.

Limited Edition
ISBN 0-9744612-490000
Hard Cover
ISBN 0-9744612-590000
Paperback
ISBN 0-9744612-690000

Chimera Publishing
—Hamilton, New Jersey

Visit our website at
www.chimerapublishing.com
E-mail: norm@chimerapublishing.com

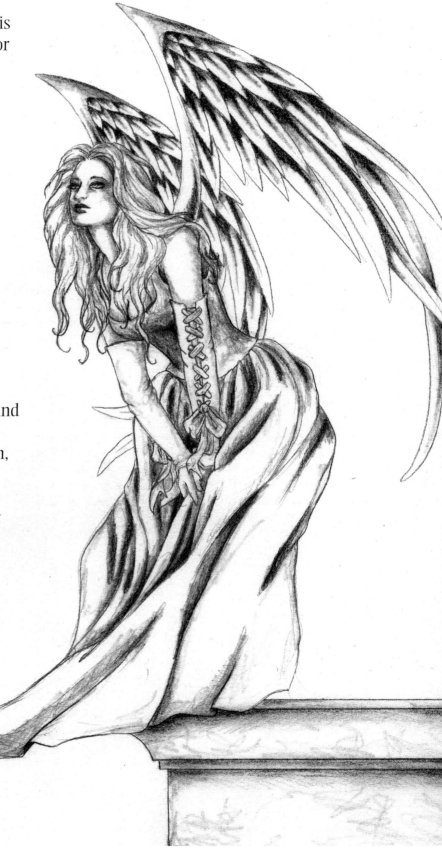

First Printing: July 2005
10 9 8 7 6 5 4 3 2 1

Printed in China by
Regent Publishing
Services Limited.

Contact RegentNY2@aol.com
for additional information.

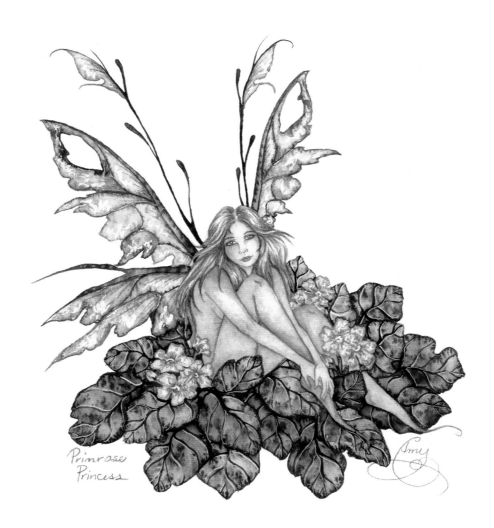

Primrose
Princess

Message From The Artist:

The other day, someone asked me how many faery pieces I have painted. I was astonished when I realized that I have completed nearly 1,000 paintings since I began doing them about 12 years ago.

You would think that by now I would be absolutely sick to death of faeries, but I'm not. The ideas keep pouring out, with no sign of slowing anytime in the near future. Sometimes the sheer volume of ideas I have for new paintings scares me: There is no way I'll ever be able to paint them all.

I feel the characters in my pieces have evolved along the way, but they still hold the same mystery and magic. Whether they are tiny, wispy creatures flitting about garden blossoms or tall, magnificent faery royalty strolling castle halls, they each have a tale to tell. We just have to take the time to listen.

Amy
June 17th, 2004

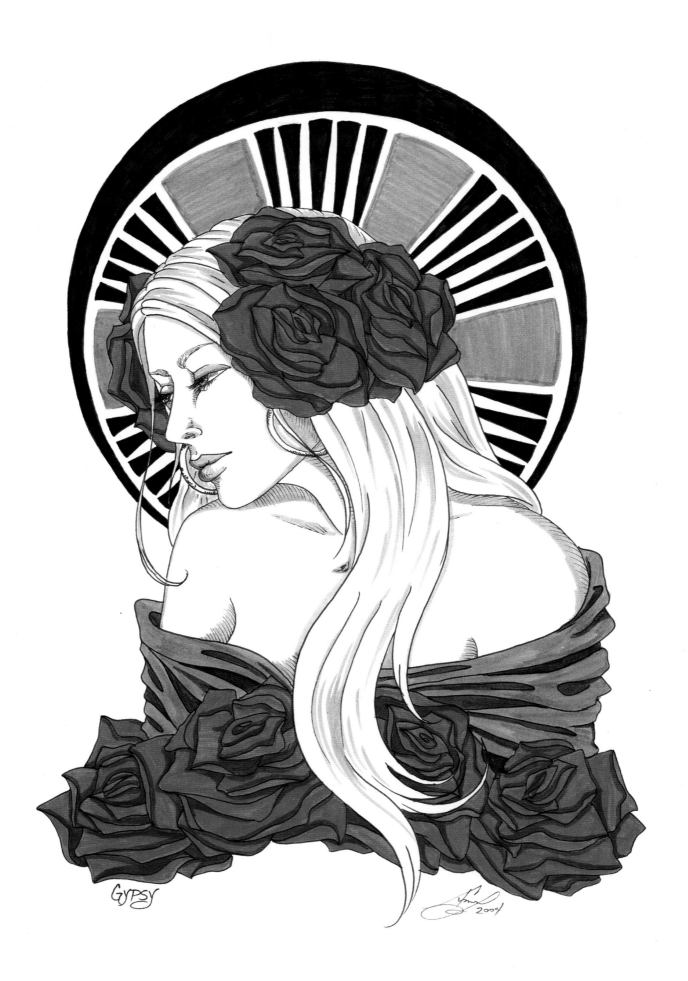

GYPSY

SPECIAL THANKS:

Again, I would like to thank various people for helping me with this book. Thank you, Mom and Dad, who would have been proud of me regardless of what I did in life, Norm and Leta, for your enthusiasm and making every effort to be sure everything turns out perfectly, Greg and Kathi, who always help in whatever capacity they can without asking for anything in return, my husband Darren, for being a great husband and father to our daughter and toiling until dawn to get my website updates finished, Sadie, for taking care of business, and Isabella, for making me smile every time I look at her.

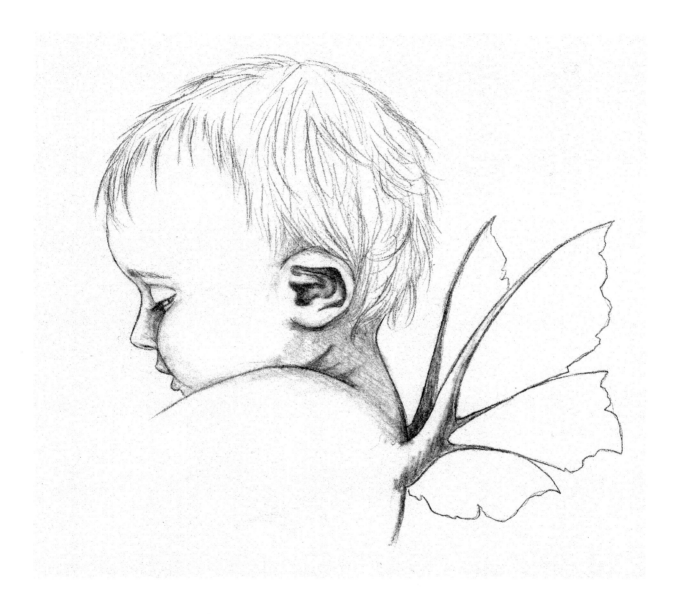

DEDICATION:
To those who will always believe.

Artists have recently begun to depict supernatural creatures—faeries, angels, elves, and more—as cute, pretty, and safe. Amy Brown is not such an artist. I would not be writing this introduction if she were. I've had a bellyful of those other artists. Those people serve up sugar, dancing, and twinkle: lies. They don't understand the supernatural or the dark side of the human imagination. Viewing their work, I get ill: My doctor starts to talk about insulin for sugar overdose. I retreat snarling to a nice, snug burrow.

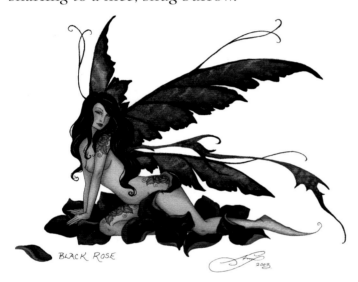

BLACK ROSE

But then I find a creation of Amy Brown's. Look: a tiny creature with pointy ears, perched on a mushroom—or perhaps a toadstool. Pretty, fluttering wings? They are tattered: this character has been in a fight or maybe six. The silky, slinky gown is tattered, too. There's a fold to those ears, like those of a feral cat about to hiss. This creature looks at me sidelong, not shyly or flirtatiously. Her look is a warning to approach *slowly*. Her companions are not human, and one notices that at a glance. Their attention is on that central figure. They could not care less about us.

When an Amy Brown creation sits on a stone in a moon pool, you have to ask if that pool is as shallow as the creature pretends it is or if she is luring you into deep waters. Don't wait until the last minute to find out! That tricky glint in her eye means the trick is on *you*. Even Amy

Brown's human characters gaze at you with challenge in their eyes. They have one foot in the other world and are headed toward it. Her gods, elves, and faeries watch other worlds, unconnected to

BEAUTY

the one we perceive. Her angels are concerned with angelic things, the orders and maneuvers of the heavenly plains and the heavenly hosts. They hear distant trumpets.

Much of Brown's pallet is wistful, even ephemeral. Her dark shades are shadowy: we view her worlds through a veil. The patina of her creations' skins is misty: we see through the haze that separates dimensions. These unearthly crea-

EARTH

tures have long eyes, as if they could take in more vistas than our rounder eyes can. They are painted in a position that indicates they only paused at the point where Brown shows them. Having come from someplace interesting, they are on their way to somewhere complicated. For Brown they seem to rest a moment, pausing on their journey to the Summerlands.

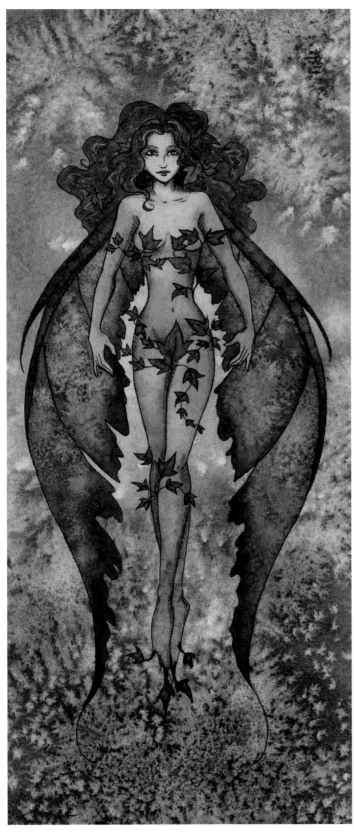

ies dark or light, always alien. Those who are gazing at the viewer head-on seem as if they are weighing the viewer. Are you strong enough? In those distant eyes, there is a hint of their answer: I did not think so.

In her creations, Brown captures mystery, wonder, and awe. In her gods and goddesses, one can observe a little terror. She makes them spicy, dangerous, and mesmerizing—giving them the qualities that have drawn humans to them since the beginning of time. She returns to them their undying aspect of *possibility*, good and bad. The magic is back. Brown has captured a piece of it for you.

Her work is deceptively pretty, like the faery ponds and wells of old. Stop looking at the rounded limbs and slender hips and pay attention to those eyes. Those eyes tell you that you are only a mote in time, ephemeral. Human, in short. Venture too far into this supernatural landscape, and you will be lost. You know it, don't you? But do you really want to be safe when the other world is calling you?

Tamora Pierce

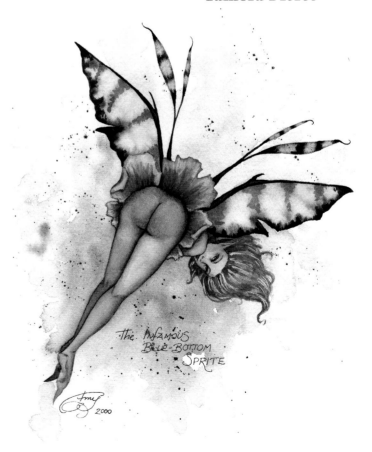

The Infamous
Blue-Bottom
Sprite

Amy Brown understands that the supernatural realm is not cuddly and safe, that its creatures would never die for human love nor set off a night's fireworks. Brown's most adorable pixies look like they will draw blood if your attention strays. Her gods and angels contemplate myster-

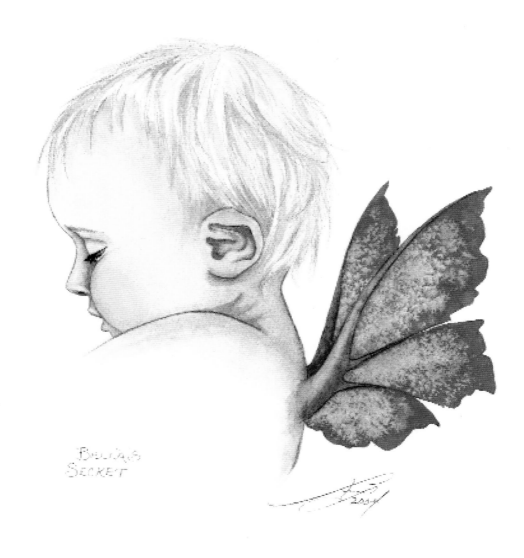

Bella's Secret (2004)
A painting of my daughter Isabella at 6 months of age.

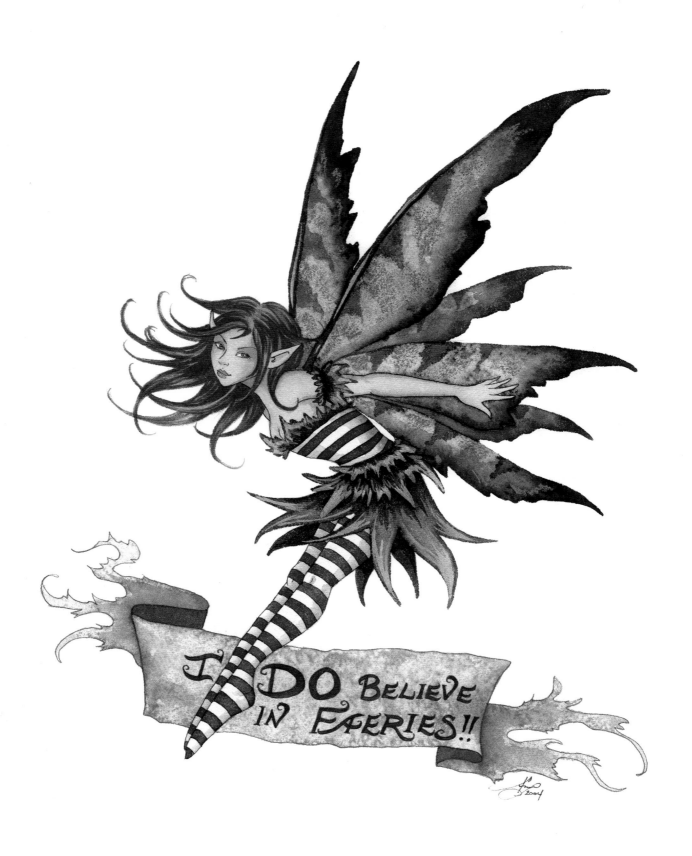

I Do Believe In Faeries! (2004)
I think the title says it all.

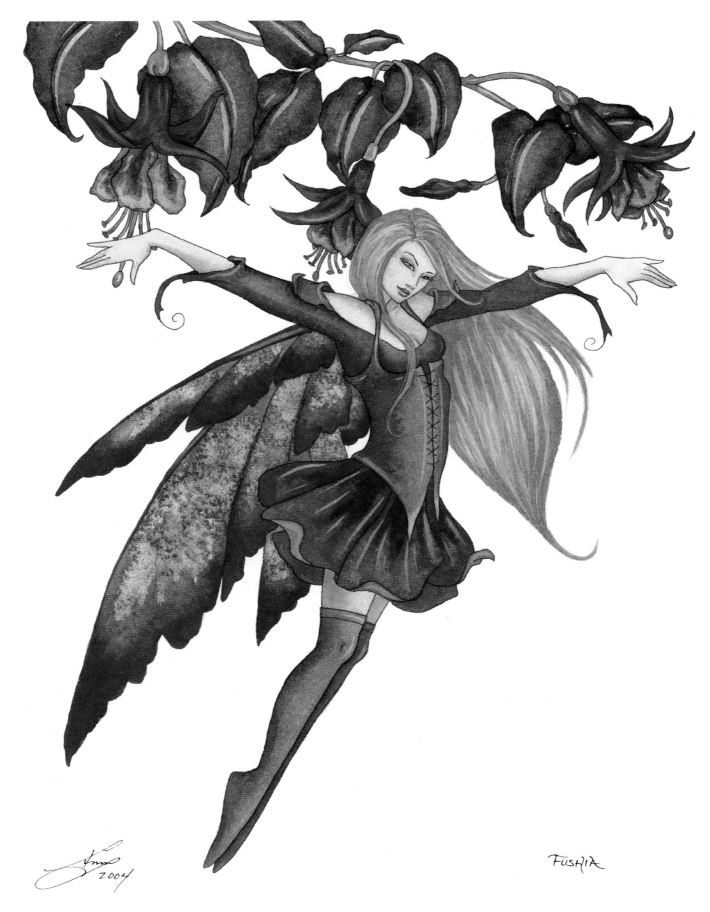

Fuchsia (2004)

I haven't done much with flower faeries in years. I felt it was time to update the idea. My newest set of flower faeries features spunky little sprites in bright colors.

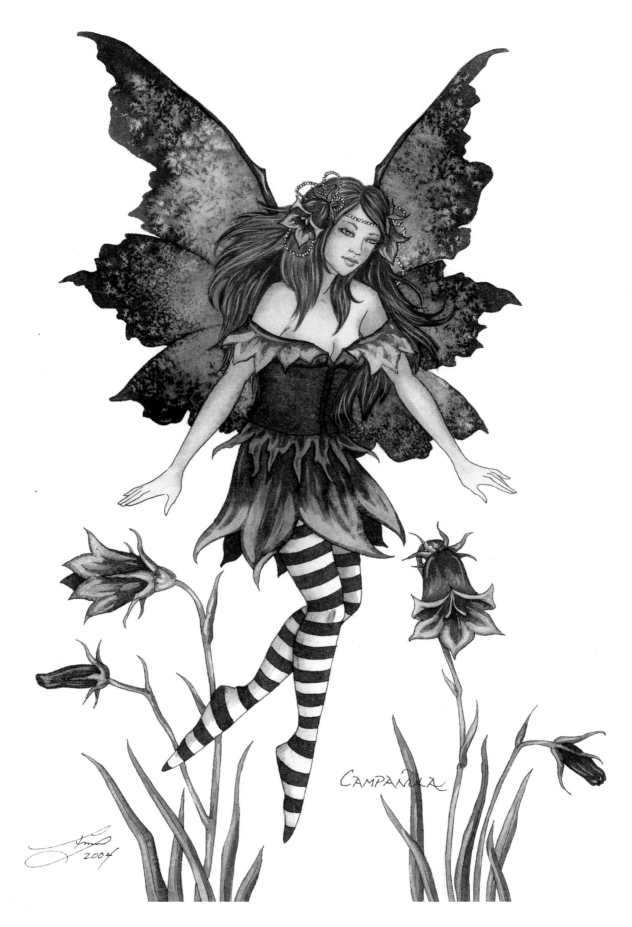

Campanula (2004)

Campanula is another piece from my 2004 flower faeries series. Campanulas, commonly called Bellflowers, are suitable for the rock garden, flower borders, and for wild or woodland gardens. This one looks like she's ready for anything.

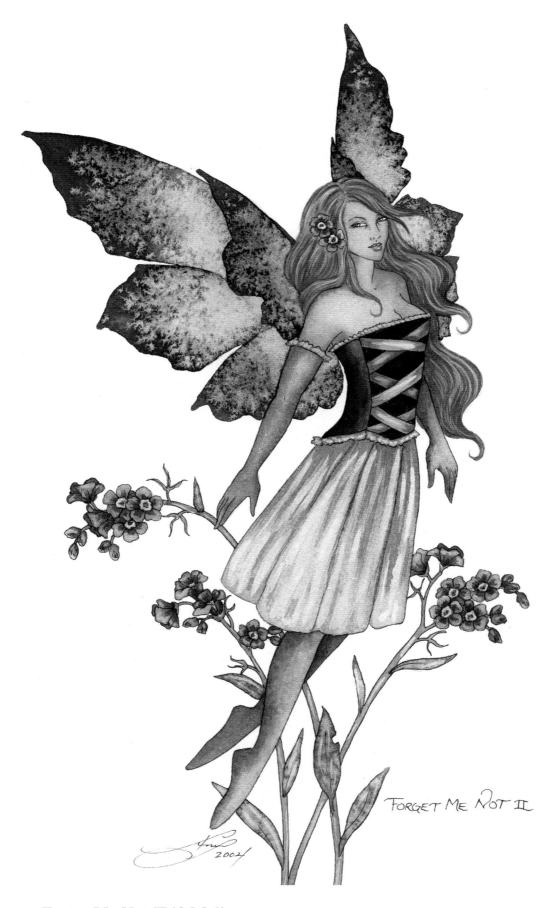

FORGET ME NOT II

2004

Forget Me Not II (2004)
A beautiful title that I couldn't help but use again.

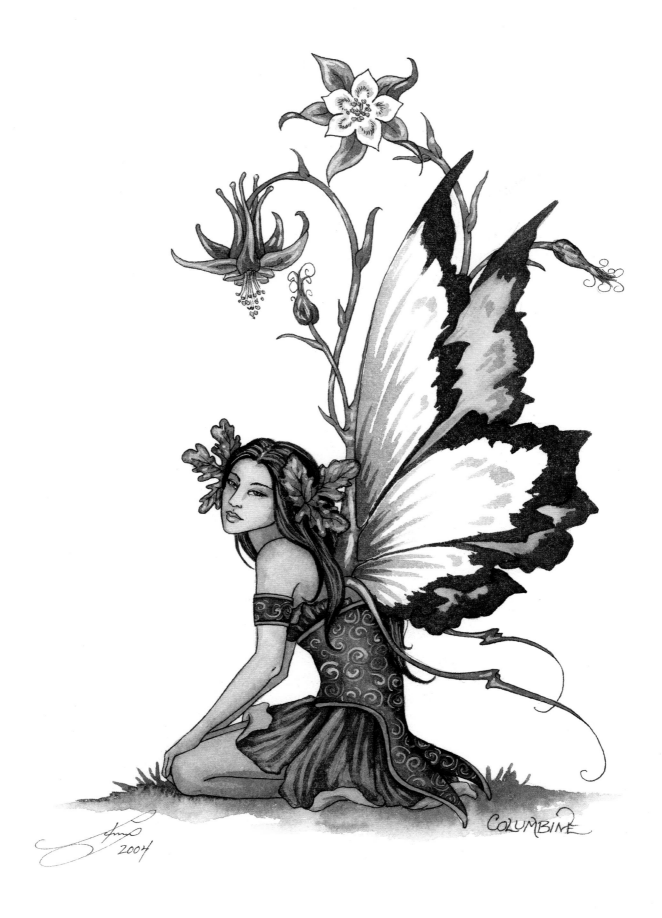

Columbine (2004)
I put a twist into this piece when I made the flower part of Columbine's wings instead of a separate element.

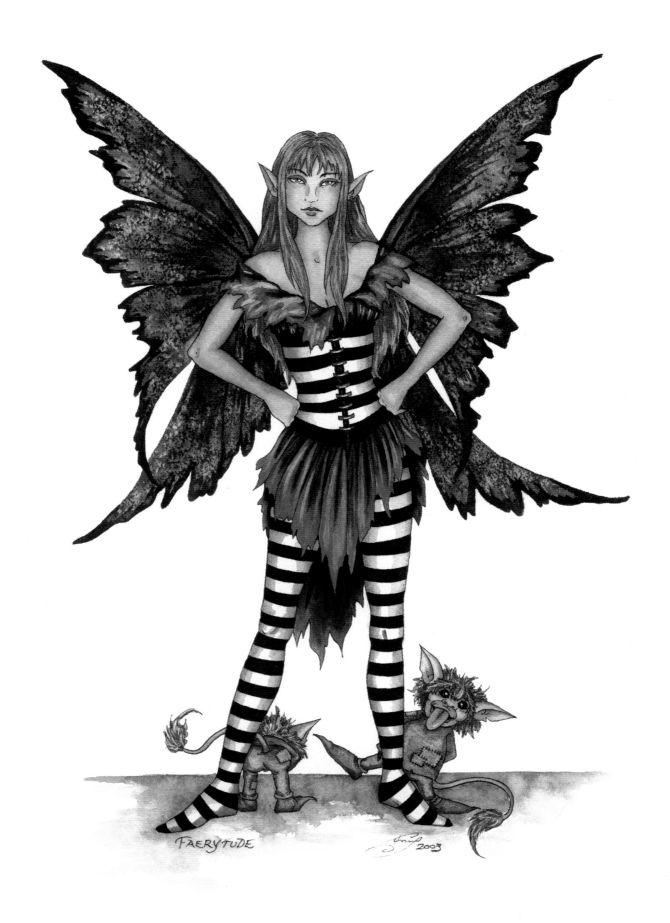

Faerytude (2003)
Faeries with attitude are always fun to do.

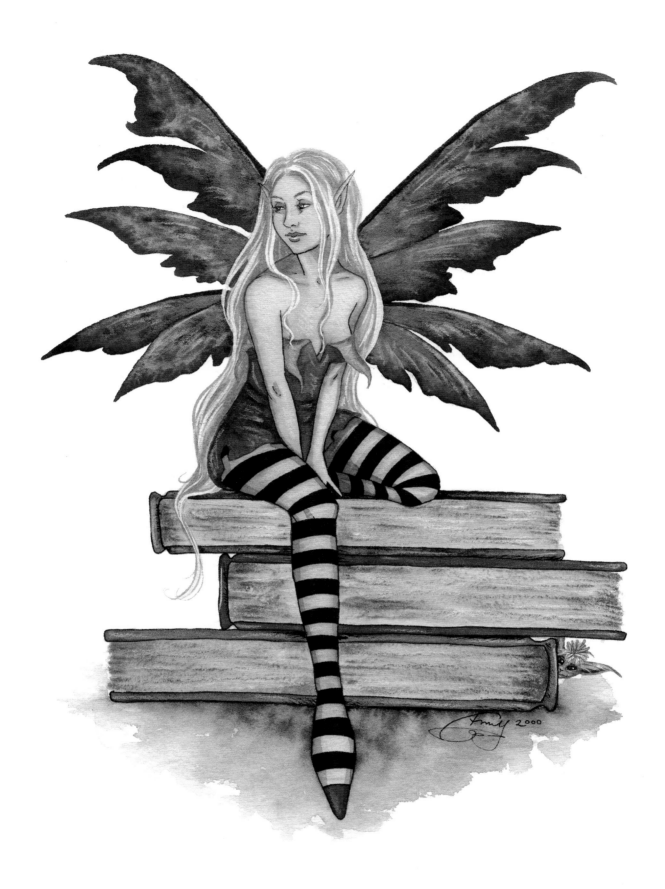

Book Faery (2000)

I imagine the book faery sitting in the library of some old, eccentric collector of books. She keeps the books free of dust and mildew. Occasionally, when she has a fit, she launches heavy volumes at the head of the nearest human.

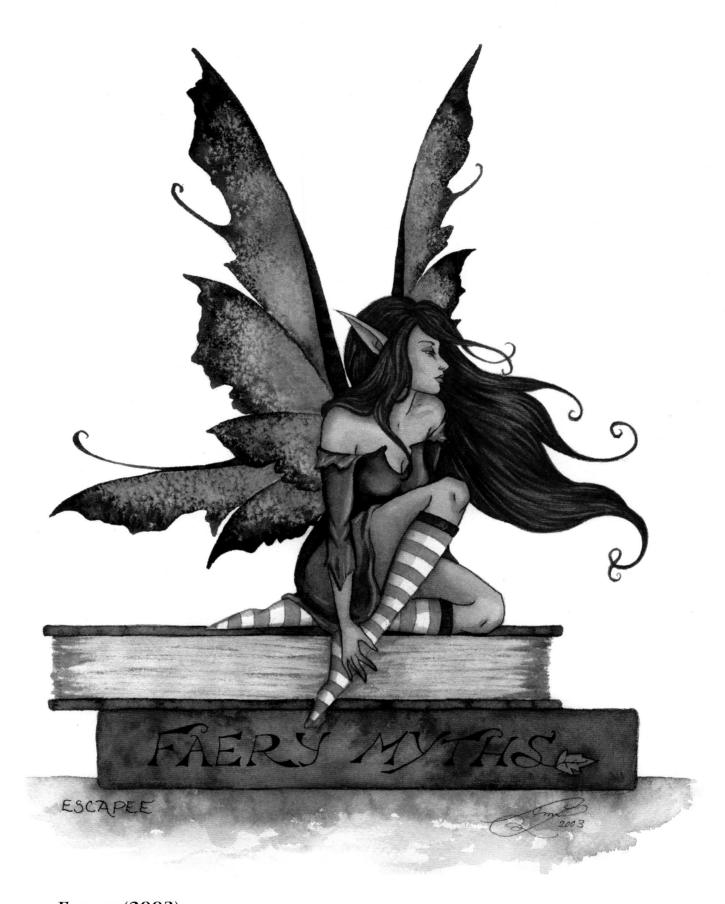

ESCAPEE

Escapee (2003)

This little creature has escaped from her story.

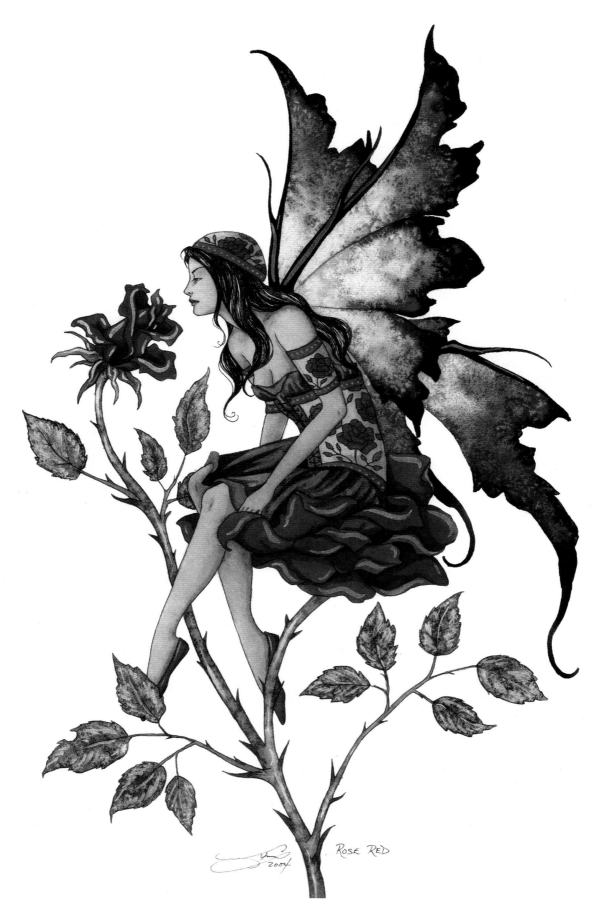

ROSE RED
2004

Rose Red (2004)

While on a rose kick, I painted *Rose Red*. Red is my favorite color, so a piece with red roses was a pleasure to do.

Wistful (2004)

Wistful is a faery designed for Hot Topic. The company had great luck with *Water Element,* an image which has black hair and a blue-green color scheme. I designed *Wistful* when I was asked for something similar.

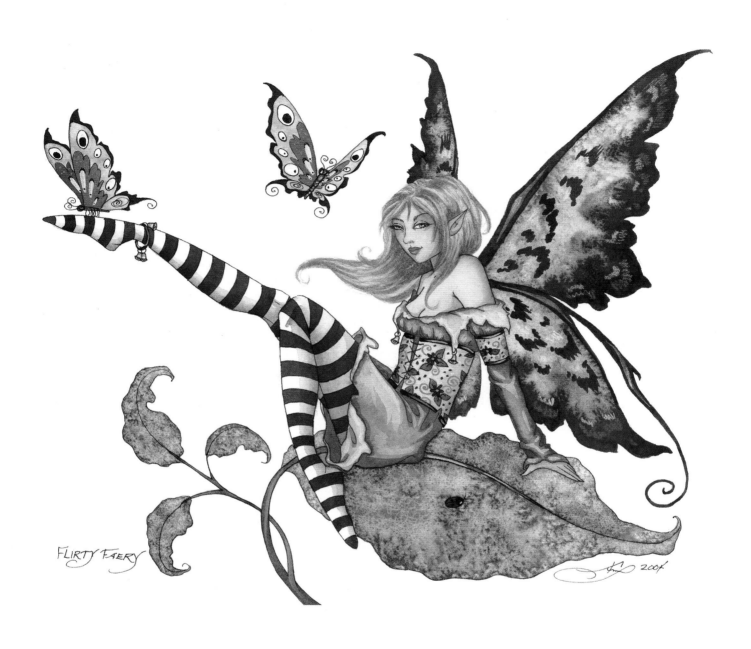

Flirty Faery (2004)
This is just a happy painting. Something with butterflies. Can't go wrong with butterflies.

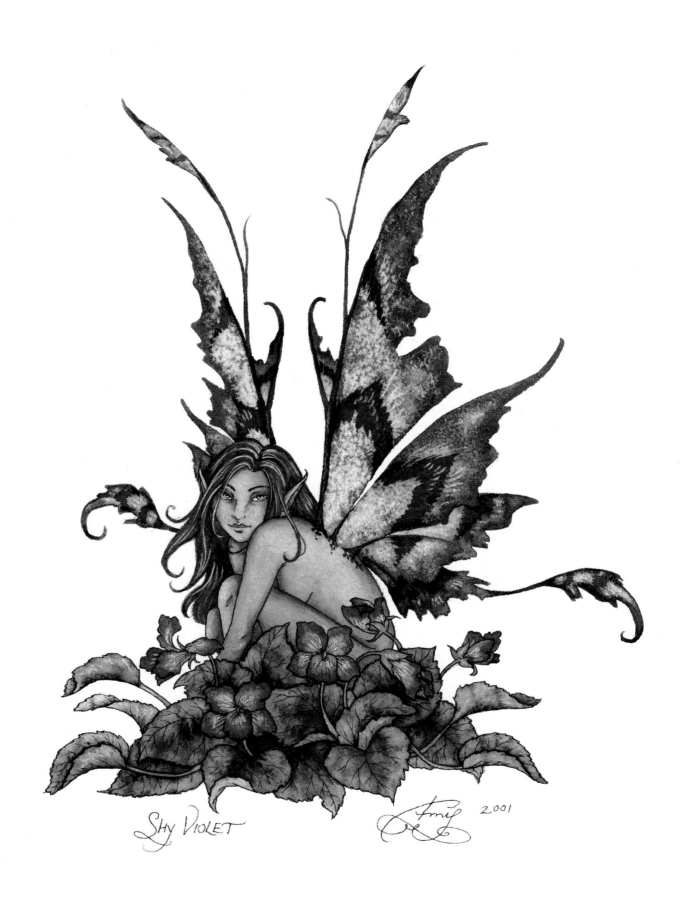

Shy Violet (2001)
I liked this title and painted a faery to go with it.

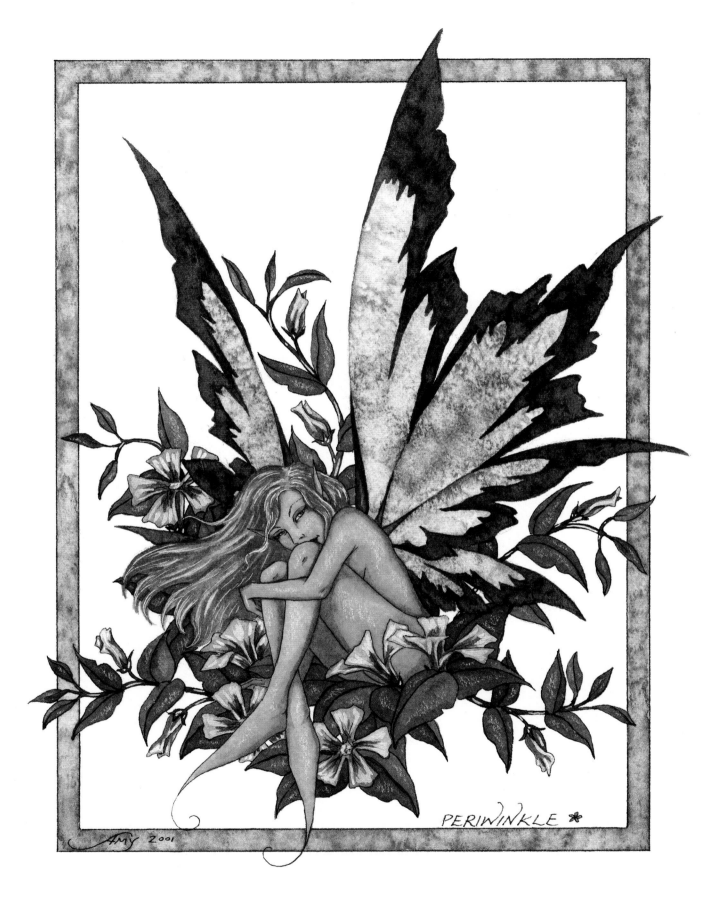

Periwinkle (2001)

I have patches of periwinkle growing in several spots on my property. I love to see the delicate blue-purple blooms every spring.

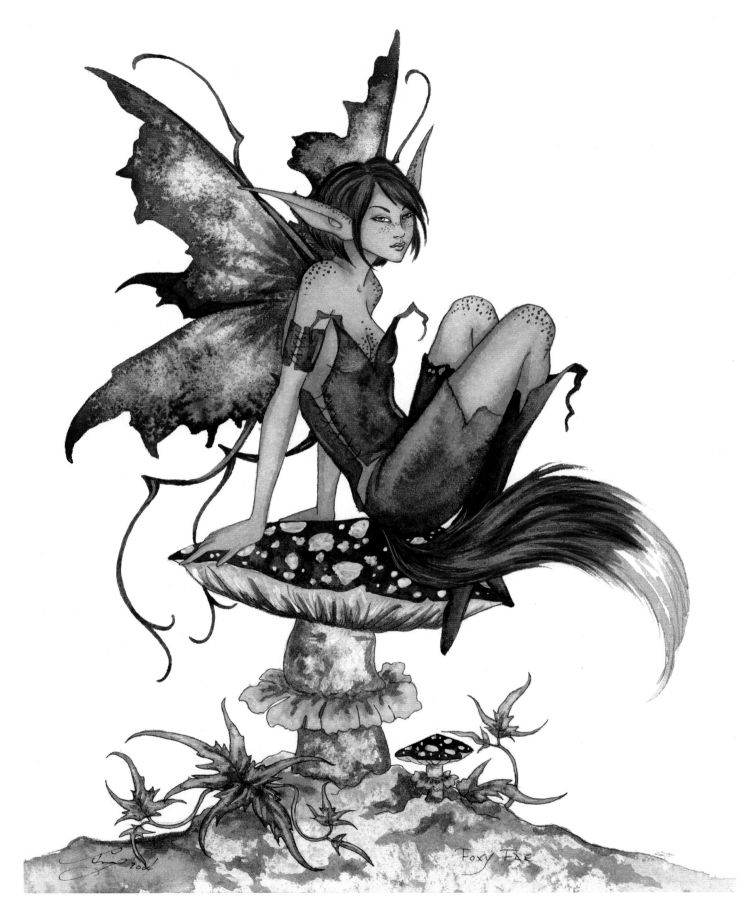

Foxy Fae (2004)

I love foxes, so creating fox faes is a fun pastime for me. They are frisky little creatures with boundless energy and mischievous ways.

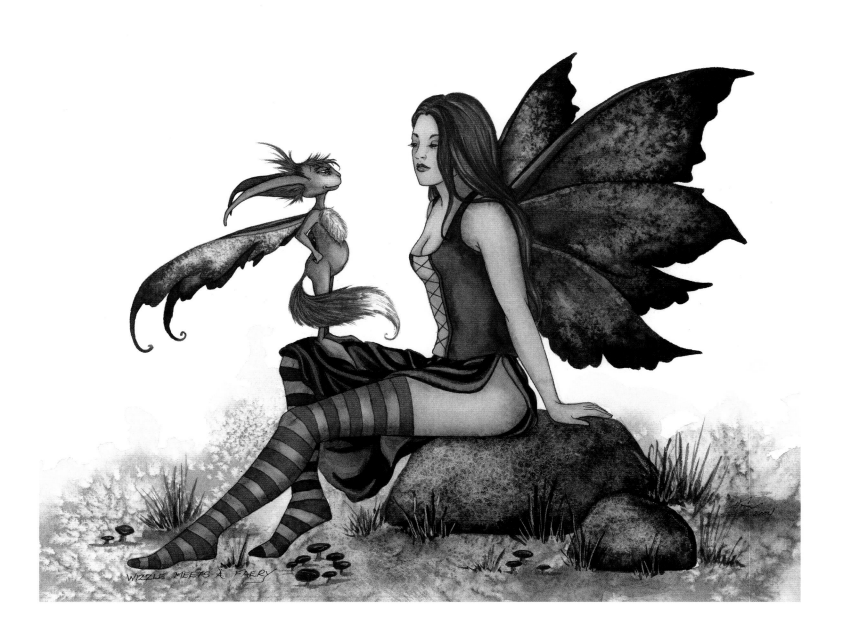

Wizzle Meets a Faery (2004)

The pose for *Wizzle Meets a Faery* was taken from a photo my husband took of me several years ago. The creature, Wizzle, reminds me of my daughter.

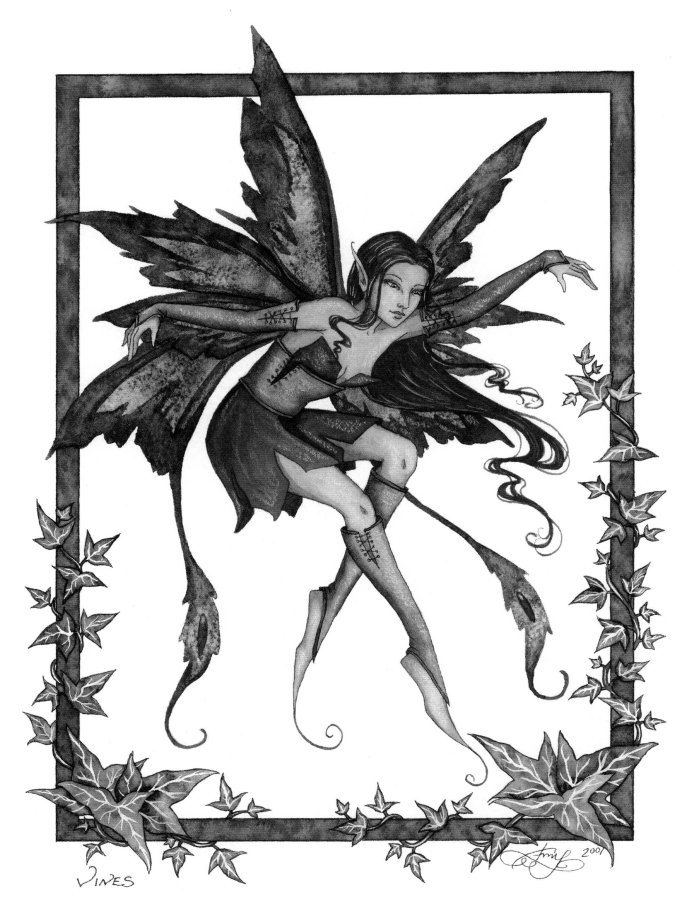

VINES

Vines (2001)

Vines was originally titled "Ivy." Then I remembered I already had too many images titled *Ivy*.

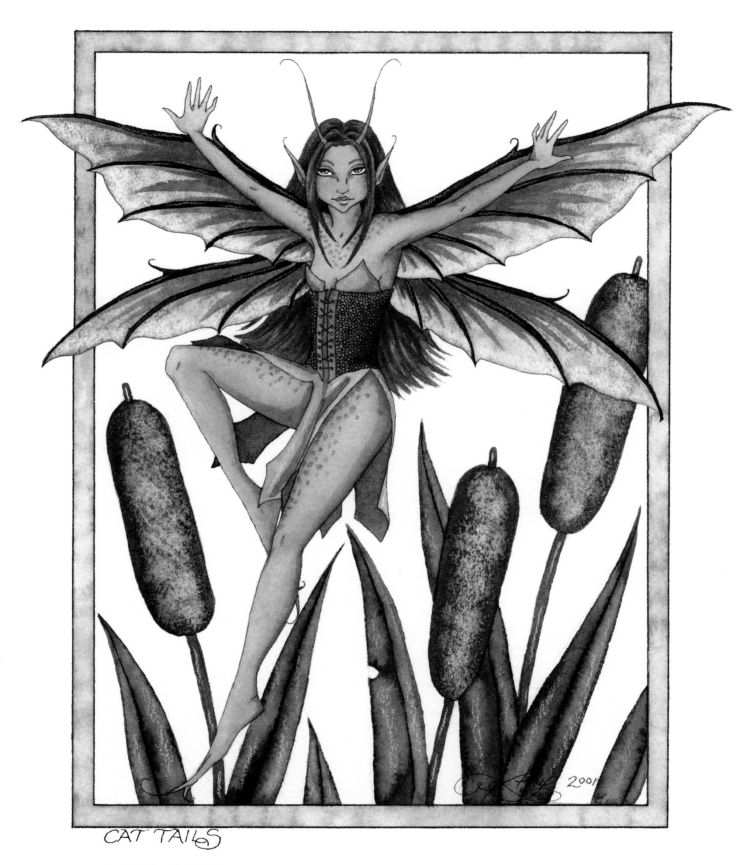

CAT TAILS

Cat Tails (2001)

Cat Tails is actually the second version of an image I did years ago. This is a species of faery that lives near ponds.

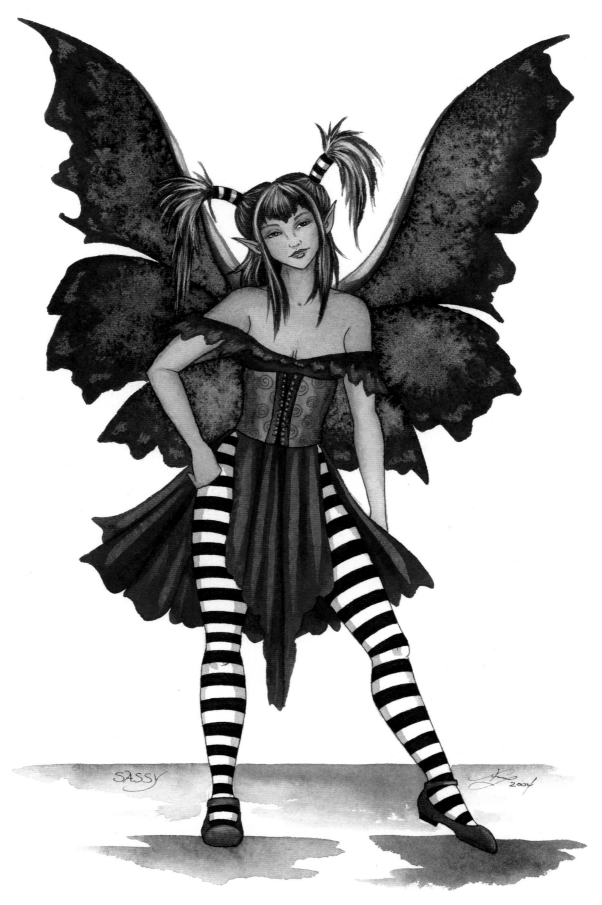

Sassy (2004)
Faeries with attitude are so appealing.

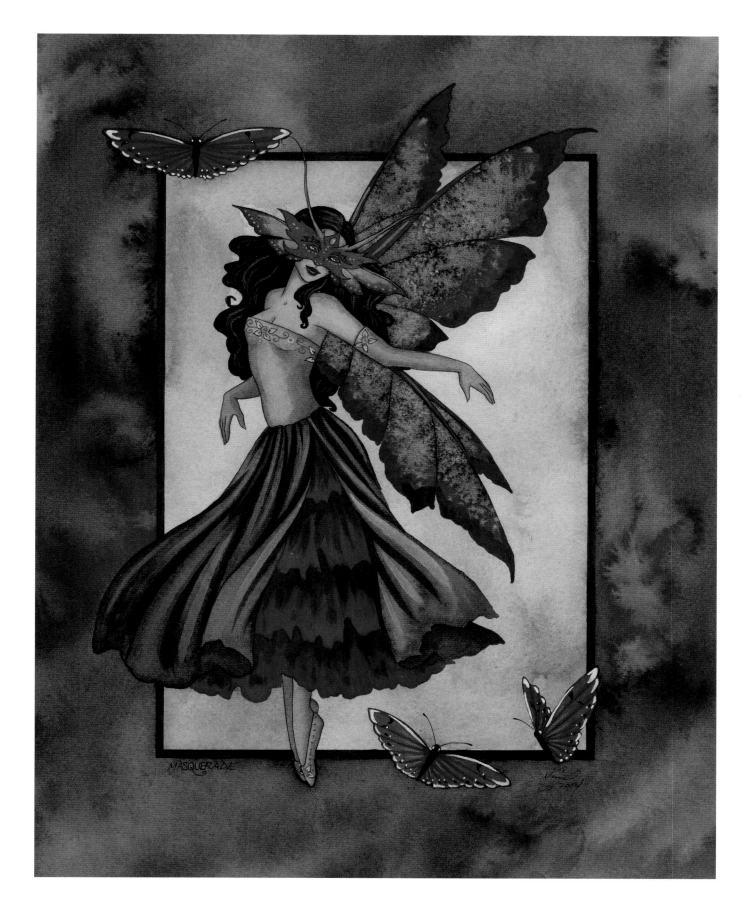

Masquerade (2004)

I have some masks made by the very talented Judith Rauchfuss. Her work inspired me to work on some images with masks in them, though the mask in *Masquerade* is no where near as cool as any of Rauchfuss' masks.

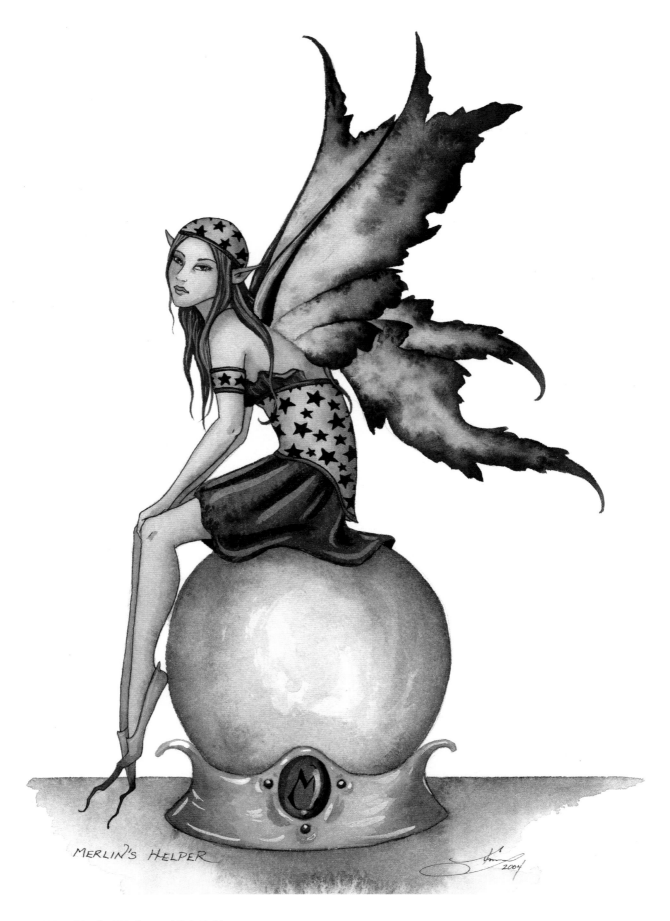

MERLIN'S HELPER

Merlin's Helper (2004)

I wanted to use a different color pallet than I usually do. I sometimes forget how beautiful shades of teal can be. Combined with gold, the image pops.

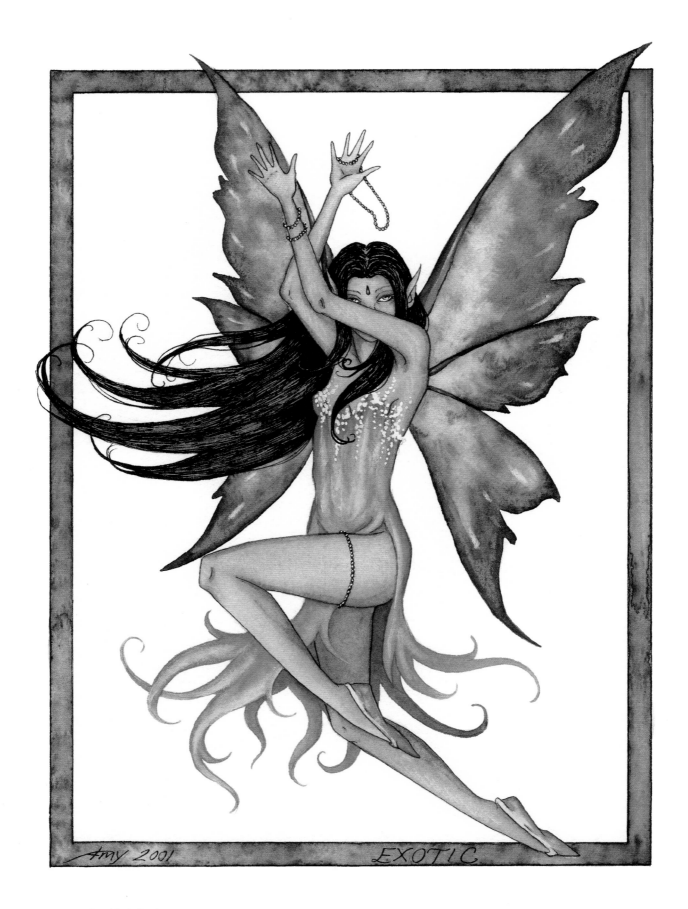

Exotic (2001)

I think I may have painted *Exotic* after attending a Renaissance fair. There is always a troupe of belly dancers jiggling around at such fairs. *Exotic* reminds me a little of belly dancers.

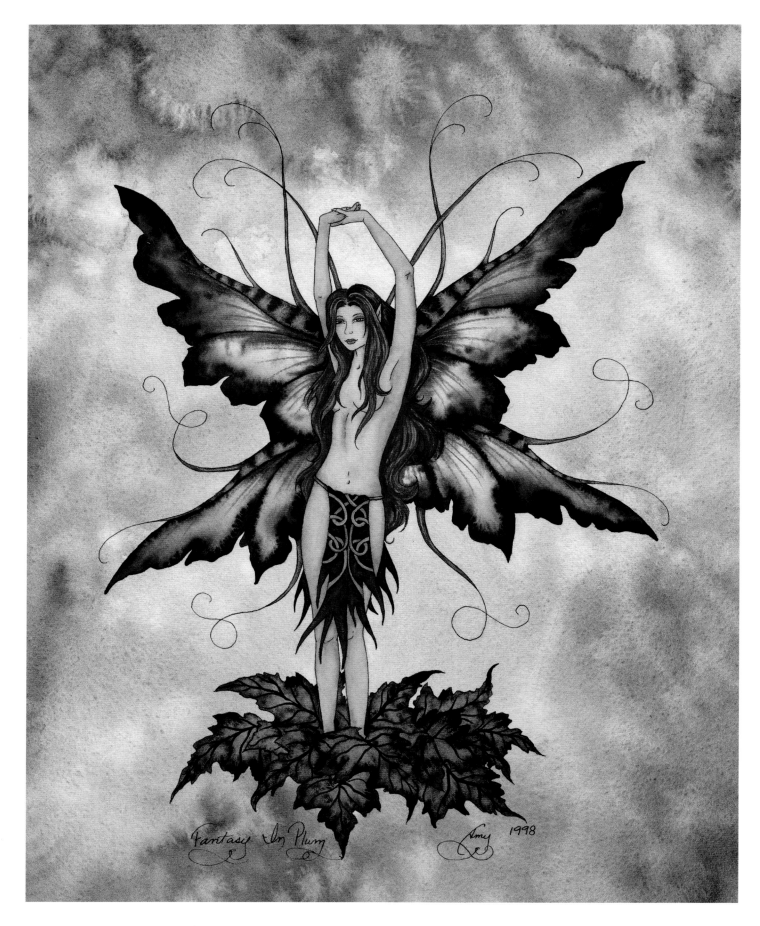

Fantasy in Plum (1998)
Someone had mentioned to me that they liked big wings on faeries — the bigger the better. So I made this faery's wings huge.

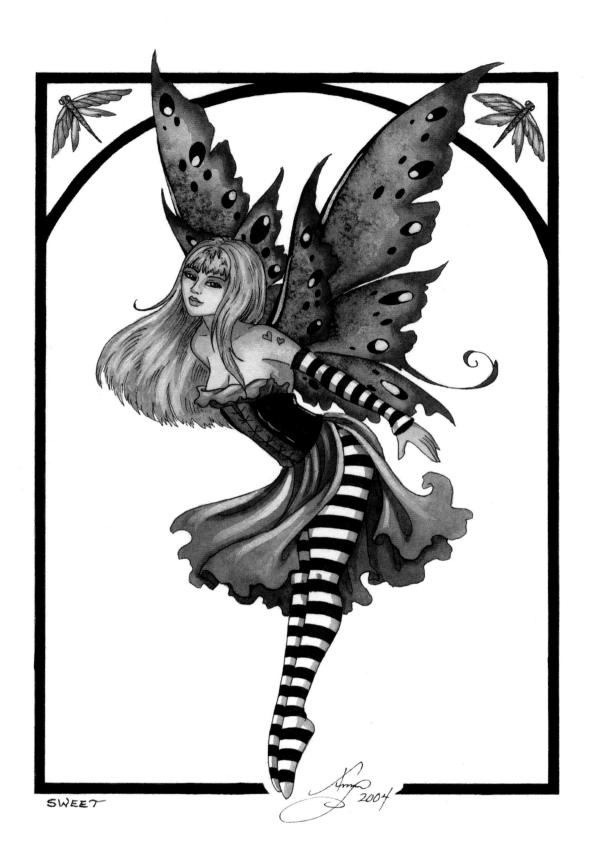

SWEET

Sweet (2004)

Sweet was designed for *Hot Topic*. The company was looking for a specific pose and color combo for the season. To my delight, the figure turned out adorable.

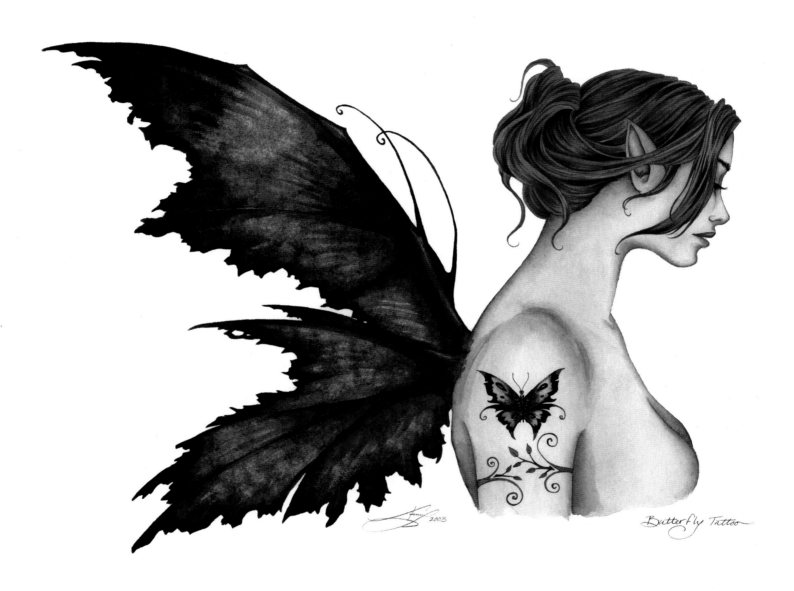

Butterfly Tattoo (2003)

Looking at old paintings I had done inspired me to paint *Butterfly Tattoo*. Early in my career, I did several pieces in a similar style, most of which are long gone. I decided to try one again.

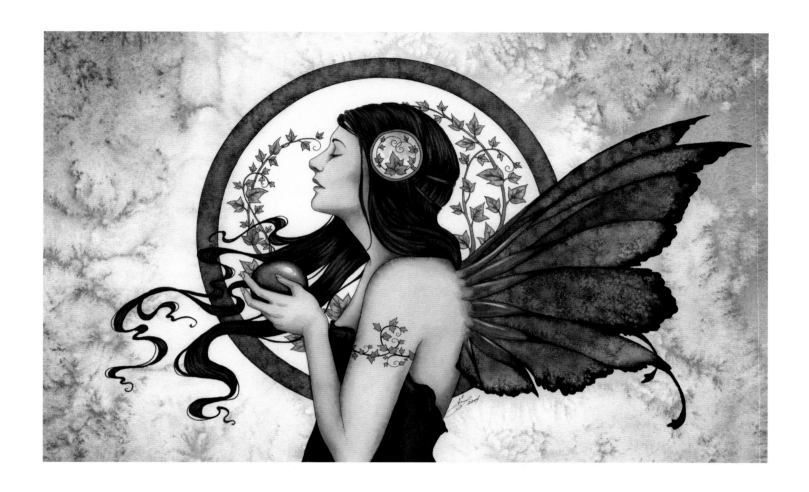

Serenity (2004)

For two or three months, I was on an art nouveau kick. I find the work of art nouveau period very inspiring.

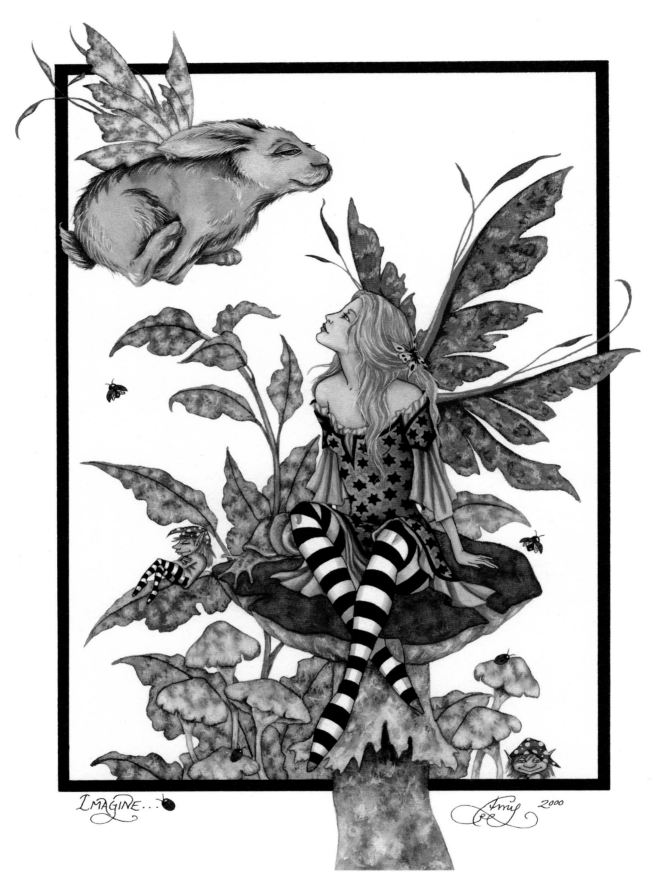

Imagine... 2000

Imagine (2000)

I love the bunny in this piece. He looks so relaxed, dreamy, and purely happy.

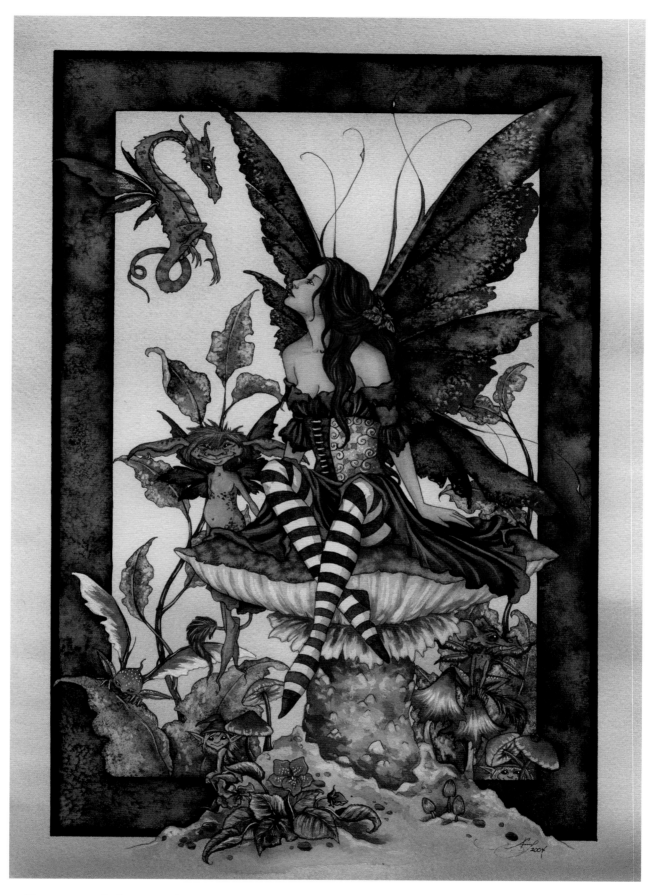

Bottom of the Garden (2004)

The border in this piece helps draw the different characters in the piece together. Without it, I felt the image might look cluttered with all of the characters and vegetation.

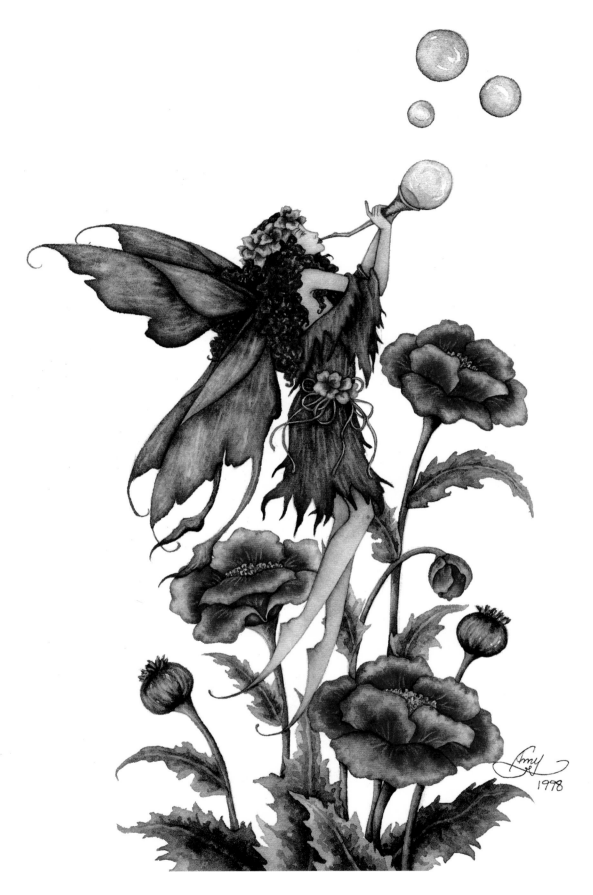

Blowing Bubbles (1998)

This faery is the first bubble-blowing faery I ever painted. I believe I have now done four. Bubbles seem to be a recurring theme for me.

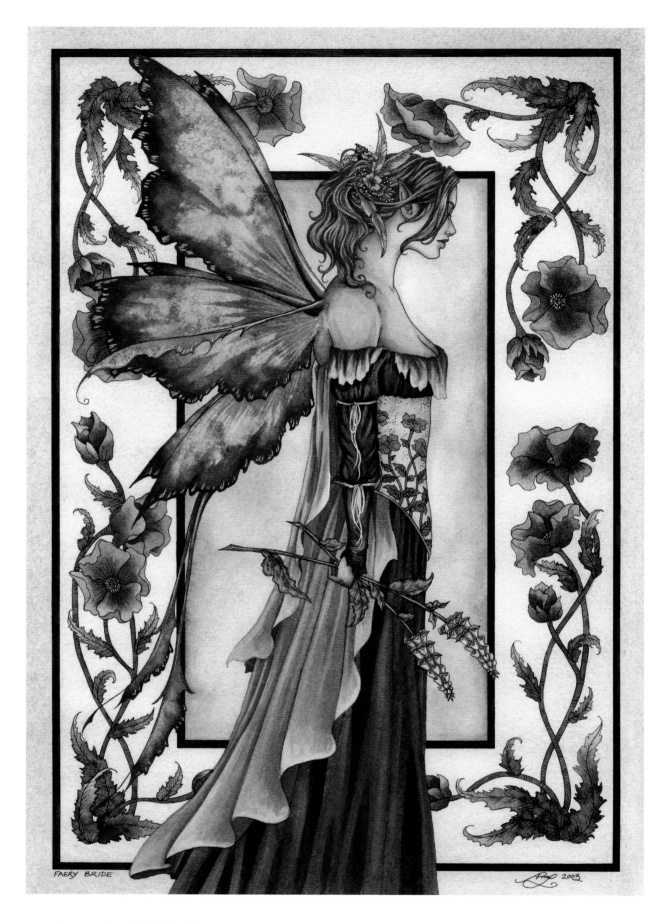

Faery Bride (2003)

Faery Bride was an excuse to create a fancy floral border. I love the rose hues in this piece.

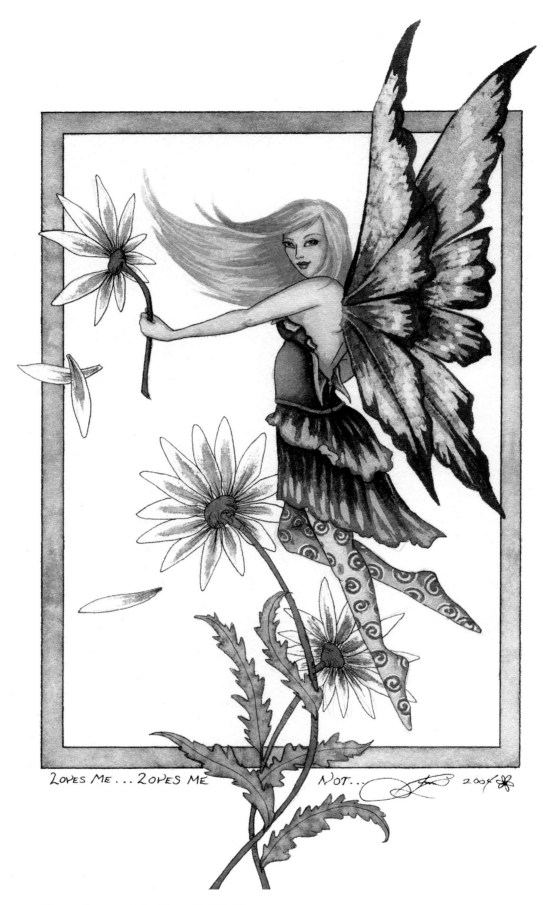

Loves Me… Loves Me Not (2004)

I came up with the pose for this piece first. The playful way the figure looks over her shoulder made me think of adding the daisies. She looks like the type to pluck petals and sing all day instead of doing something productive.

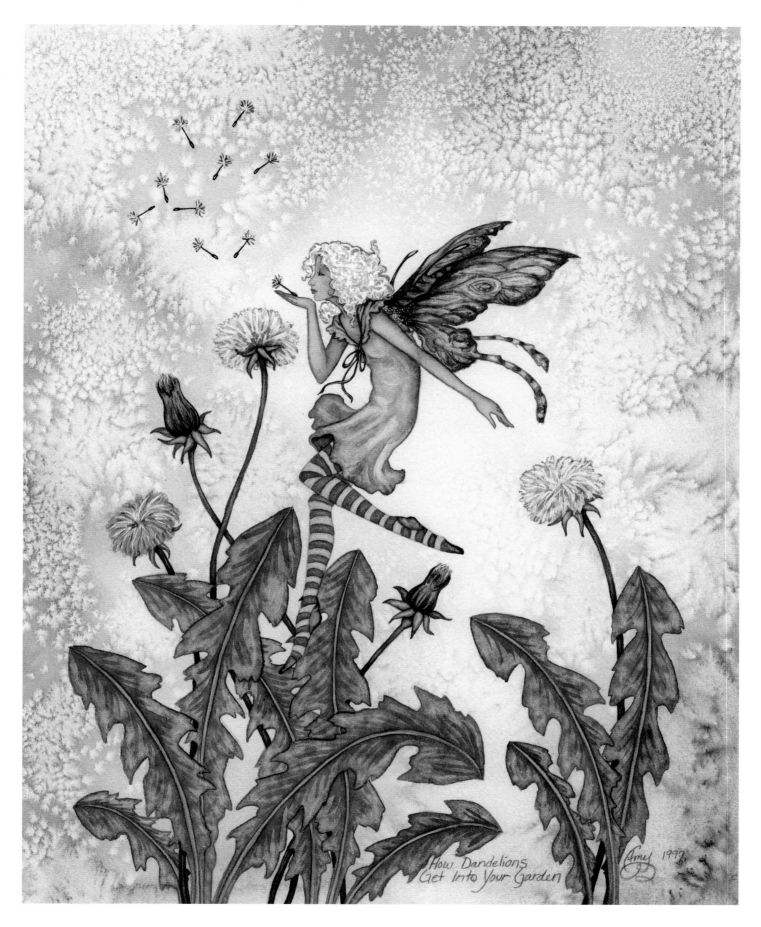

How Dandelions Get into Your Garden (1997)
The mystery has been revealed!

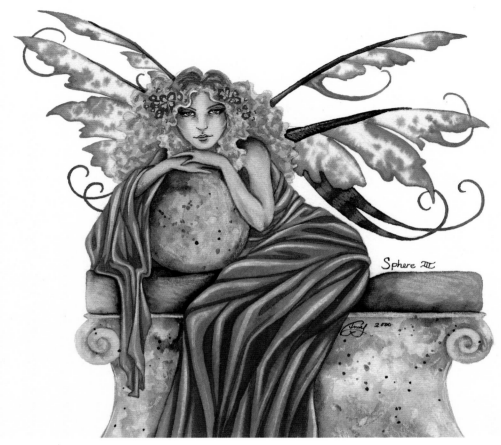

Sphere III (2000)
The pose in *Sphere III* was inspired by an Alphonse Mucha painting.

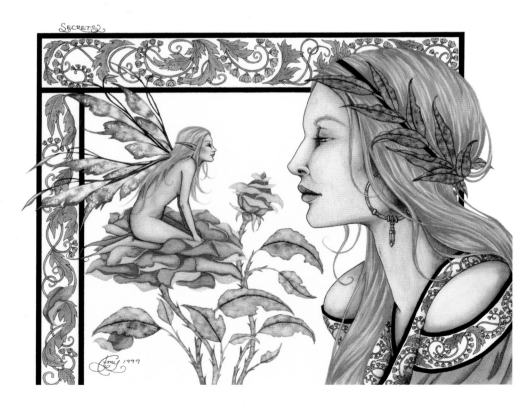

Secrets (1999)
I enjoy doing floral borders. This one is reminiscent of the beautiful works of Alphonse Mucha.

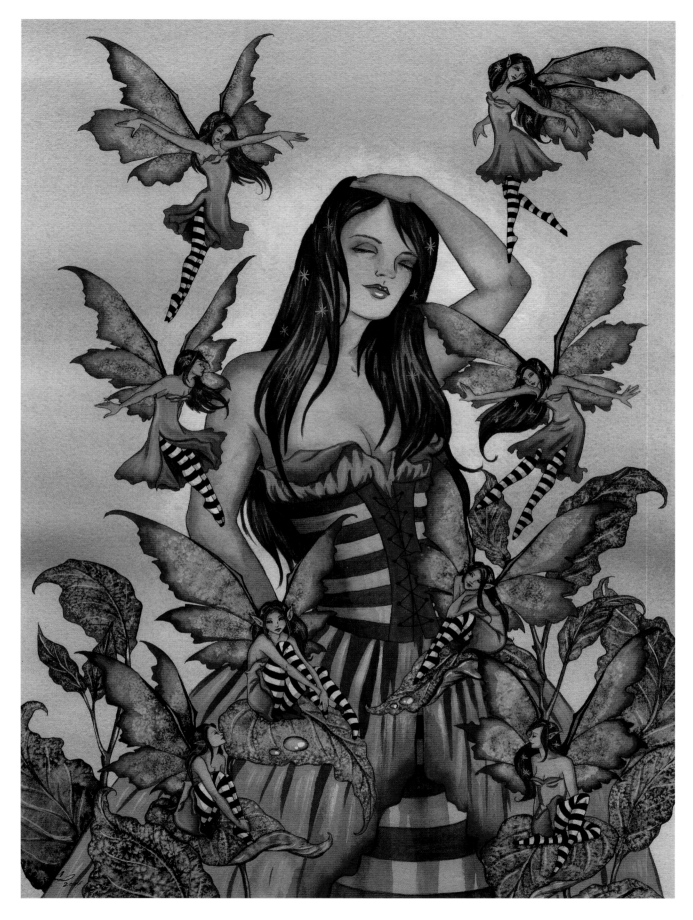

One Summer Afternoon (2004)

Originally, all the little faeries in this piece were going to look completely different. After some thought, I decided that giving the faeries too many looks would make the image confusing. I settled on the same hair and clothing for each faery so the picture would flow better.

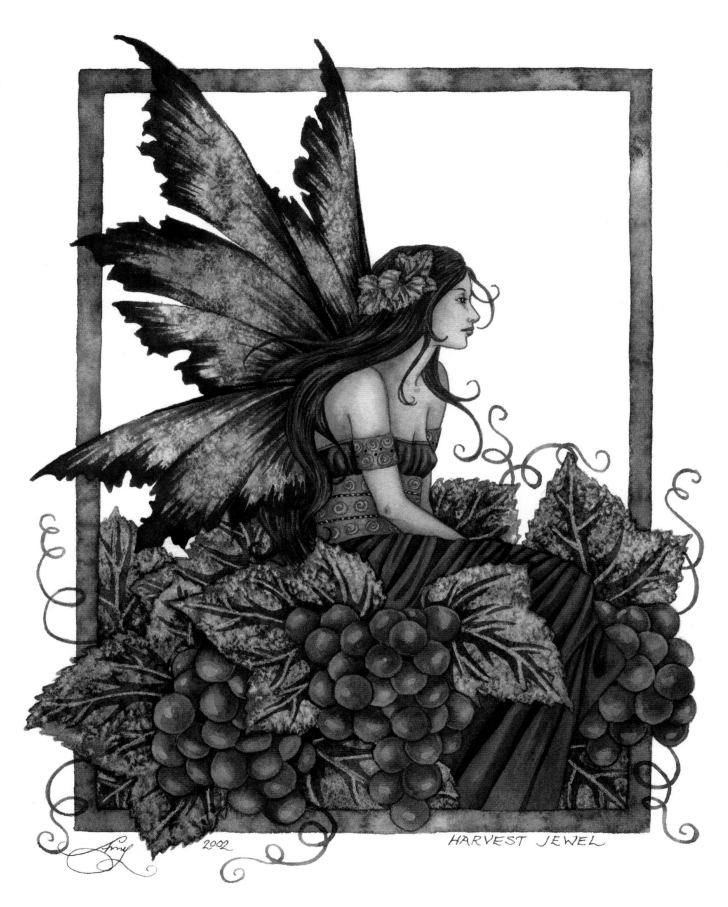

Harvest Jewel (2002)
Oh, more romantic grapes…

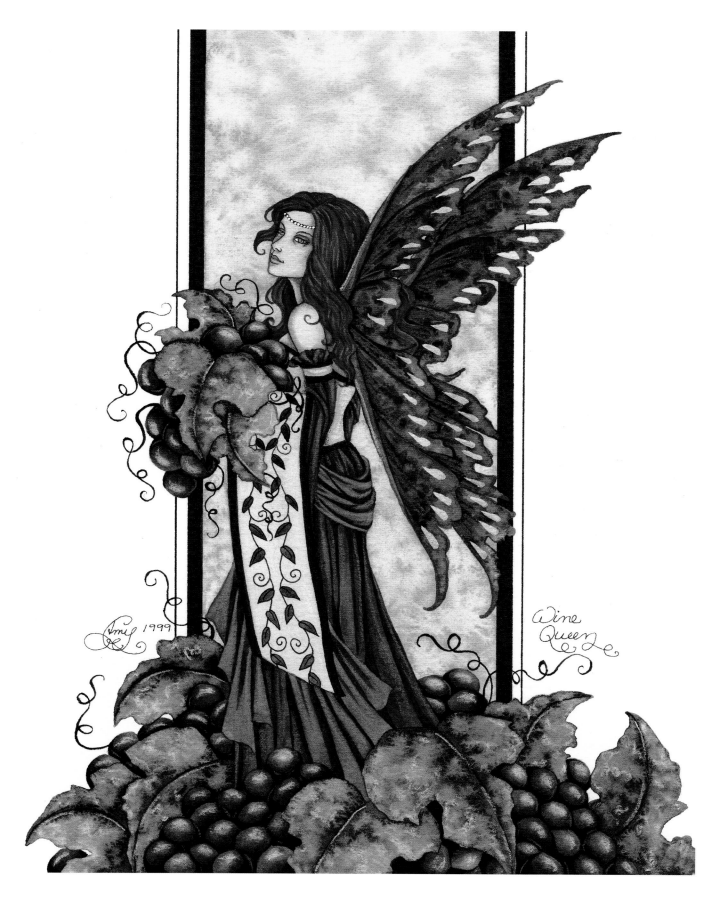

Wine Queen (1999)

Argh! Even more grapes! I must be obsessed with grapes or something!

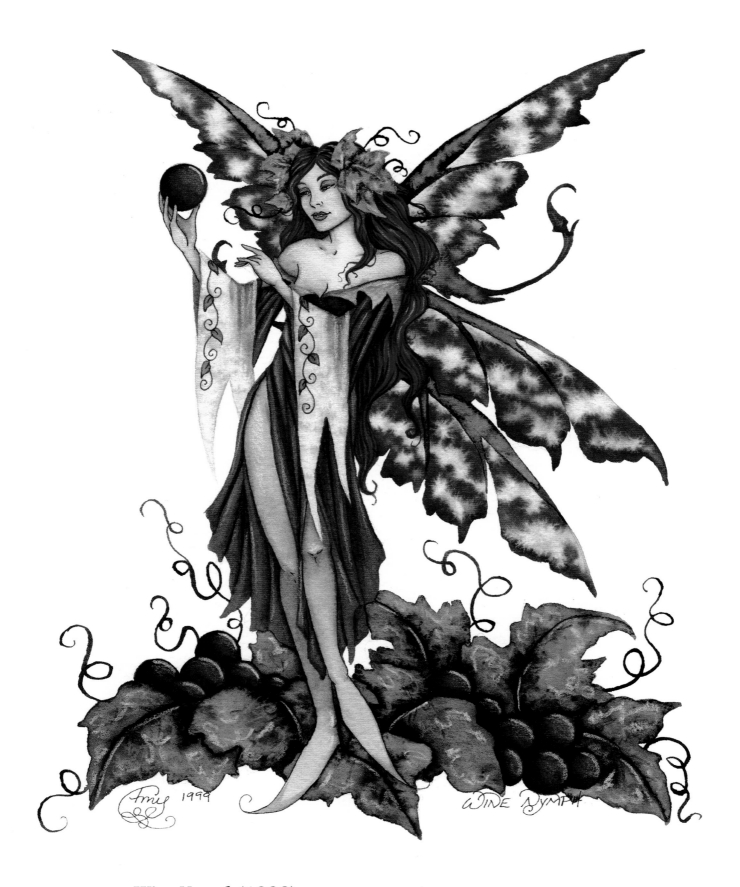

Wine Nymph (1999)
I don't drink wine, but I love the romantic feel of it.

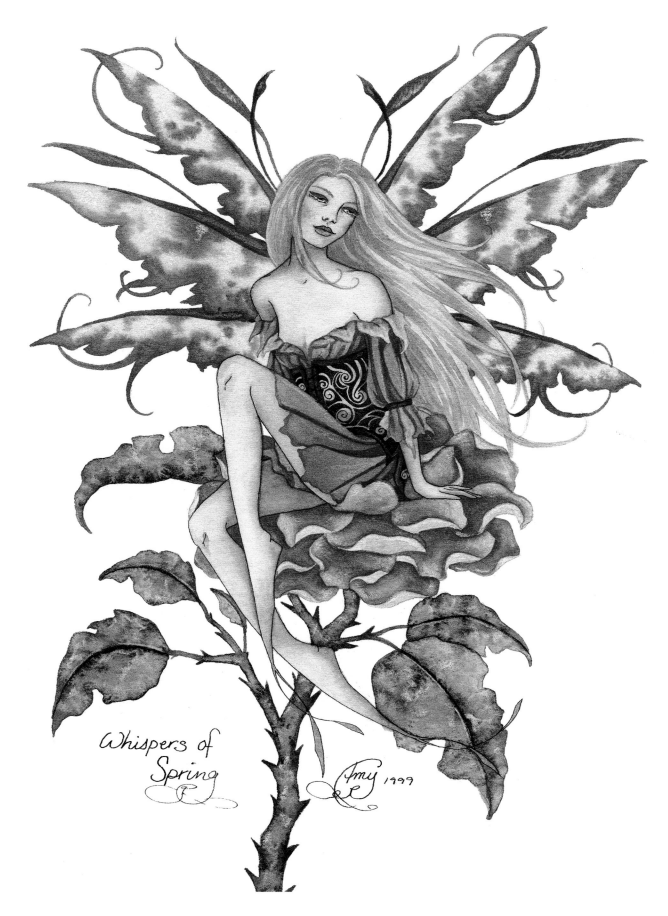

Whispers of
Spring

Amy 1999

Whispers of Spring (1999)

Whispers of Spring was part of a set of four paintings I did of the four seasons. Every two or three years, I try to paint a new set of seasons.

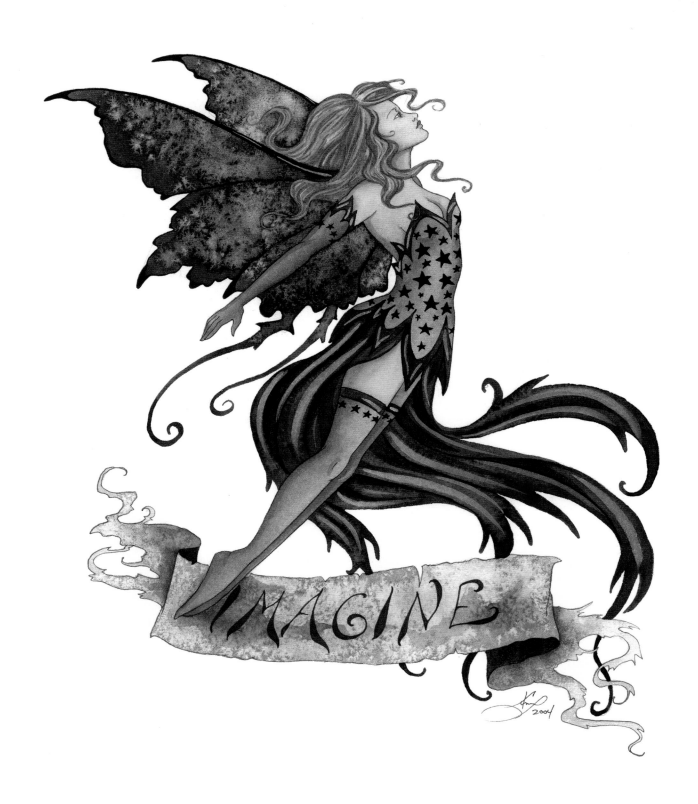

Imagine (2004)

Imagine is a piece from my *Inspirational* series. I hope the image encourages viewers to let their minds wander more often.

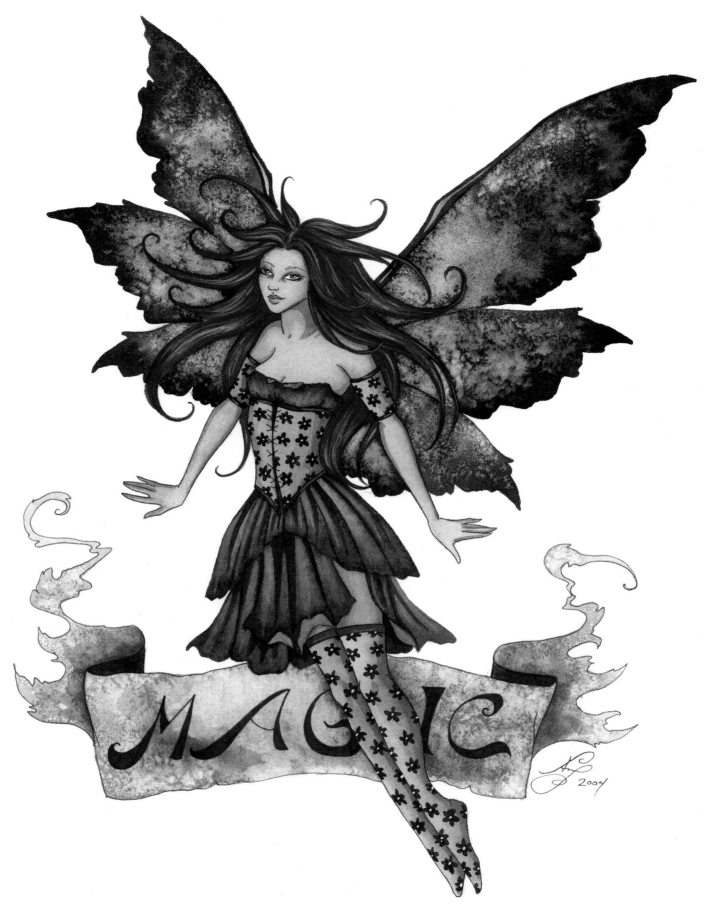

Magic (2004)

Magic is another inspirational piece. I think it's important to surround ourselves with images that remind us to think positively each day or every day or even every hour.

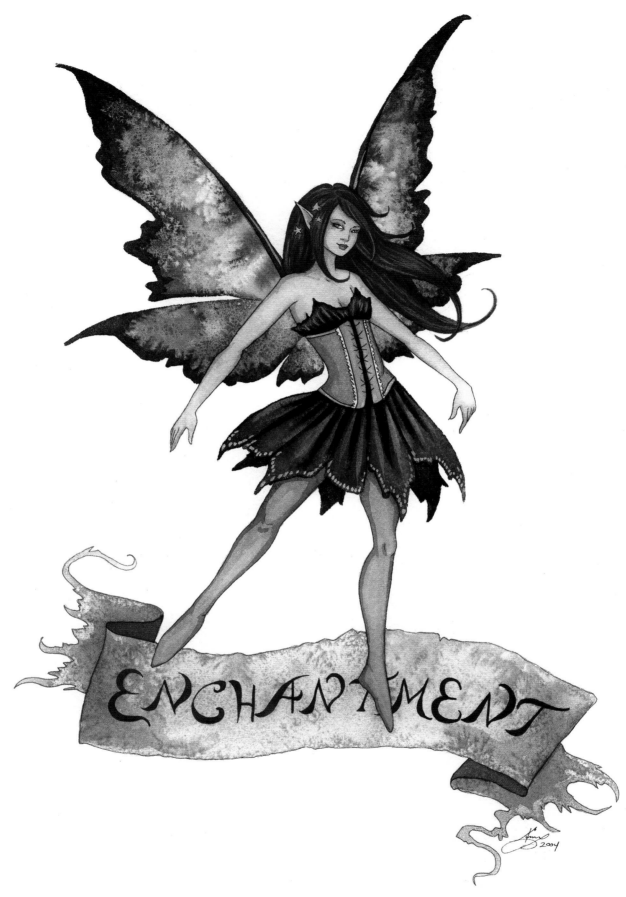

Enchantment (2004)
Enchantment is another piece in my *Inspiration* series.

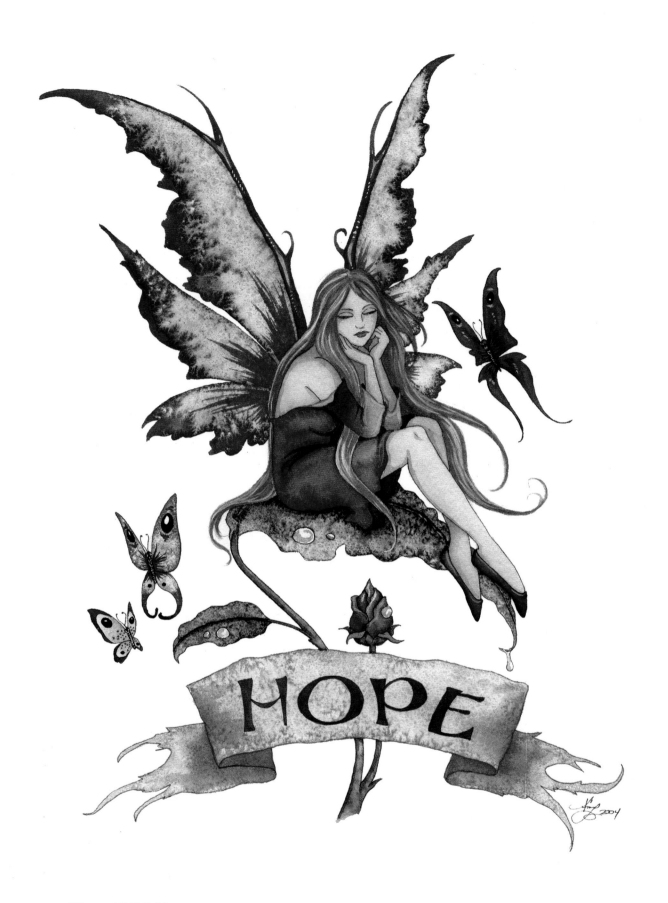

Hope (2004)

Hope is another inspirational piece. The simplicity of the image helps to get the meaning across.

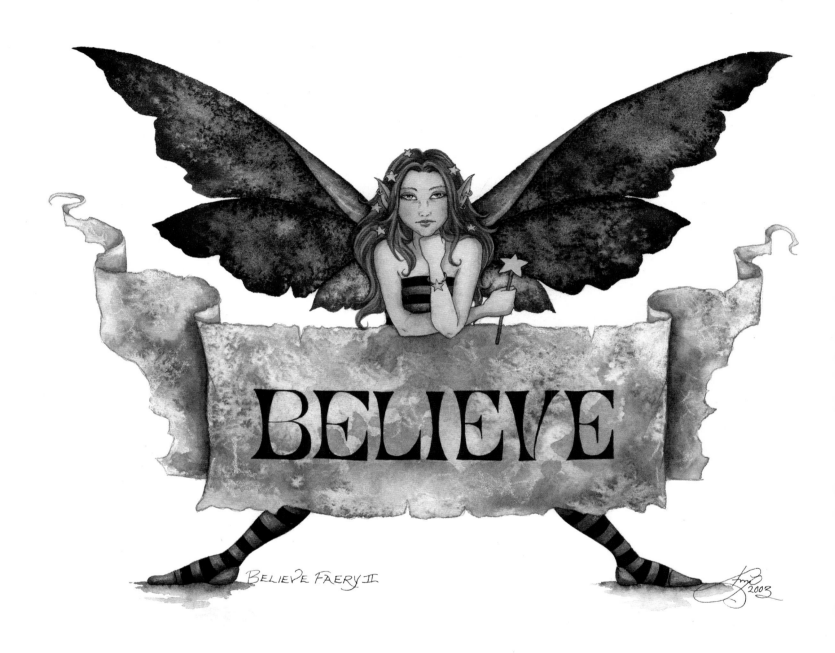

BELIEVE

BELIEVE FAERY II

Believe Faery II (2003)

I am hoping to do a new version of *Believe* every couple of years. I'd like to offer a wide range of colors and poses so customers can choose the faery that suits them best.

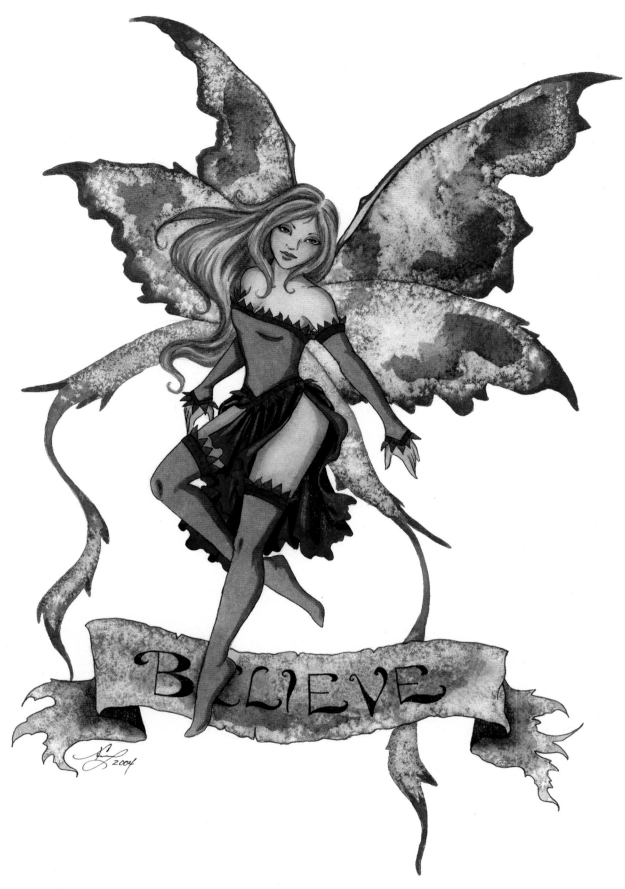

Believe Faery III (2004)

I think *Believe Faeries* are important for keeping up our spirits. They constantly remind us to keep going.

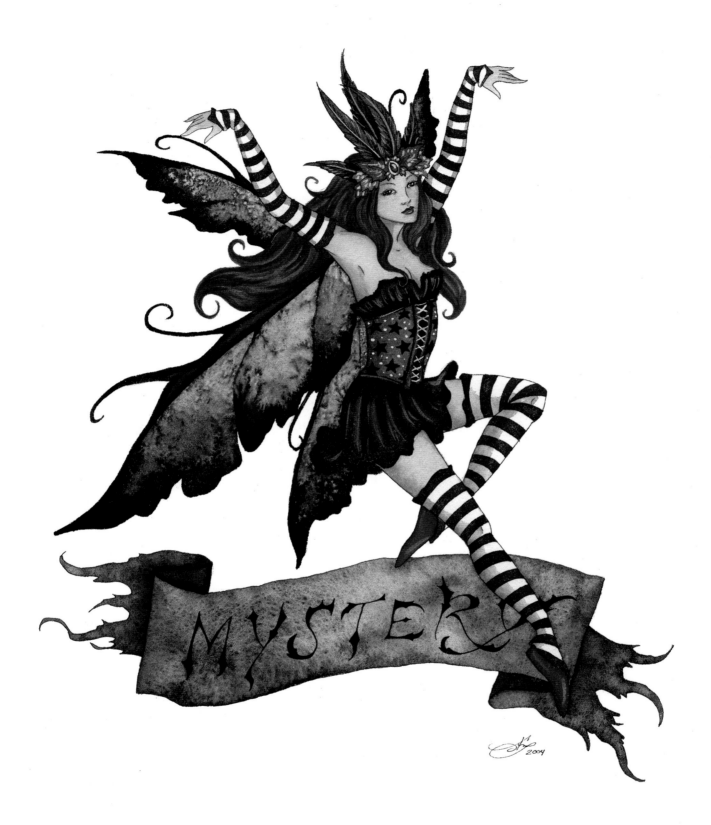

Mystery (2004)

Mystery was painted on a type of watercolor paper I don't use anymore. I was trying to use up old paper that I had in my studio. Unfortunately, I hadn't used that type of paper in so long that I had become unaccustomed to painting on it and had a horrible time fighting with the painting. The paint did not want to flow properly on the paper. Once the piece was finished and I could step back, I felt it worked out, though I will never paint on that type of paper again.

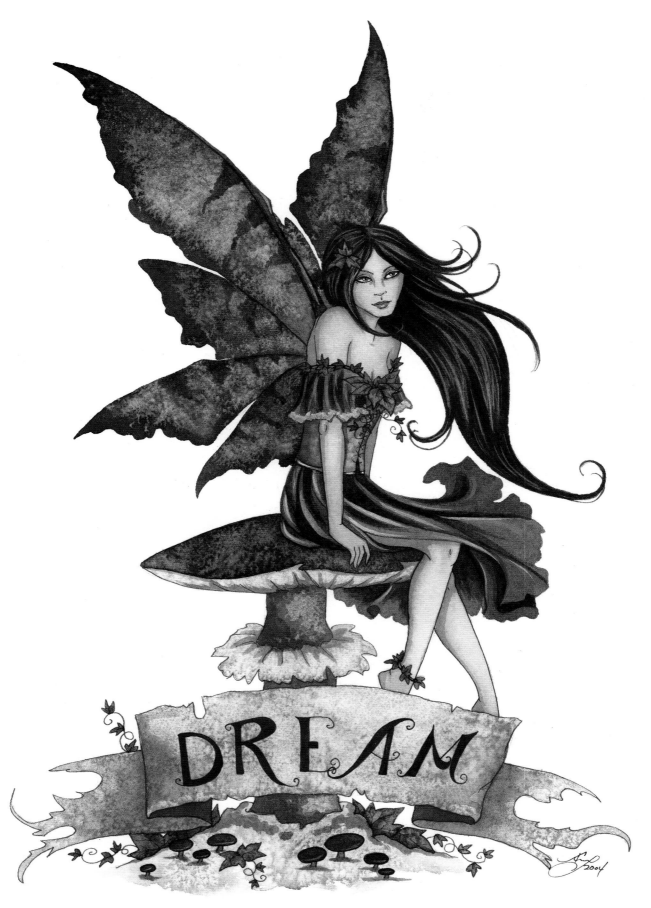

Dream (2004)

I'm not real happy with the way this piece turned out, but I finished it anyway. Sometimes images that I don't personally like become well loved by everyone else. I guess I have a different way of looking at my own work.

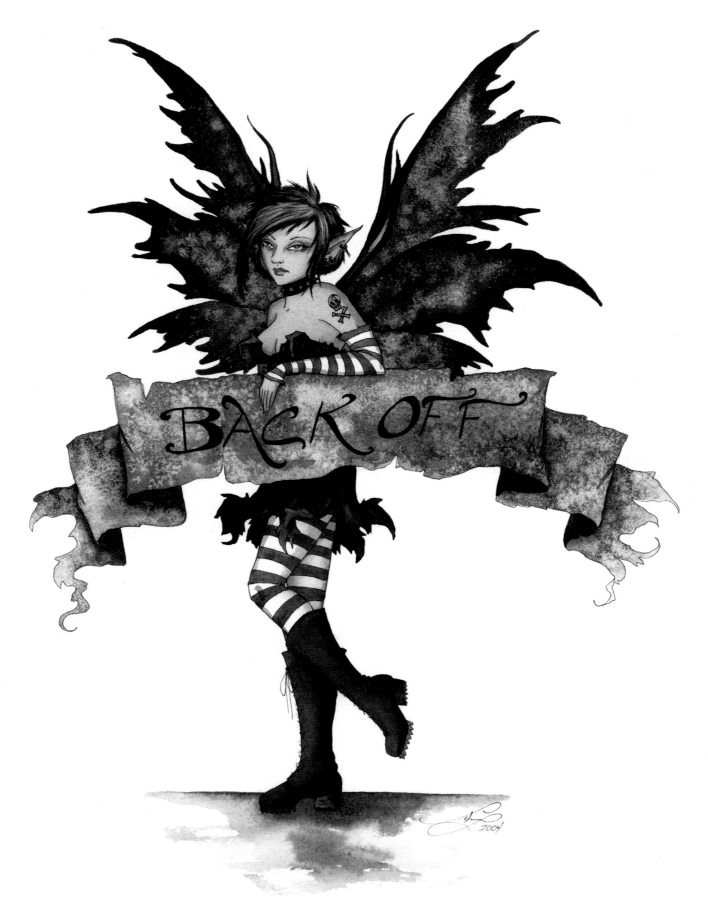

Back Off (2004)
I had to do this piece just for fun.

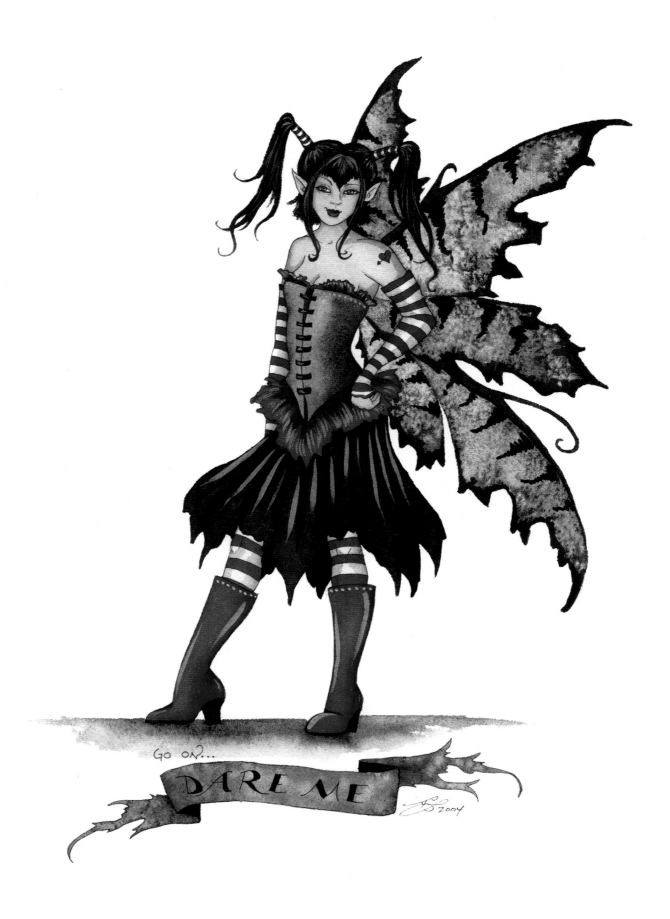

Go on… DARE ME (2004)
This sentence popped into my mind one day.

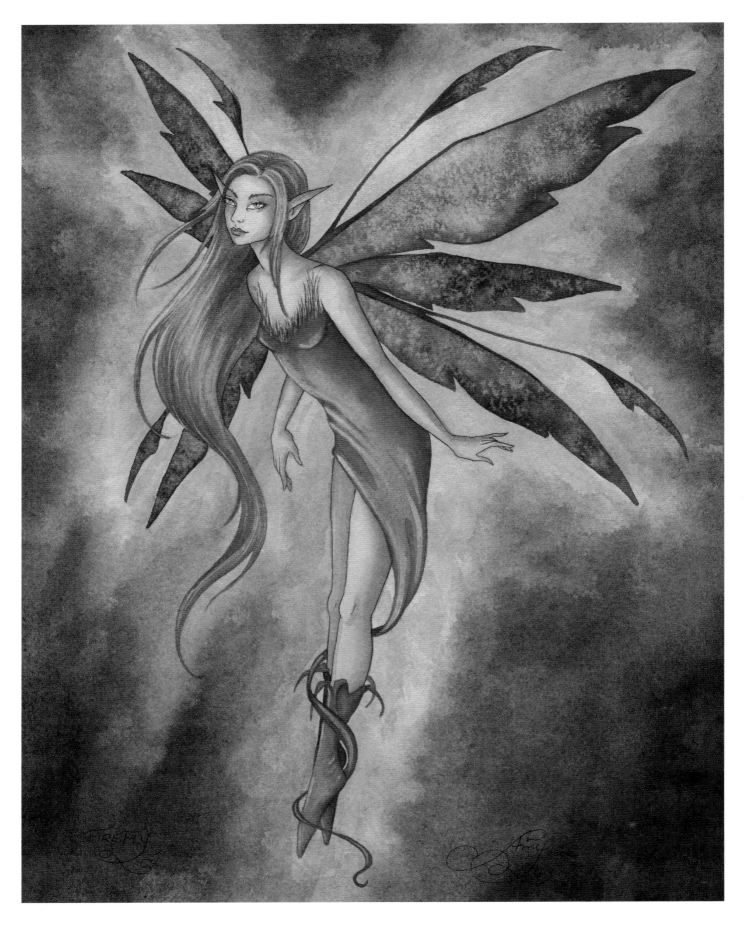

Fire Fly (2002)
Look more closely next time you see fireflies about.

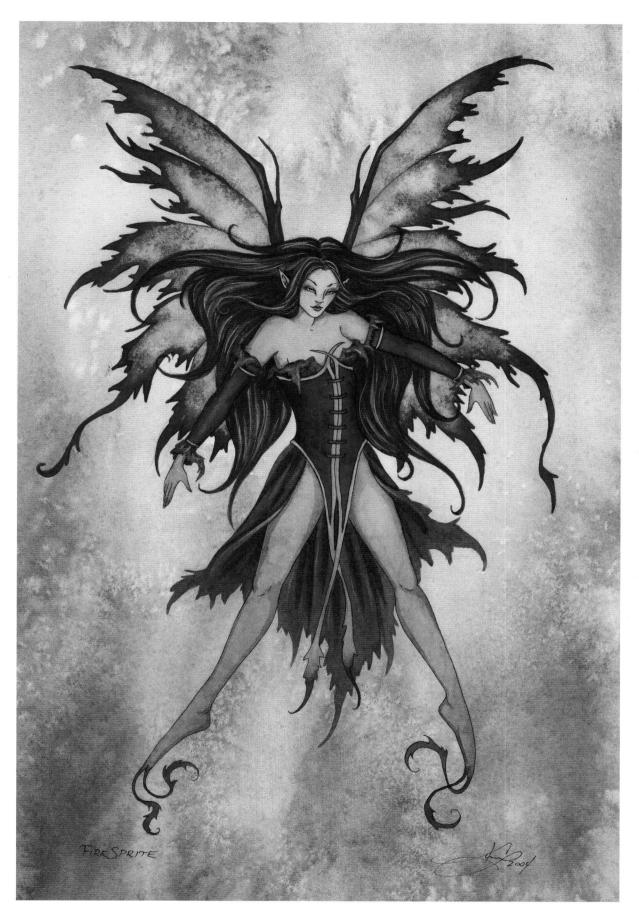

Fire Sprite **(2004)**

Fire is always a popular theme for me. This is my favorite fire piece.

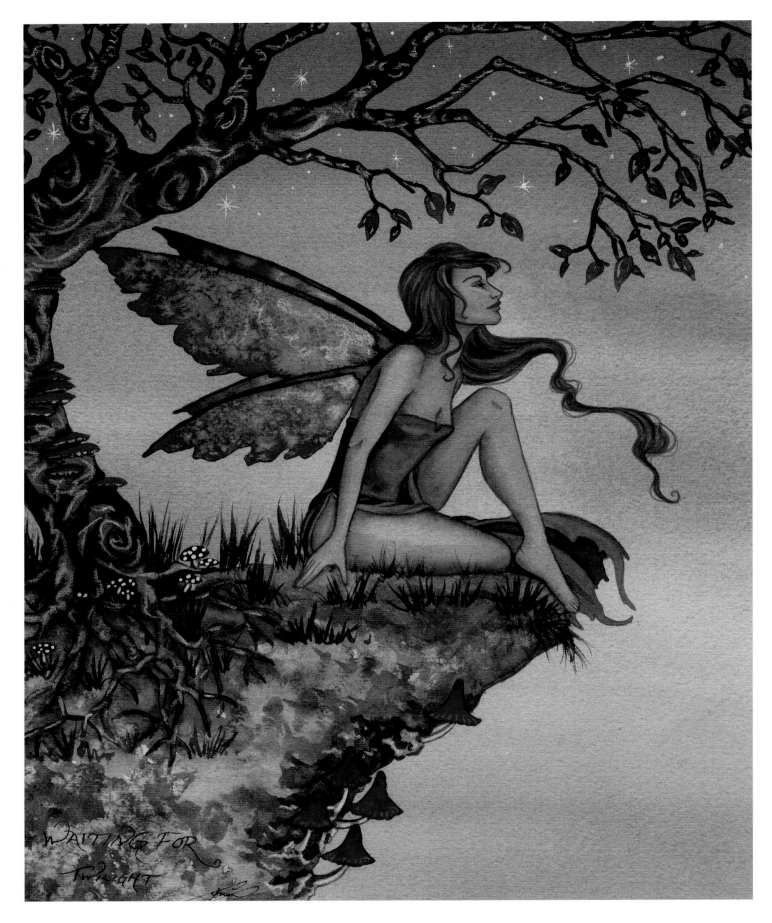

Waiting for Twilight (2003)

Originally, this painting had no stars in it. My husband came up with the idea as he was scanning it for our archives and I added them a few months later.

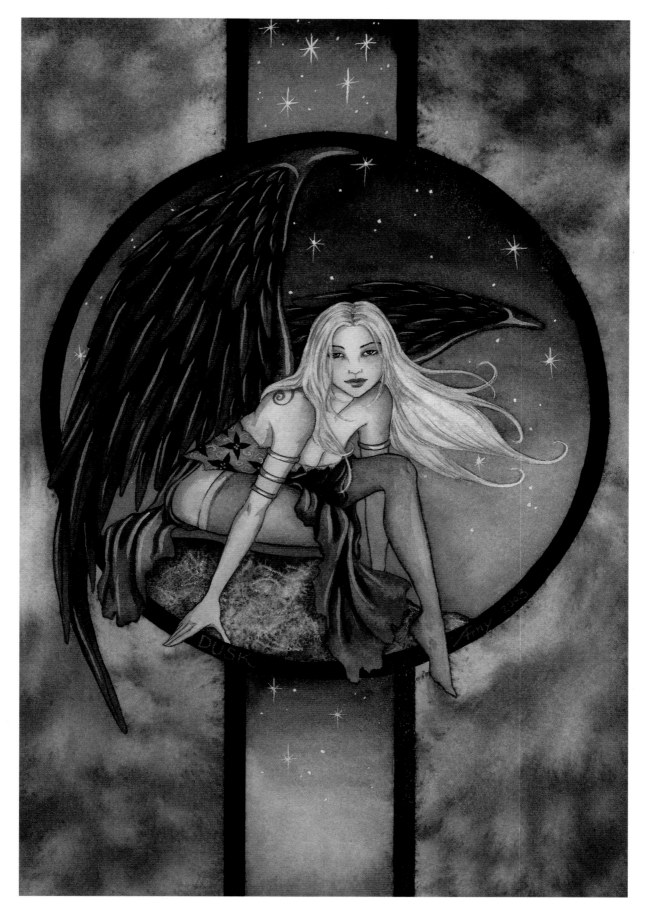

Dusk (2003)

Dusk is the first of my *Dusk till Dawn* series. At the bottom of the picture, you can see the sun has just dipped below the horizon.

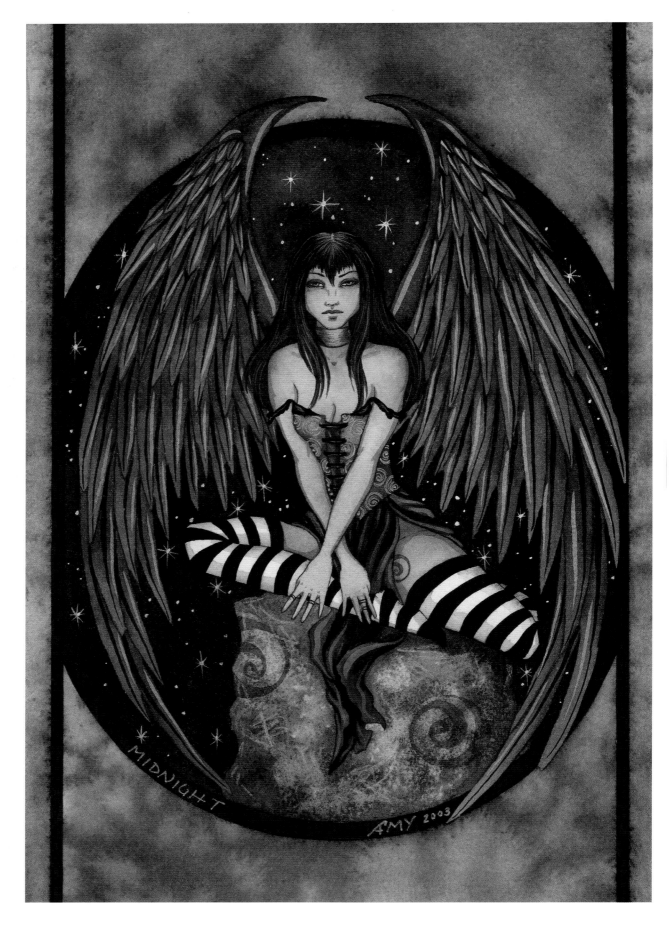

Midnight (2003)

Midnight is the second piece of the *Dusk till Dawn* series. All is dark and are the stars are out.

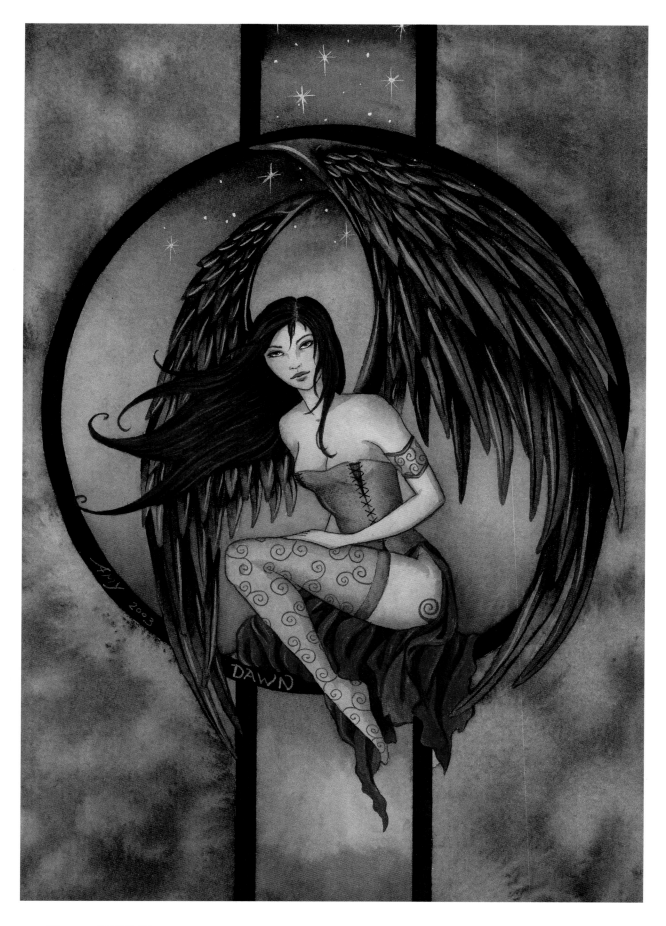

Dawn (2003)

This is the third and final piece of the *Dusk till Dawn* series. The sun has begun its climb into the sky and its warm glow is spreading upward.

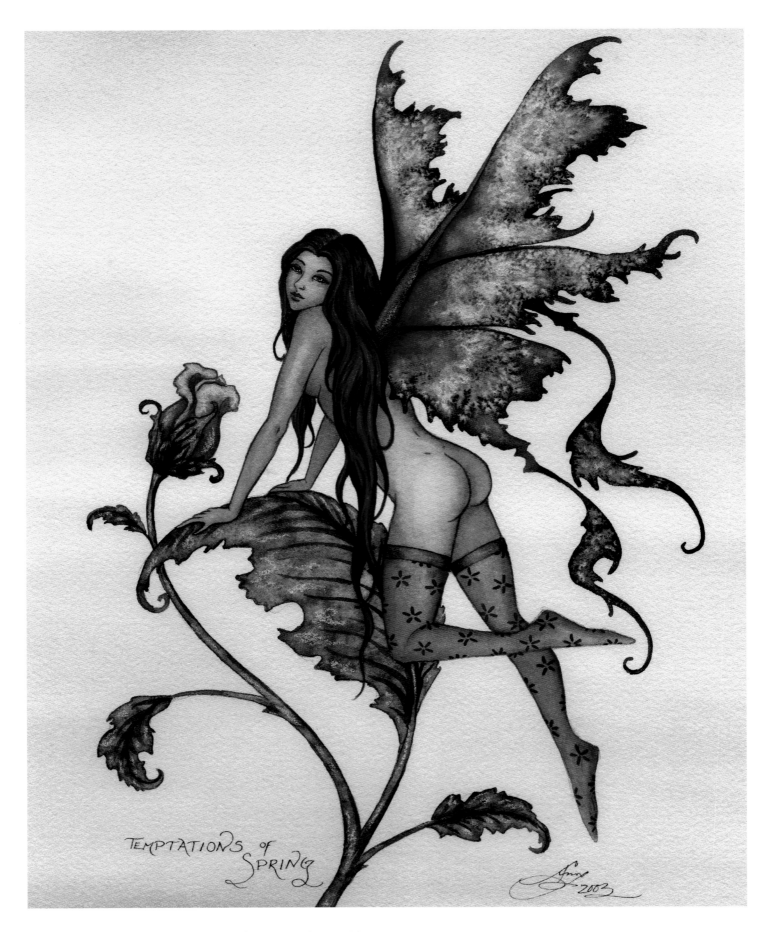

Temptations of Spring (2003)
Well, she's a cheeky little thing, isn't she?

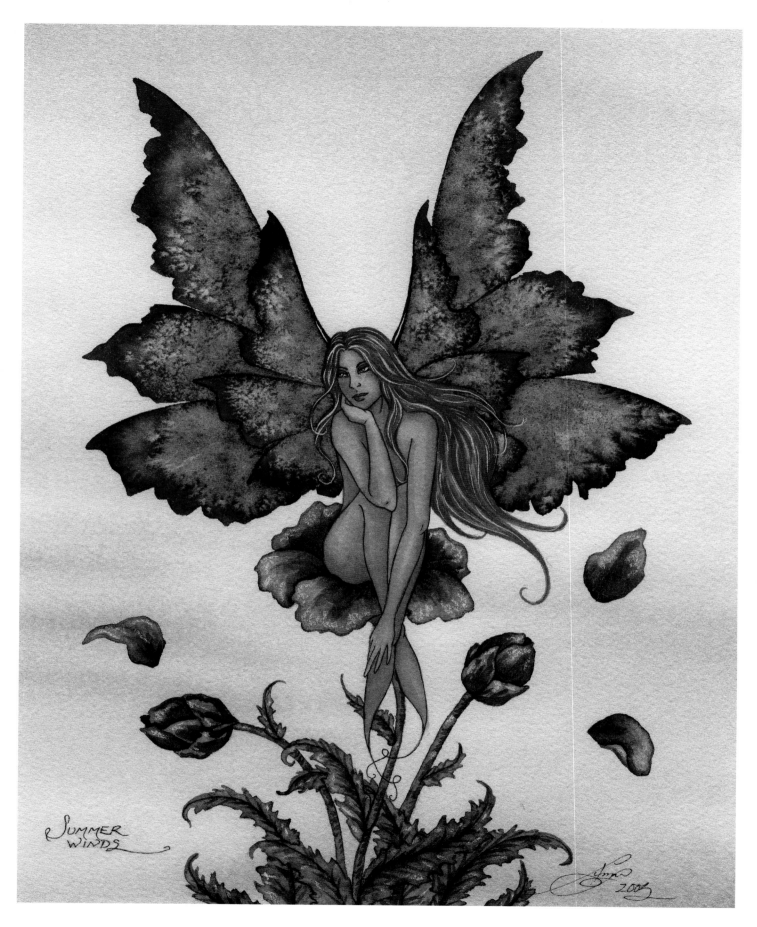

Summer Winds (2003)
Warm winds in June blow poppy petals through the air.

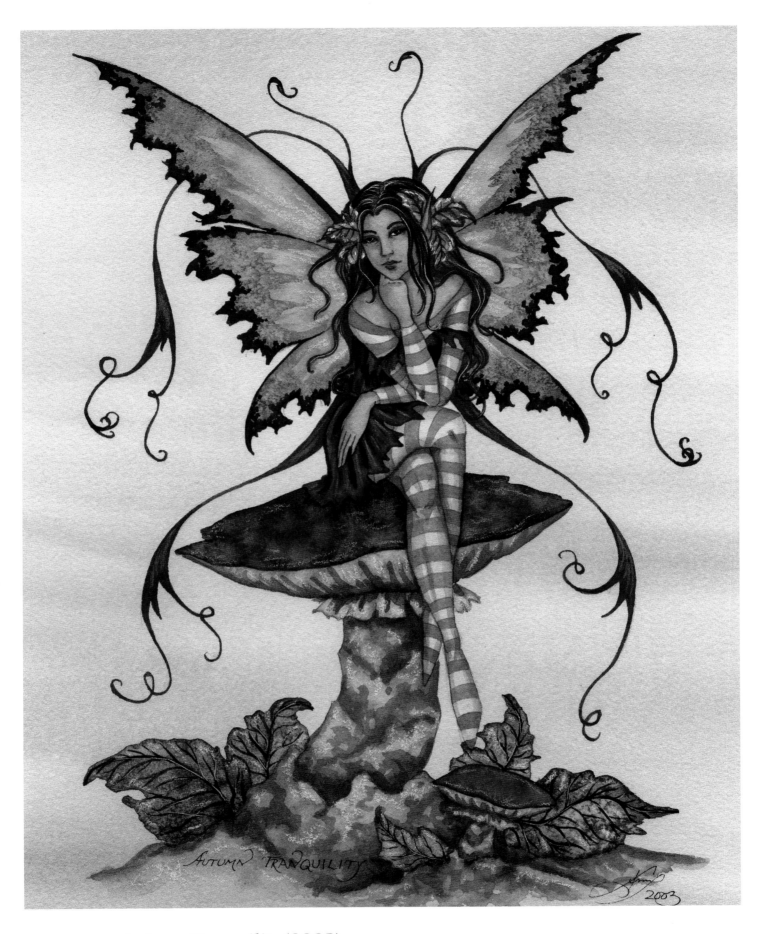

Autumn Tranquility (2003)
Autumn Tranquility is from my most recent *Four Seasons* series.

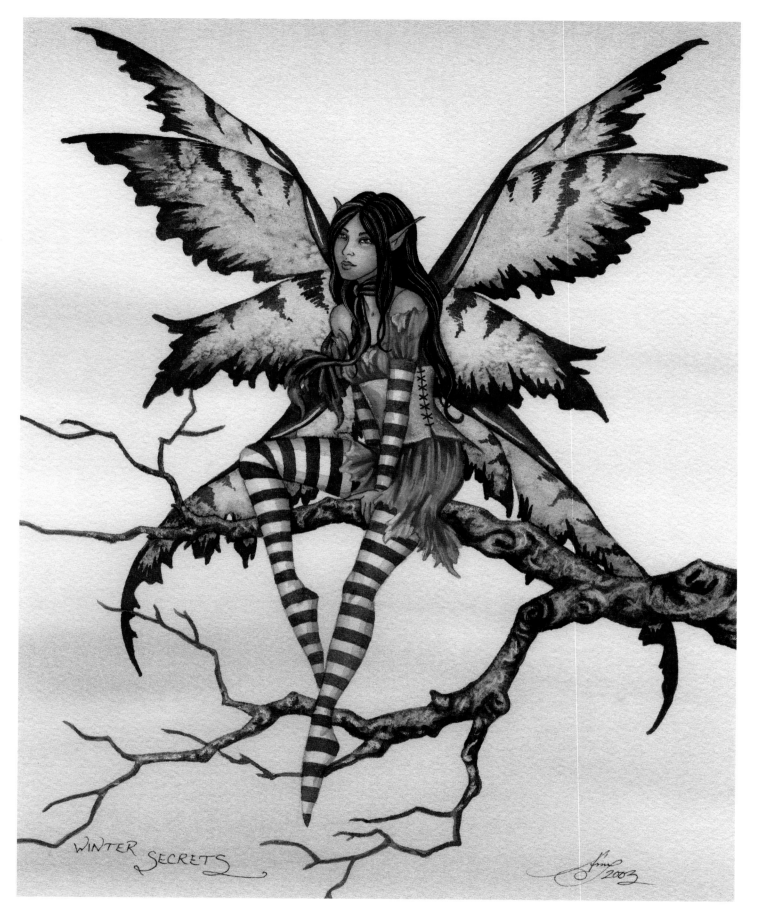

Winter Secrets (2003)
The Winter Faery puts the bite in the winter air and the sparkling frost on the ground.

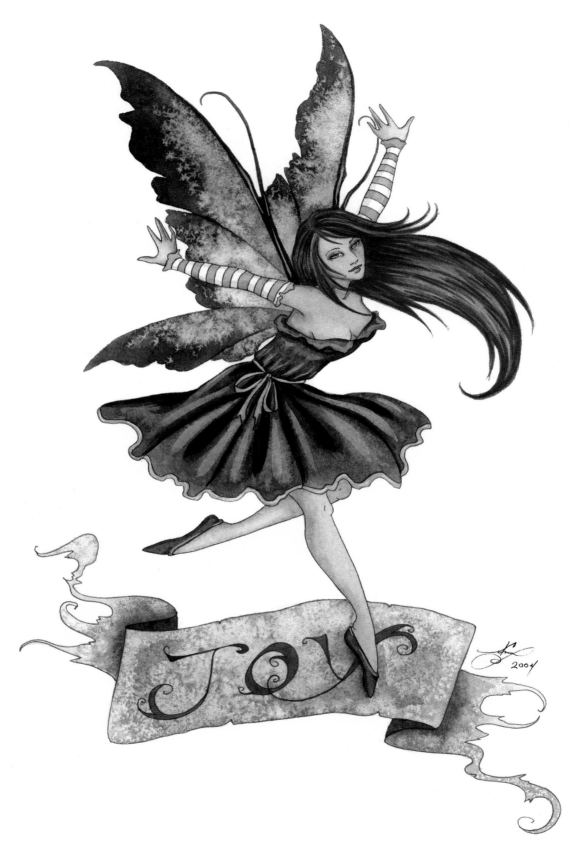

Joy (2004)

Joy was created for the 2004 Christmas card set. Just as I did with *Peace*, I wanted Joy to work all year round. I feel the green and gold color scheme gives it some versatility.

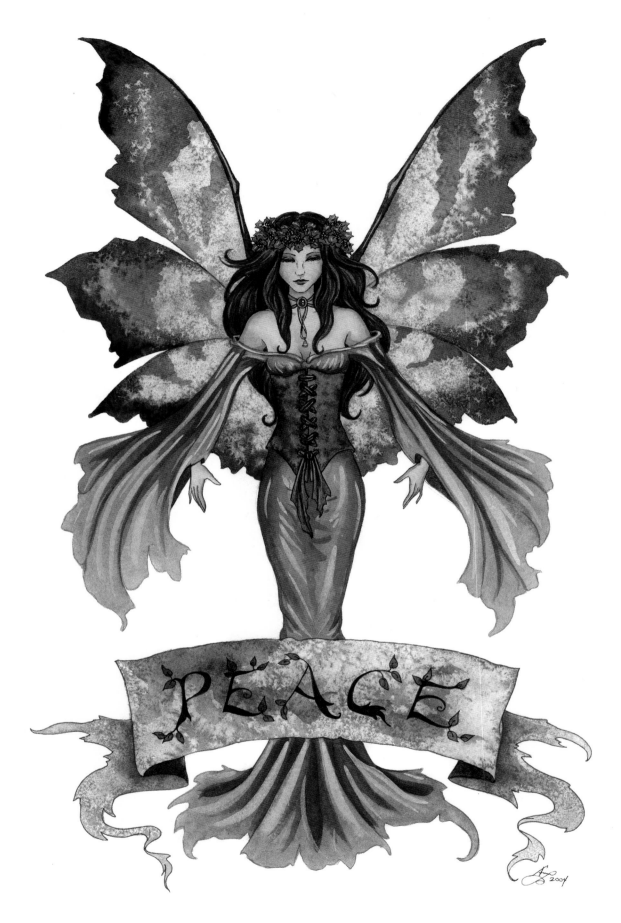

Peace (2004)

Peace was designed for a Christmas card set. I also wanted the figure to work as an everyday image because the image's message is so important. I thus chose rose tones instead of traditional Christmas reds and Greens.

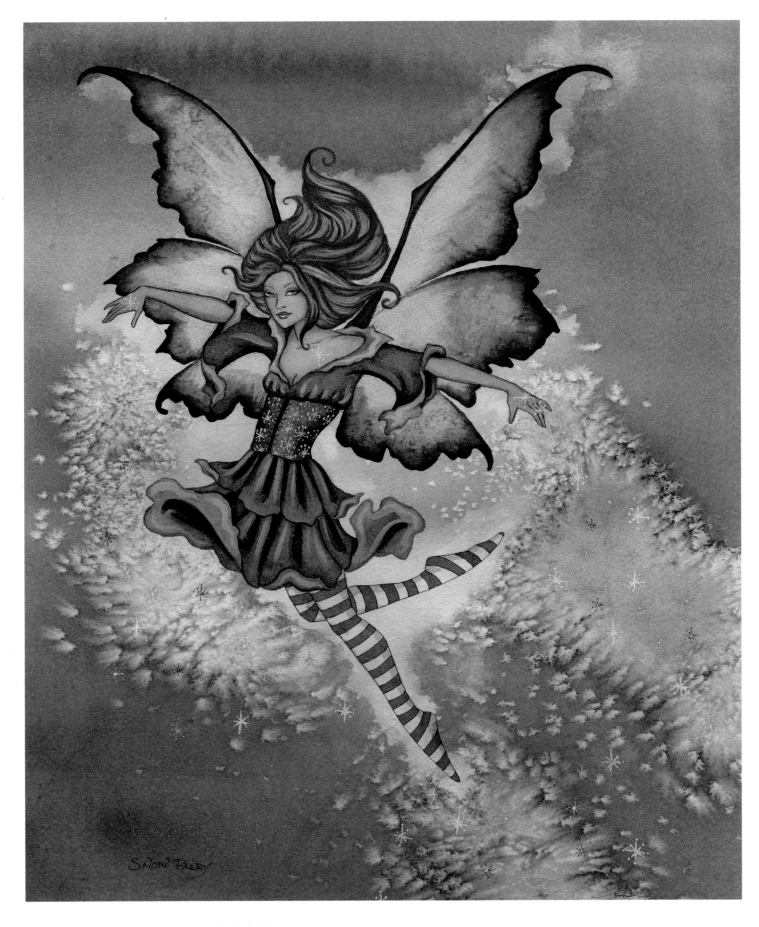

Snow Faery (2004)
Snow Faery was created to finish off a four image Christmas card set for the 2004 holidays.

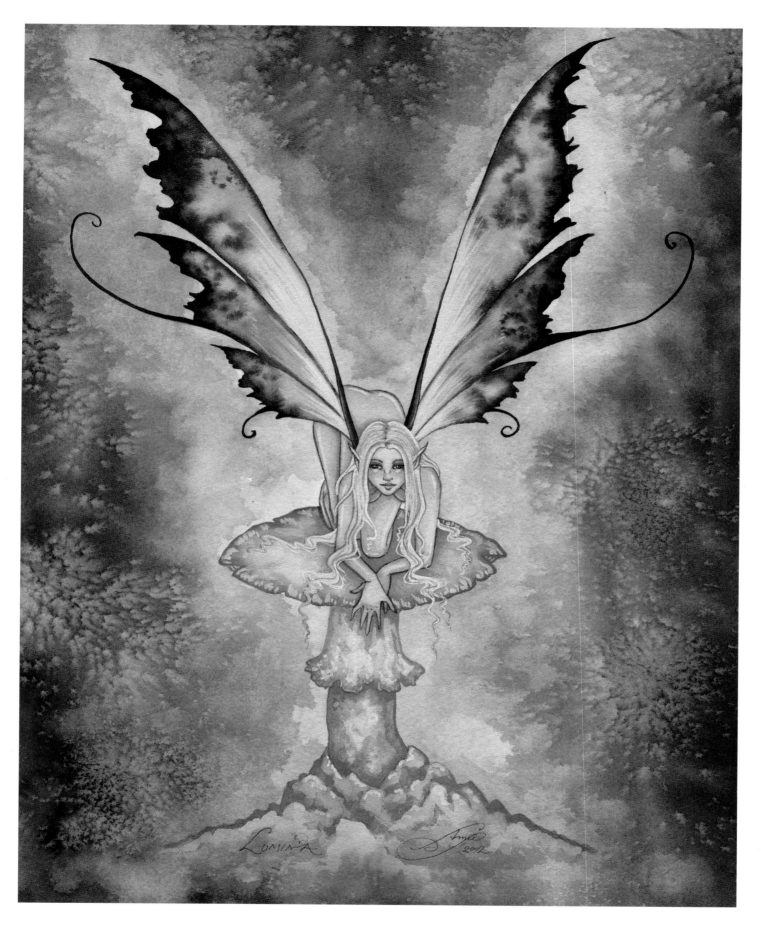

Lumina (2002)

I have used the pose in Lumina at least three times now. It's a fun pose to draw, and it's a challenge to make each painting in which I use it look different.

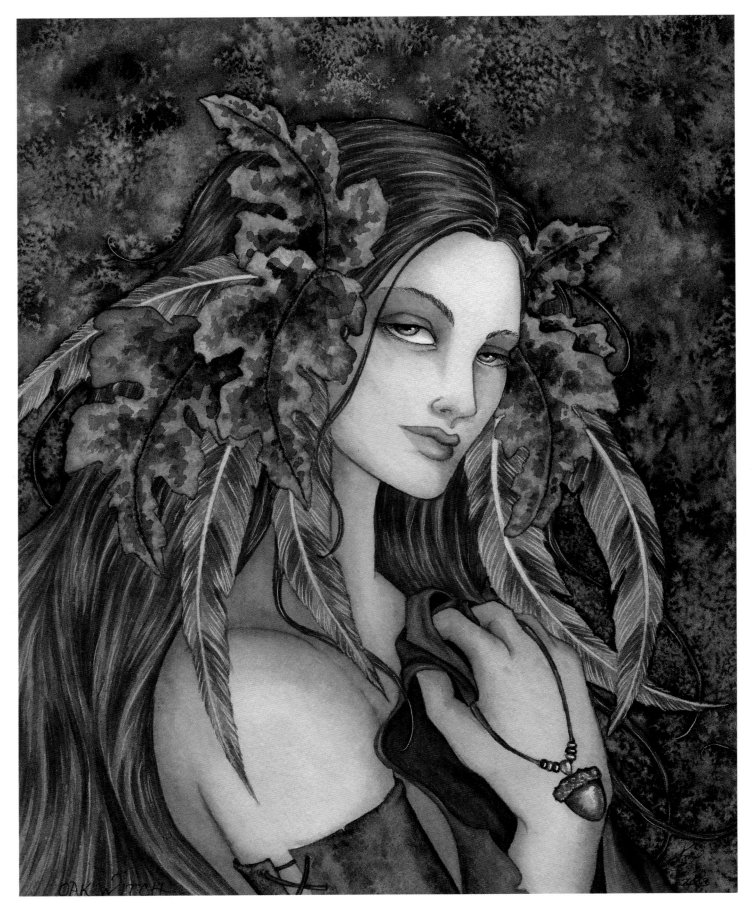

Oak Witch (2003)
A perfect little acorn that came off of my grandfather's oak tree inspired this piece.

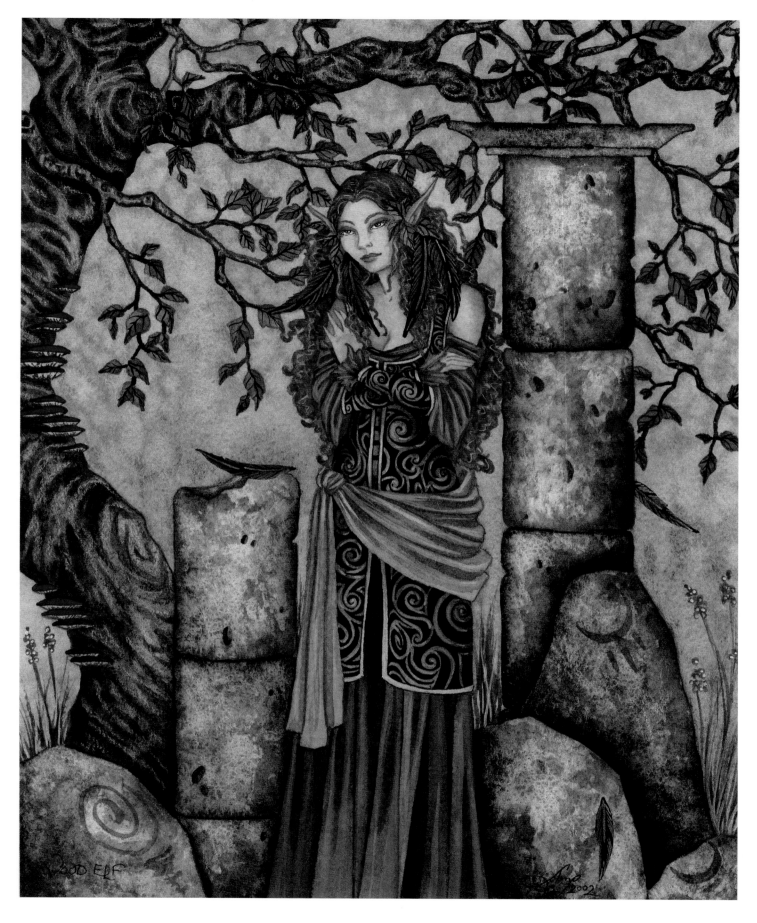

Wood Elf (2002)
Green Faery...also known by my friends as the "Butt Faery."

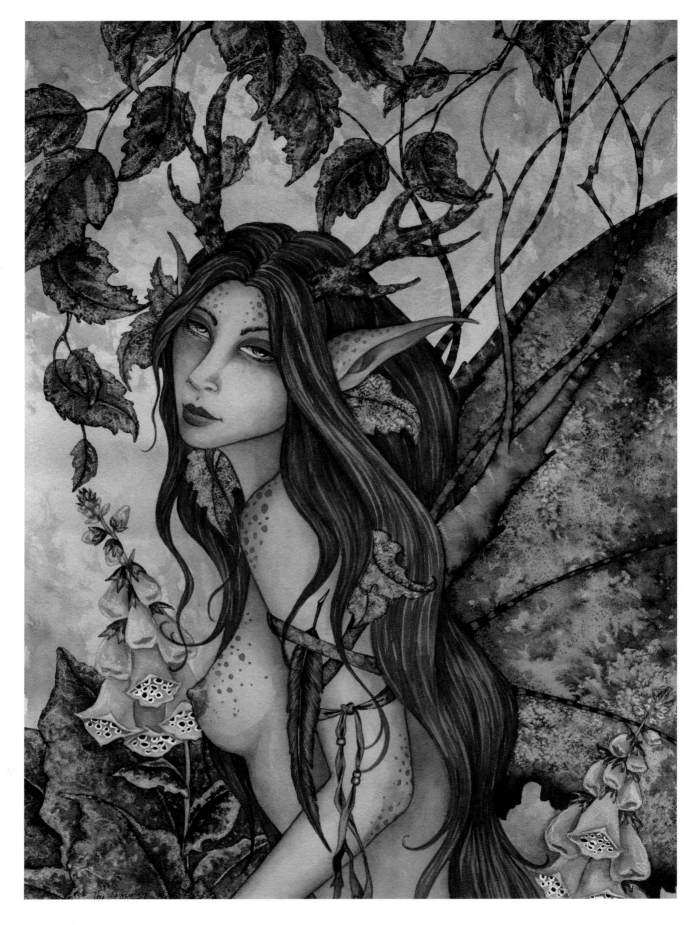

The Forest Has Eyes (2003)

In *The Forest Has Eyes*, I use the same pose that I used for *Something Rich and Strange*. I had always liked the pose, and I decided to rework it and give it a new feel.

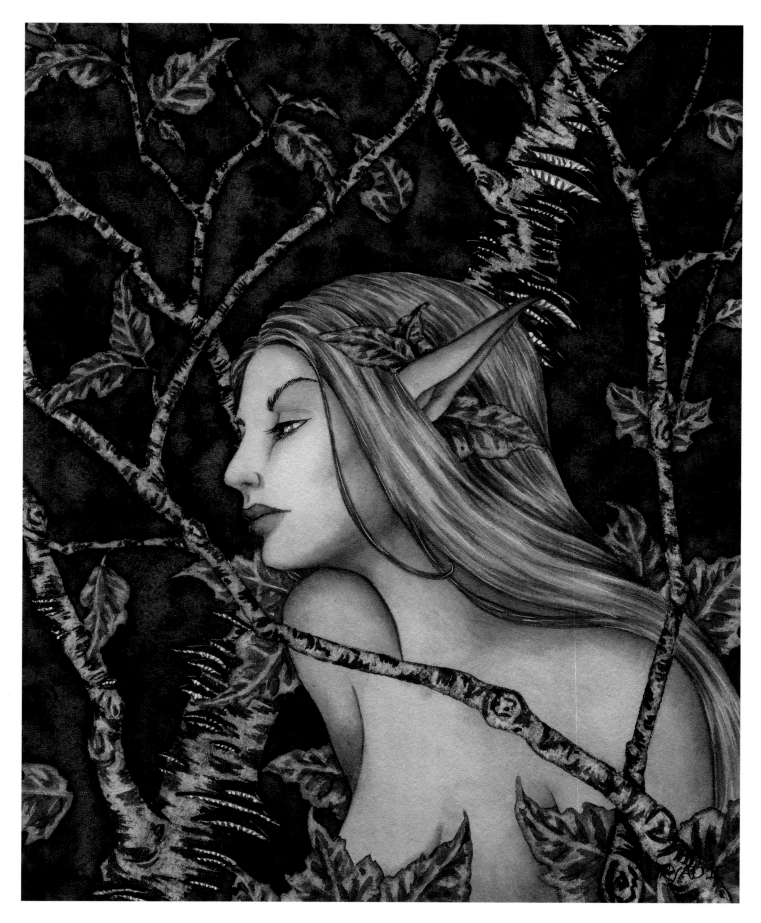

Dryad II (2003)

Several years ago, I did a painting with this same woman and sold the original to a friend. Done in rose and cream hues, it was simple. I always liked the way it turned out and decided to use the general pose again. I added trees, changed the colors, etc.

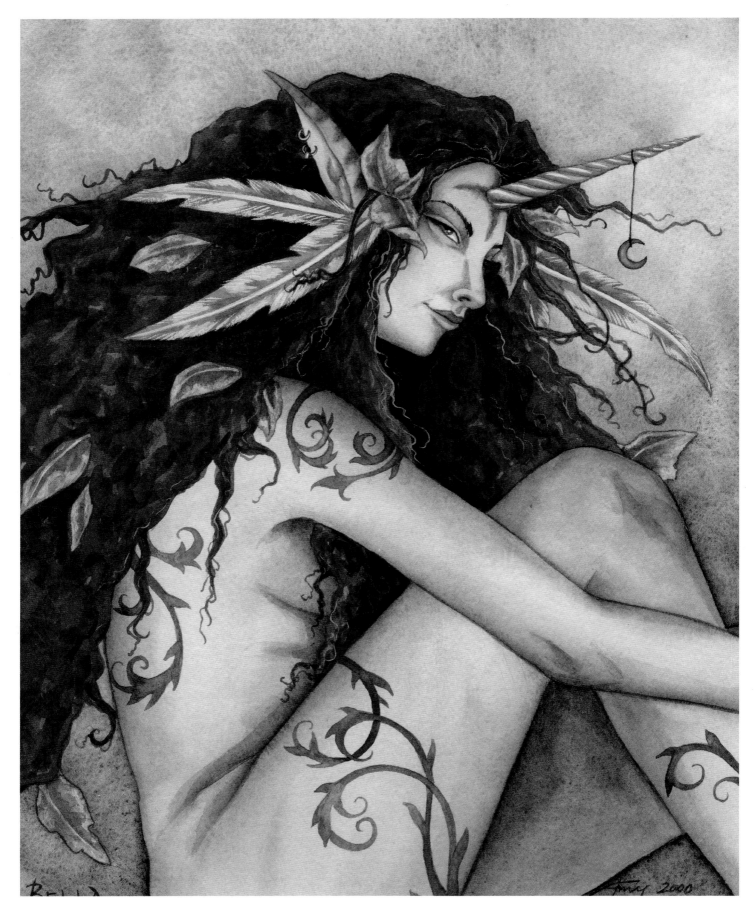

Bella (2000)

I needed a change from painting faery wings, and *Bella* was created.

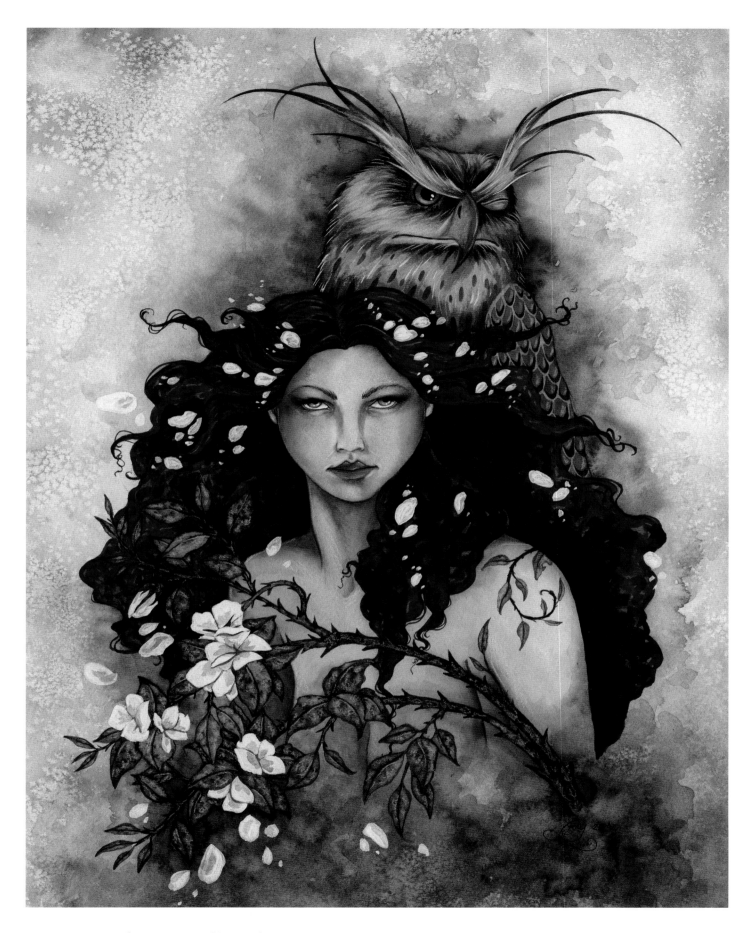

White Roses (2000)

This image was painted solely to fit a beautiful picture frame I have. After it had hung in my house for a few years, I wanted a change and took it down. I still need to paint a new piece for that frame.

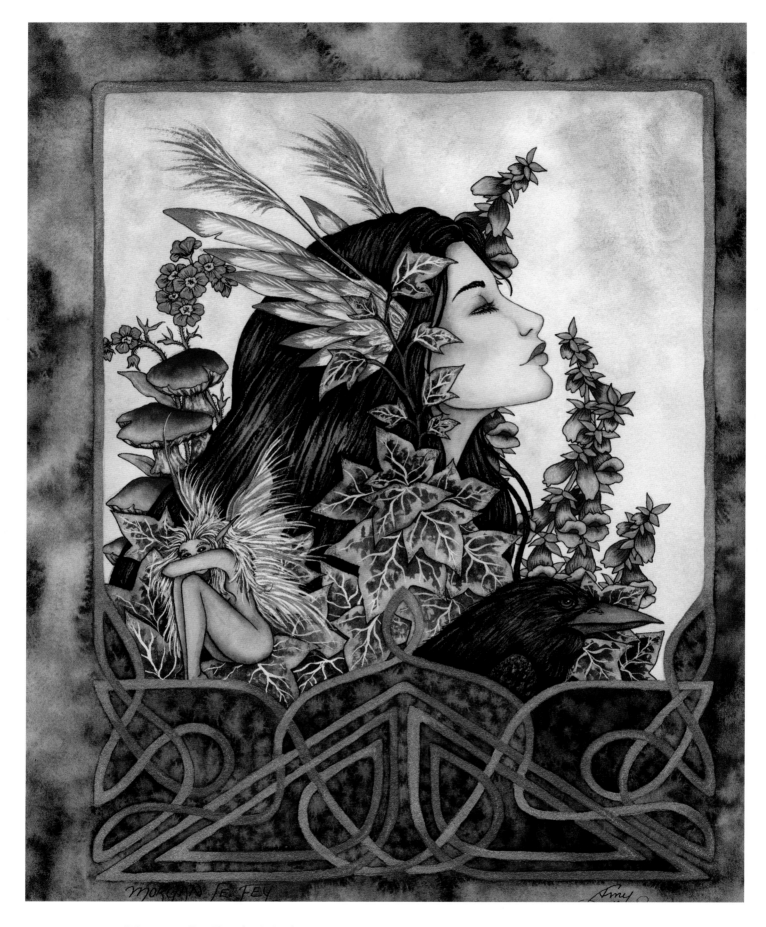

Morgan Le Fey (1998)

I have always had a special place in my heart for *Morgan*, who is sometimes portrayed good and other times bad. I wanted to portray her rumored faery heritage.

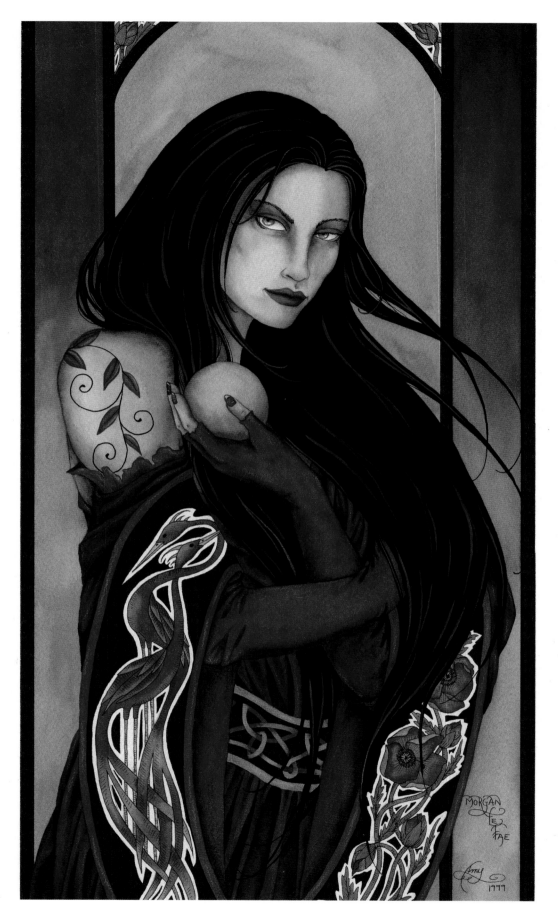

Morgan Le Fae (1999)

Here's Morgan again. This time she's a bit naughty.

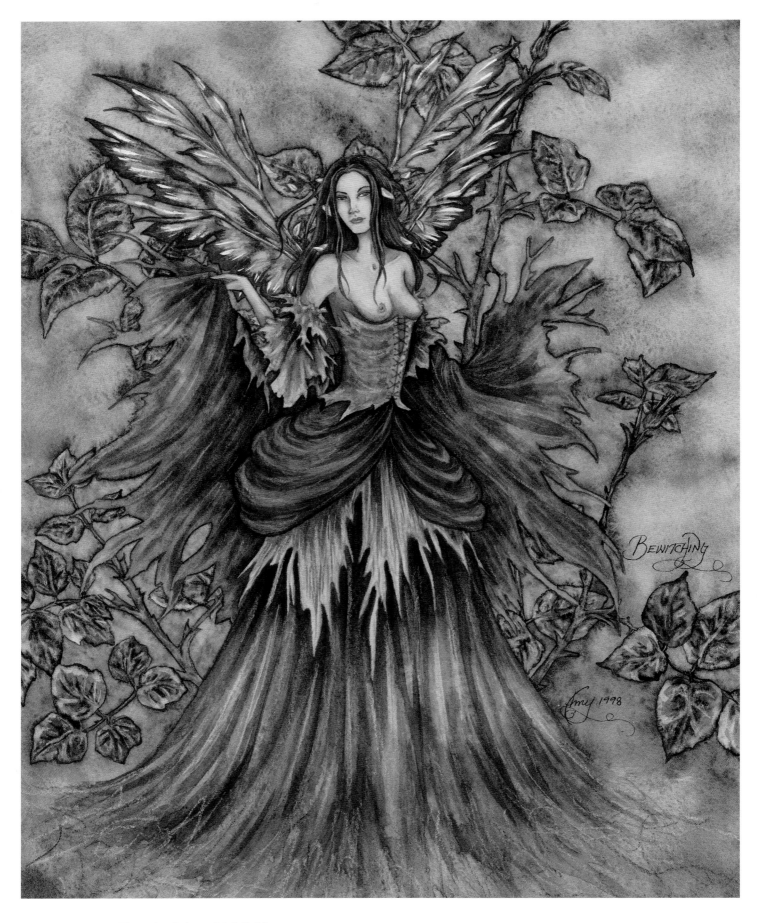

Bewitching (1998)

Driven into a frenzy one day by the works of Brian Froud, I was desperate to create an image as beautiful and mysterious as Froud's images. *Bewitching* was as close as I was able to get.

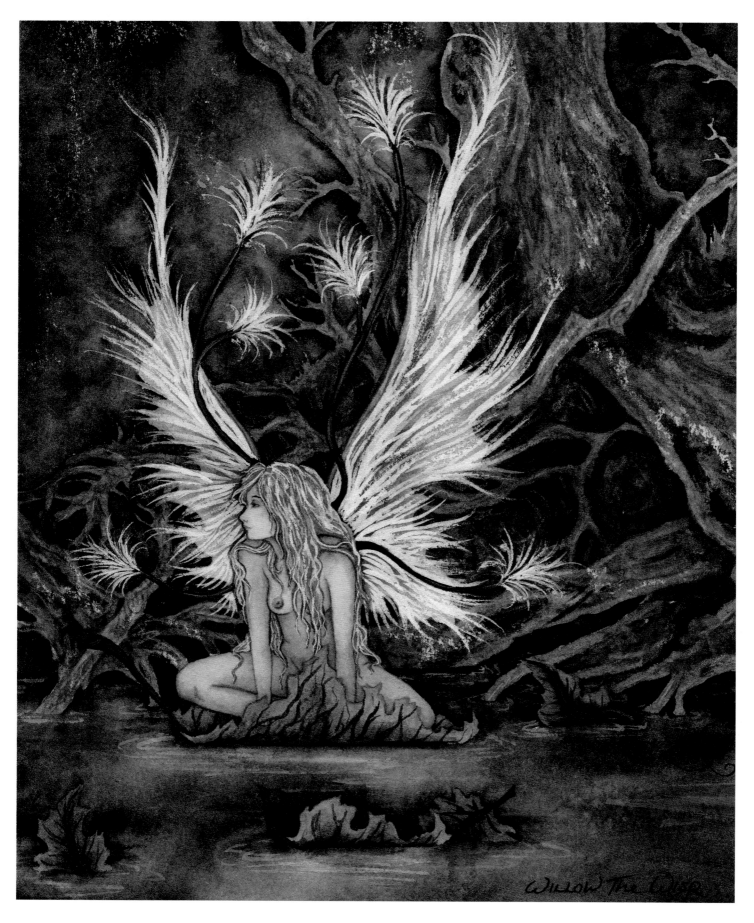

Willow the Wisp (1998)

Willow the Wisp was my first attempt at a piece with a full background. It was also my first attempt at painting water. Not bad for a first try, but there was plenty of room for improvement.

Passage to Autumn (2002)

Passage to Autumn was painted just before *Mystique*, the cover image of the first volume of the *Art of Amy Brown*. I loved the pose and wanted to recreate it a little differently, so I began work on *Mystique* as soon as I had *Passage to Autumn* completed.

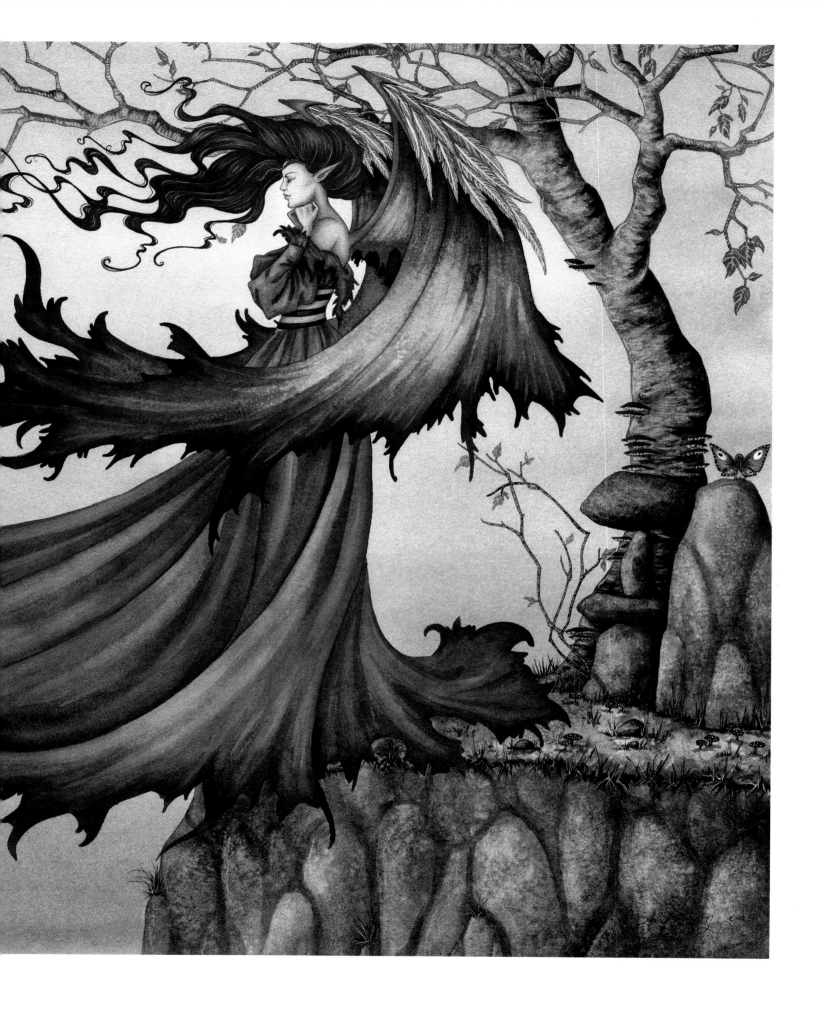

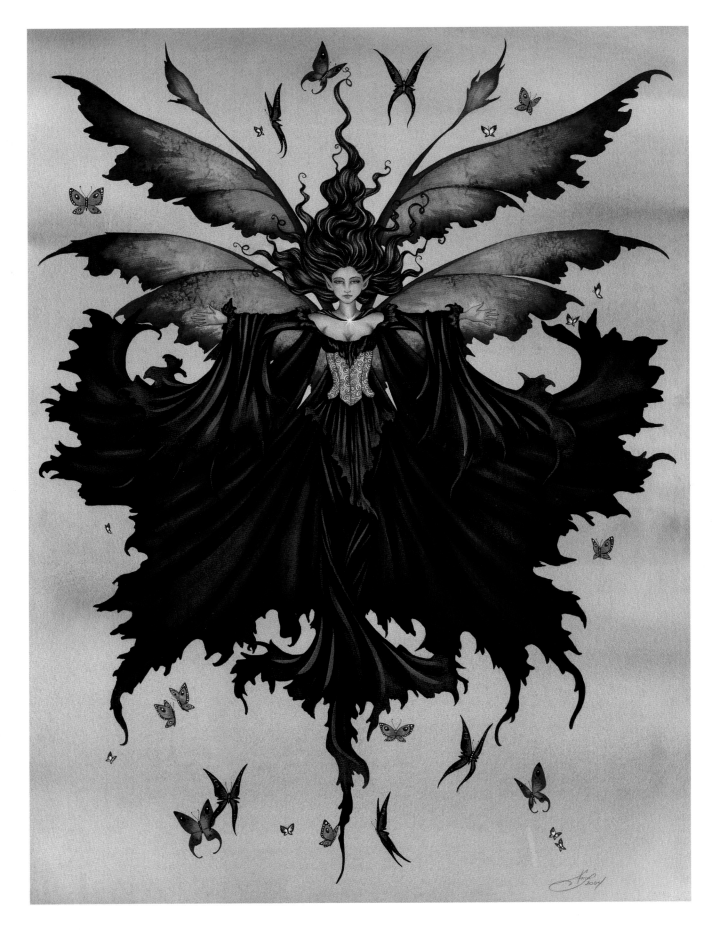

Unbound (2004)

I think when I started this drawing, I really didn't know where to go with it. So it sat in my studio for over two years before I completed it. I just knew something good would materialize eventually.

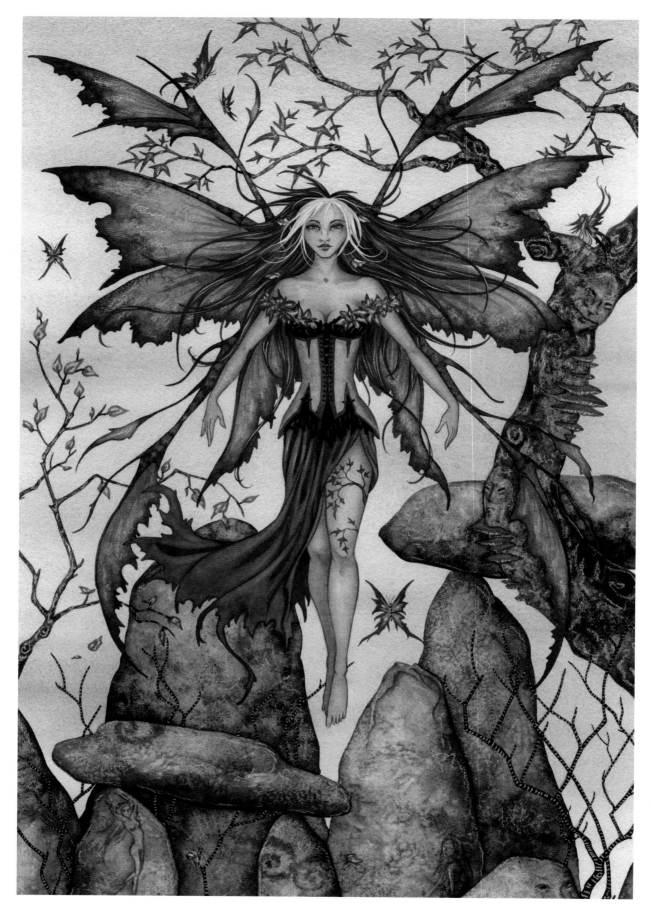

The Arrival (2003)

The faery in this piece reminds me of the arrival of autumn. She sweeps in on swirling winds, and her passing sounds like the rustle of dried leaves.

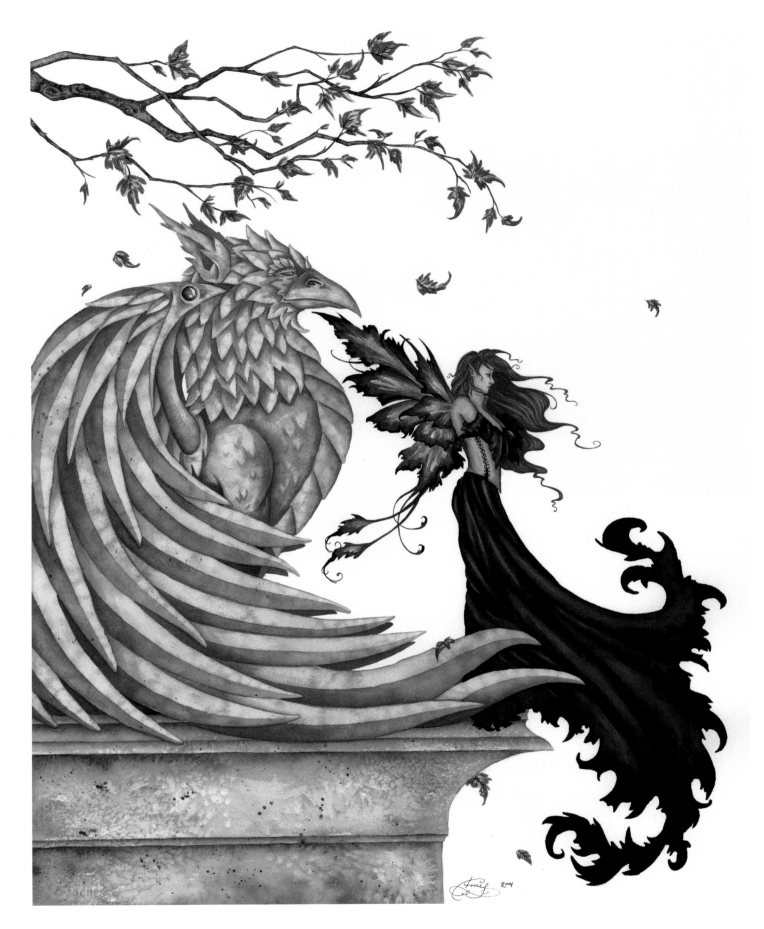

Autumn Griffin (2001)

I keep coming back to the pose in this piece. *Autumn Griffin* was actually painted before *Mystique* and *Passage to Autumn*. It was inspired by a painting I did of an angel long ago. For some reason, I keep painting the pose over and over again.

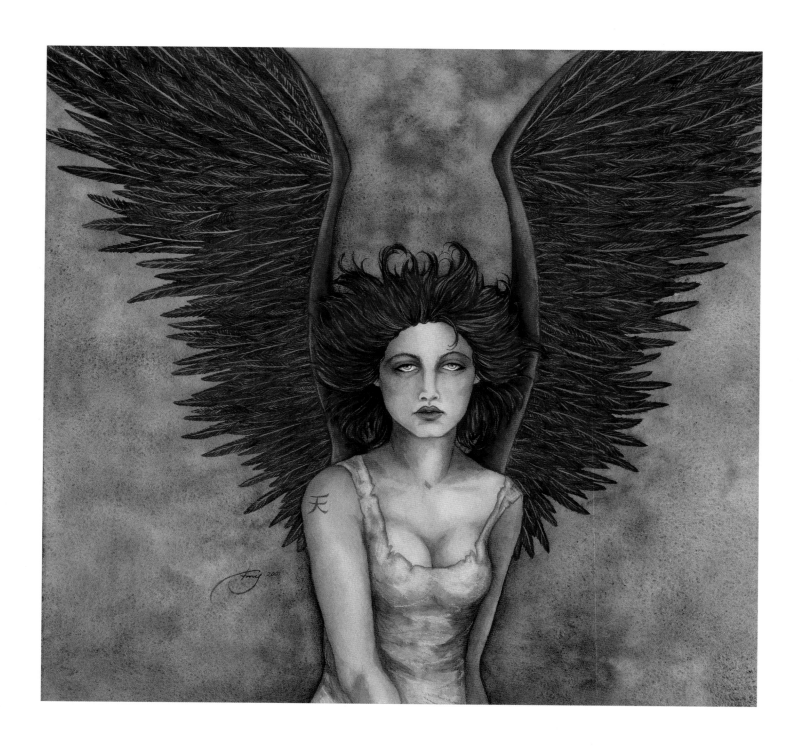

Phoenix I (2001)

Phoenix is a fiery haired fae. She is wild, strong and free.

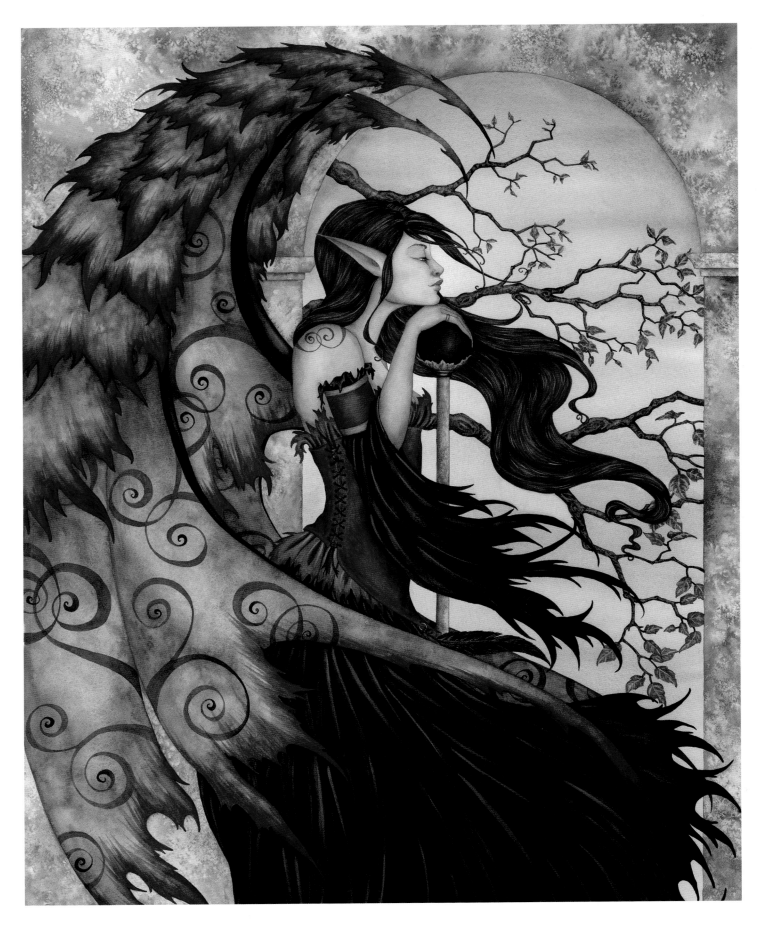

Contemplating Secrets (2003)

Contemplating Secrets is one of my rare 22x30 inch paintings. The original is fabulously framed and hangs in my home.

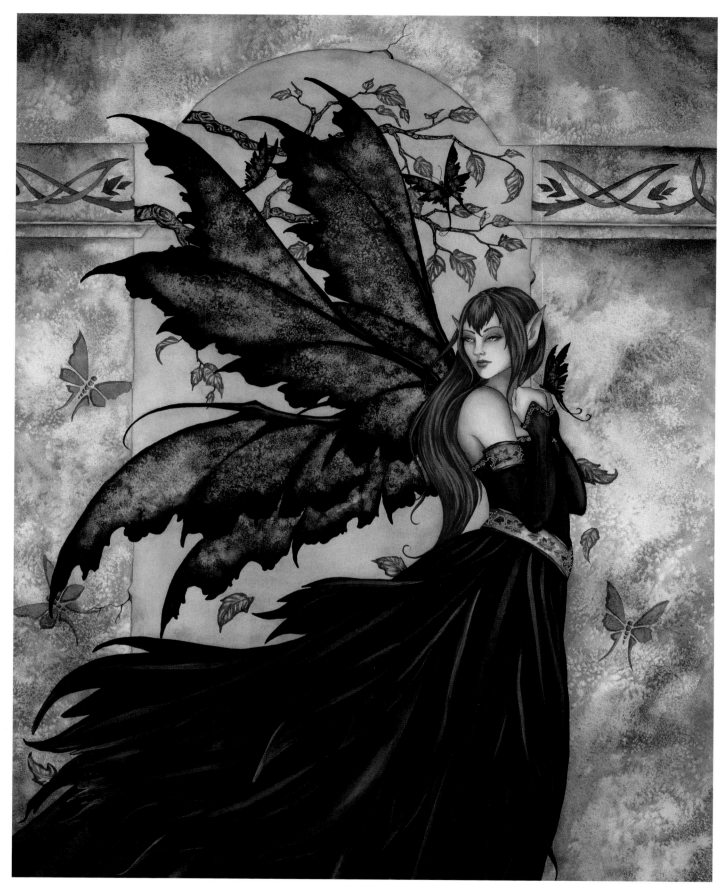

Restless Thoughts (2004)

For about two or three months, I got obsessed with painting large paintings. I almost never paint anything larger than 11x17 inches. *Restless Thoughts* is 22x30 inches. Large paintings are fun to paint, but my husband has a horrible job scanning them in pieces and then pasting them together in Photoshop. I try not to paint this large very often to save him the headache. It's also hard to store paintings this large!

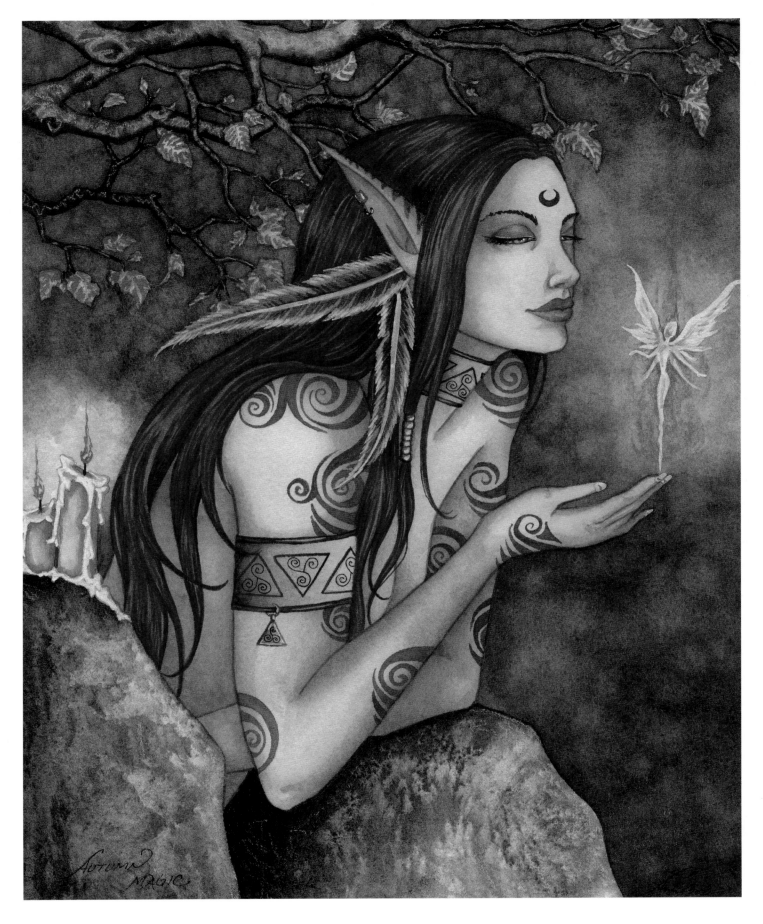

Autumn Magic (2002)
In this piece, an Elvin mage conjures up a faery in its purest form.

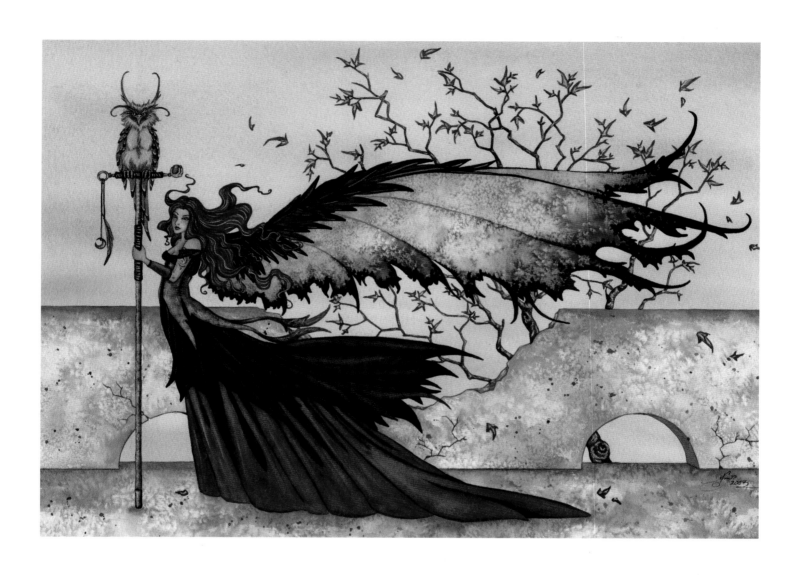

Autumn Stroll (2003)

Yes, I am obessed with autumn and its reds, rusts and golden hues.

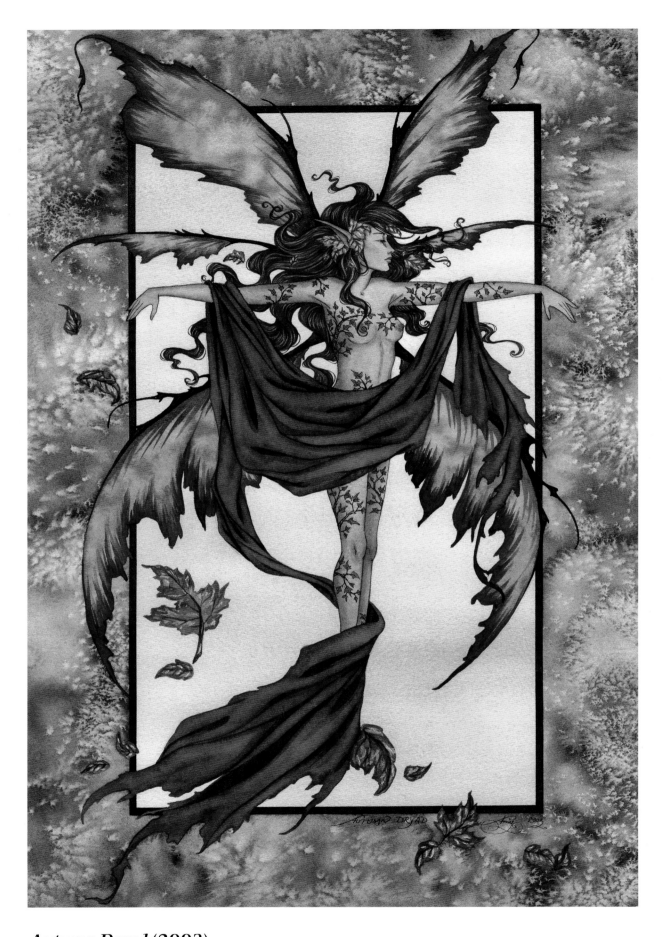

Autumn Dryad (2003)

This painting was inspired by an idea I had one day to do a body covered in autumn branch tattoos.

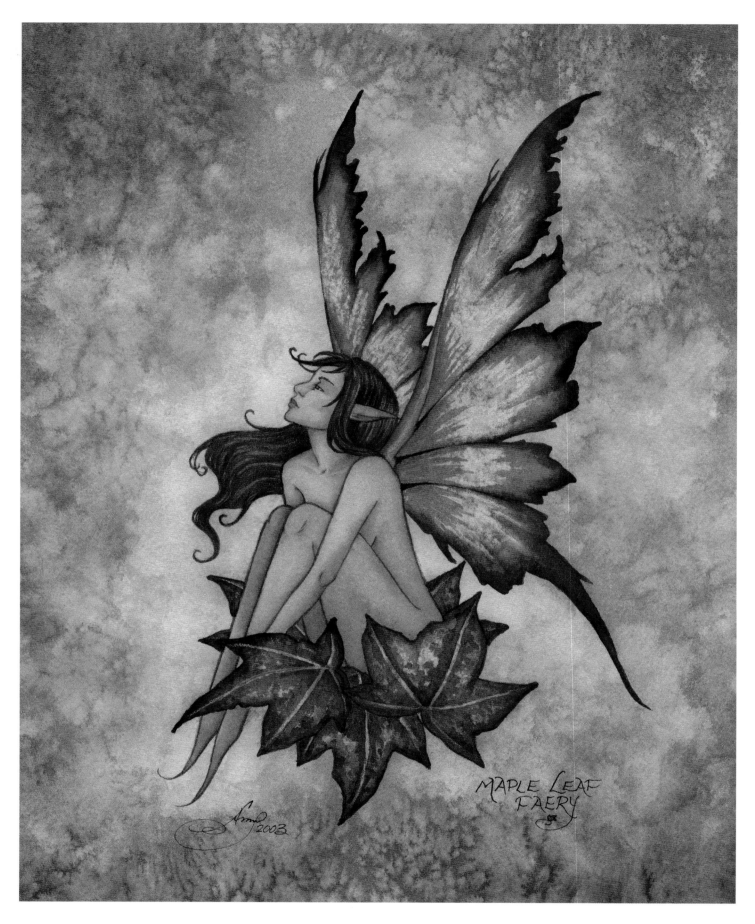

Maple Leaf Faery (2003)
Just a simple faery piece in my favorite autumn hues.

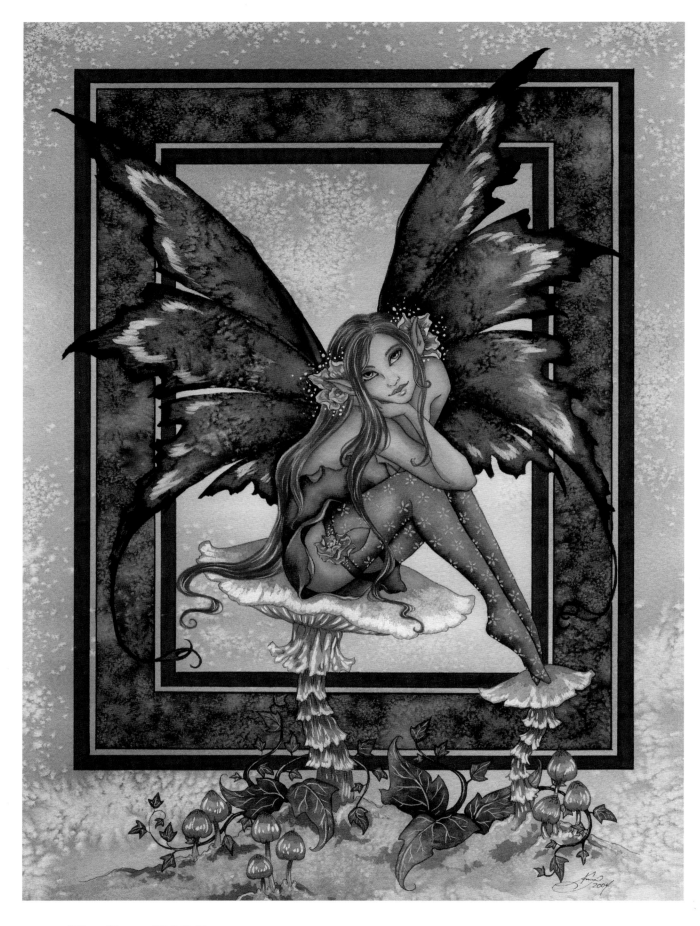

Nice Faery (2004)

While *Naughty Faery* was painted in dull purples and rusts to give the figure a dirty quality, *Nice Faery* was done in vibrant blues and greens to give the figure a happy look.

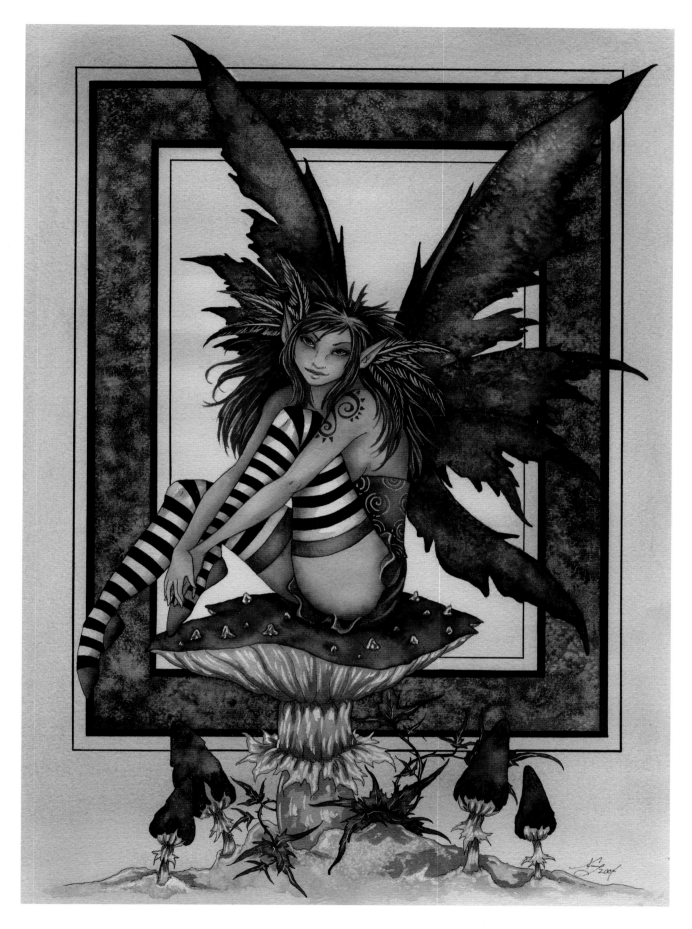

Naughty Faery (2004)

In *Naughty Faery*, *Nice Faery*, and *Bottom of the Garden*, I added colorful borders, an element that resembles French matting techniques. I was a professional picture framer for more than seven years, and I occasionally draw on that experience when I paint.

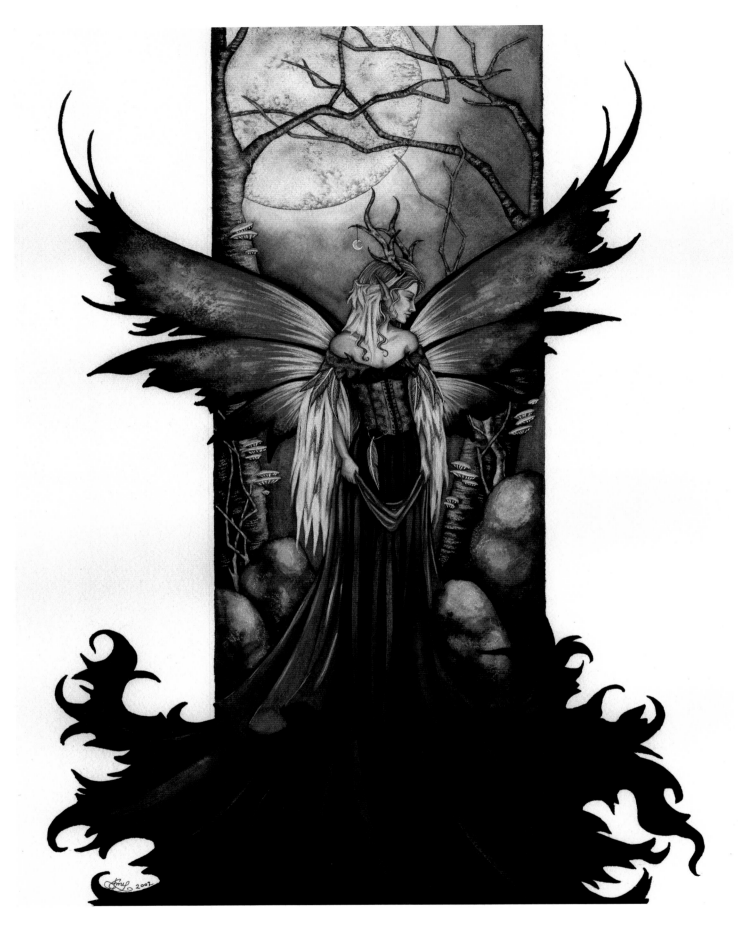

The Gray Lady (2002)

The *Gray Lady* is another monochromatic experiment. I like the mood that the gray night in the background gives the picture.

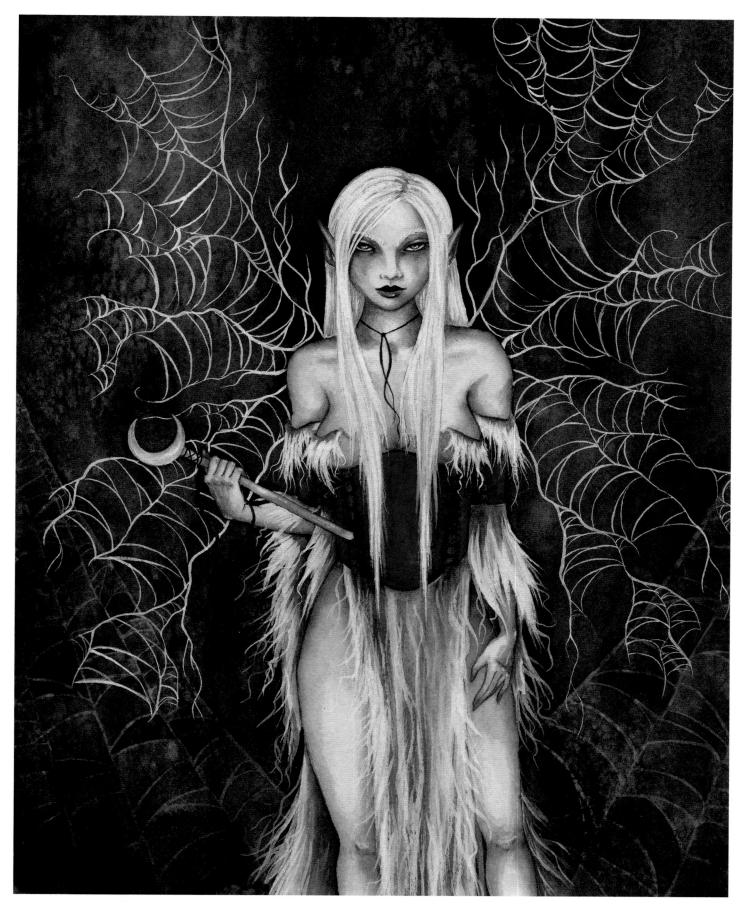

Cobweb (2001)

Cobweb was a fun piece. I think the color combination gives the figure in it an extra creepy quality.

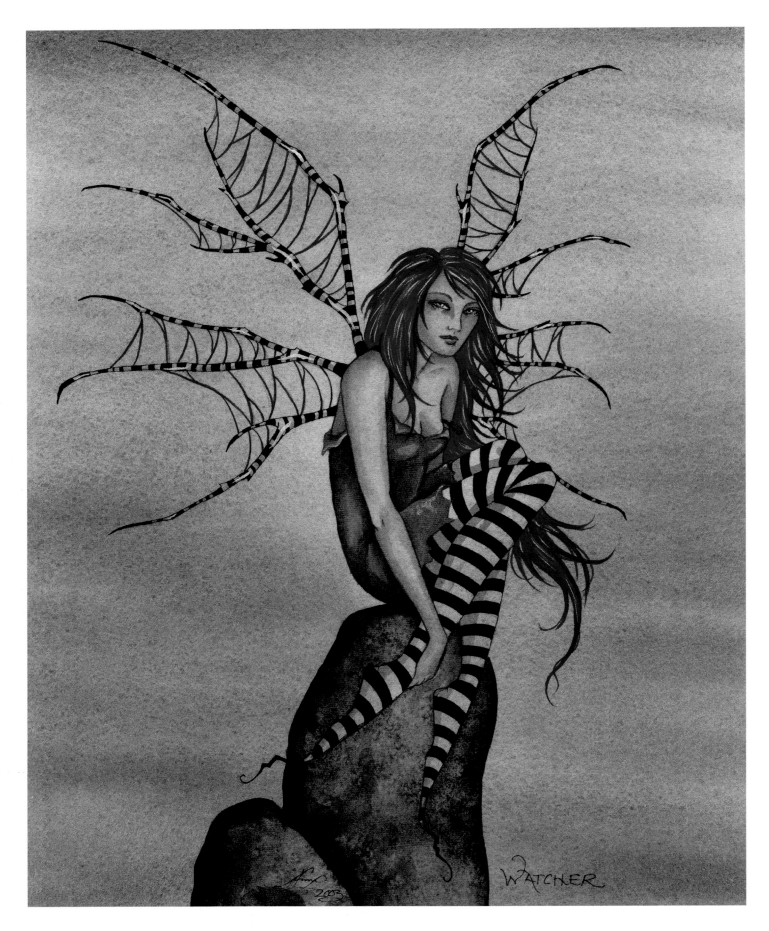

Watcher (2003)

Every now and then, I like to do spider web wings. It's nice to break away from my usual wing design and do something different.

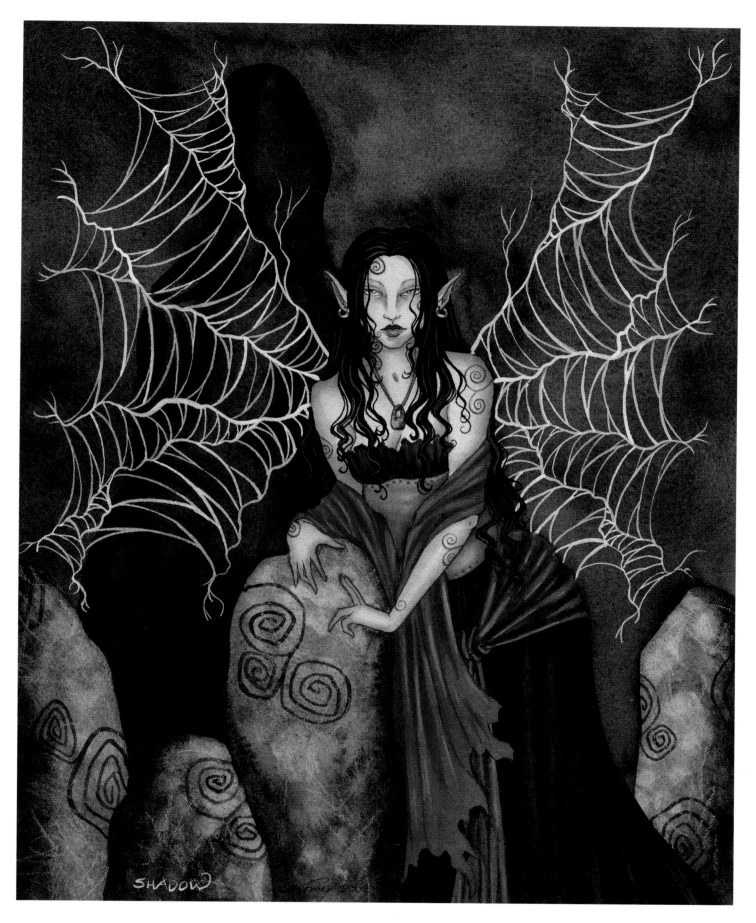

Shadow (2002)
Another spider-web faery. The shadow behind her is not her own.

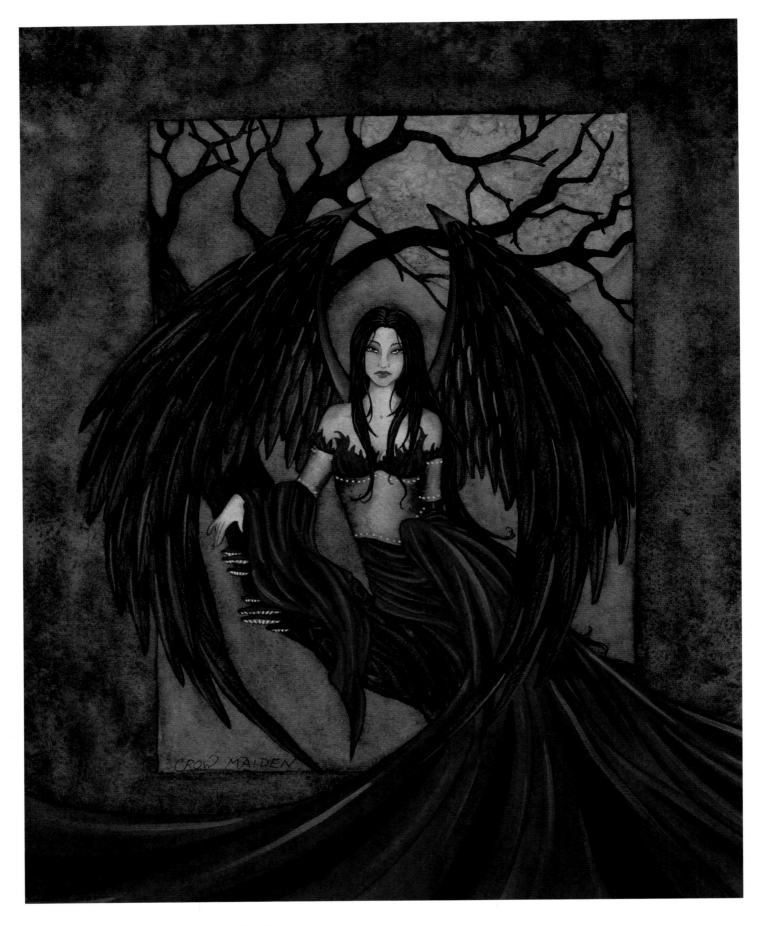

Crow Maiden (2003)

I liked the title *Crow Maiden* and created a painting to go with it. Many of my paintings begin with a title I find appealing.

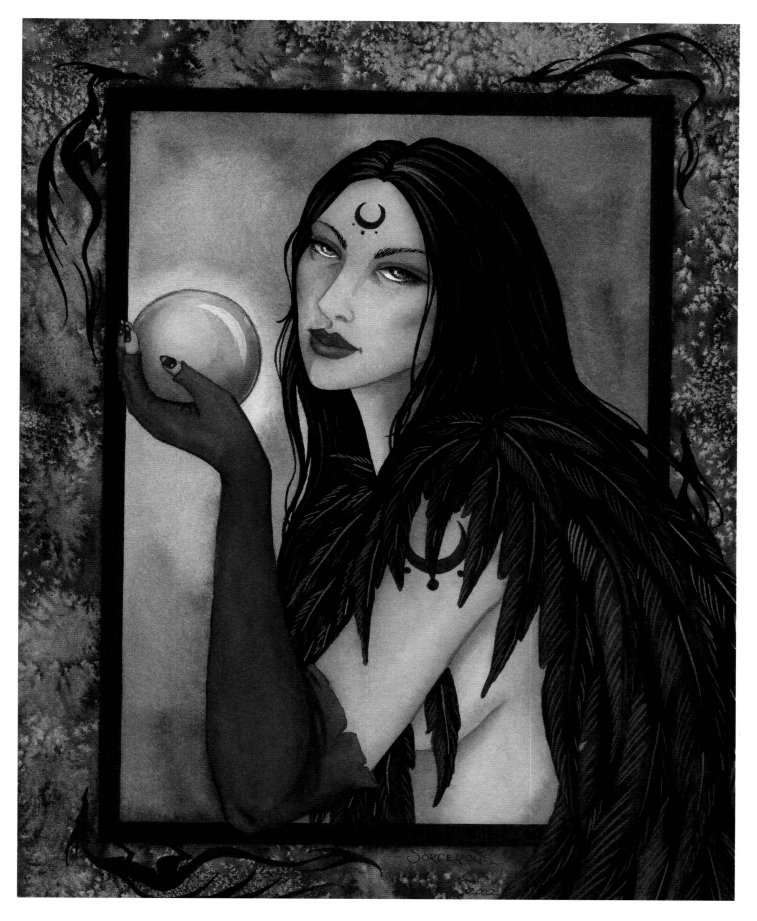

Sorceress (2002)
Every once in a while, I don't feel like painting wings on a character.

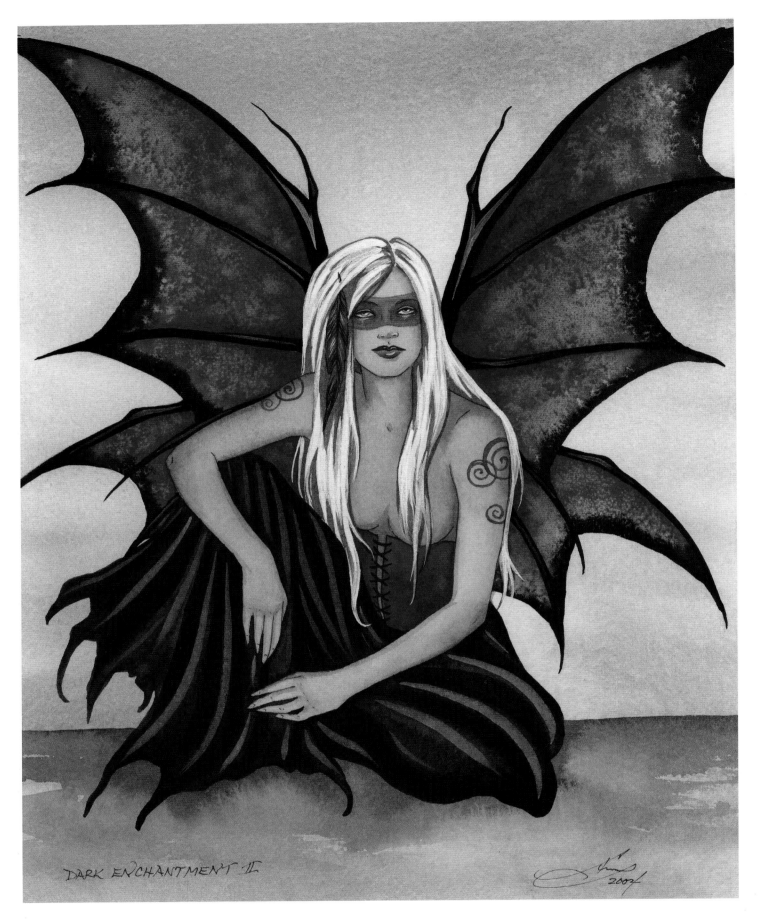

Dark Enchantment II (2004)

Creating this image gave me an excuse to use the bright reds that I love so much. I also enjoy working on darker pieces. I get the chance to go a little crazy when developing the characters.

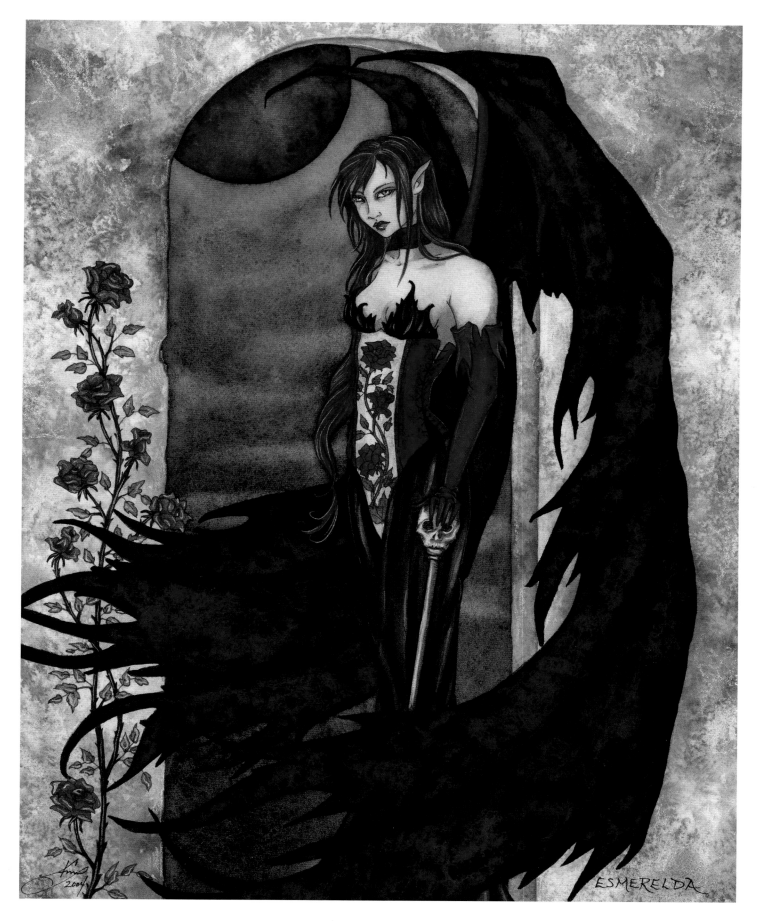

Esmerelda (2004)

Esmerelda was created from a sketch I was working on called *Water Hazard*. The sketch was not coming along as I had hoped, but I liked the pose. I thus reworked the piece and came up with the lovely *Esmerelda*.

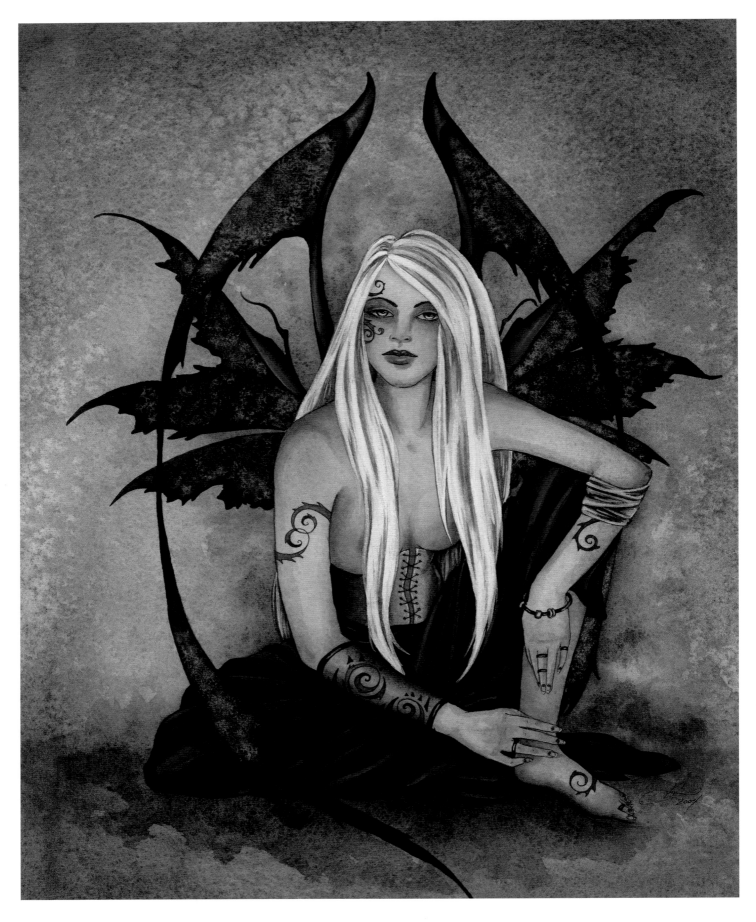

Something Wicked (2004)

Something Wicked was painted because I needed a break from bright, pretty pieces. Now and then, I like to create something dark and compelling to balance myself out.

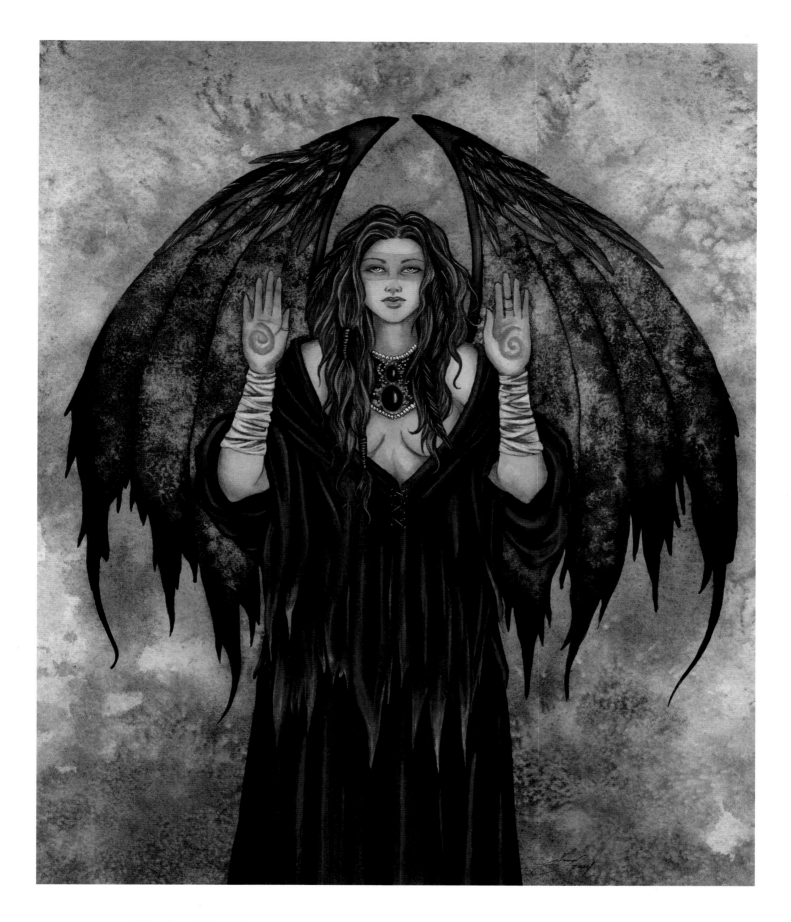

Healer (2004)

Originally, I painted this image to look like a ghost or a statue and used a dark background and a pale monochromatic figure. I liked the way the painting turned out and named it *Dream Catcher*. Later, I felt I needed to see what the image would look like in full color, so I painted it again.

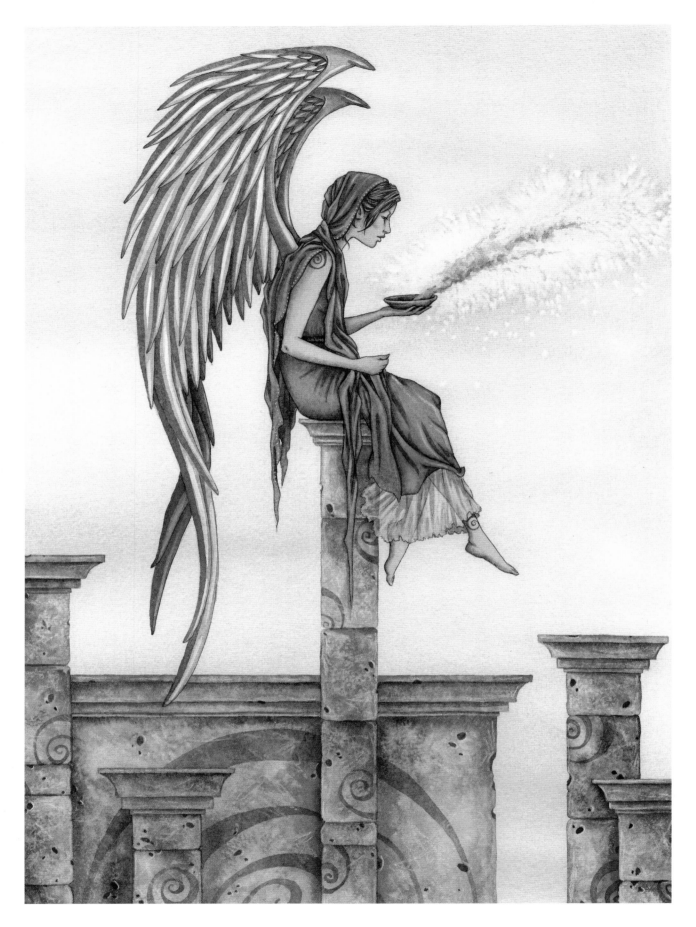

Dust Angel (2003)

Dust Angel is a monochromatic piece. I enjoy limiting myself to a few colors. It's a challenge to make the image interesting without adding much color.

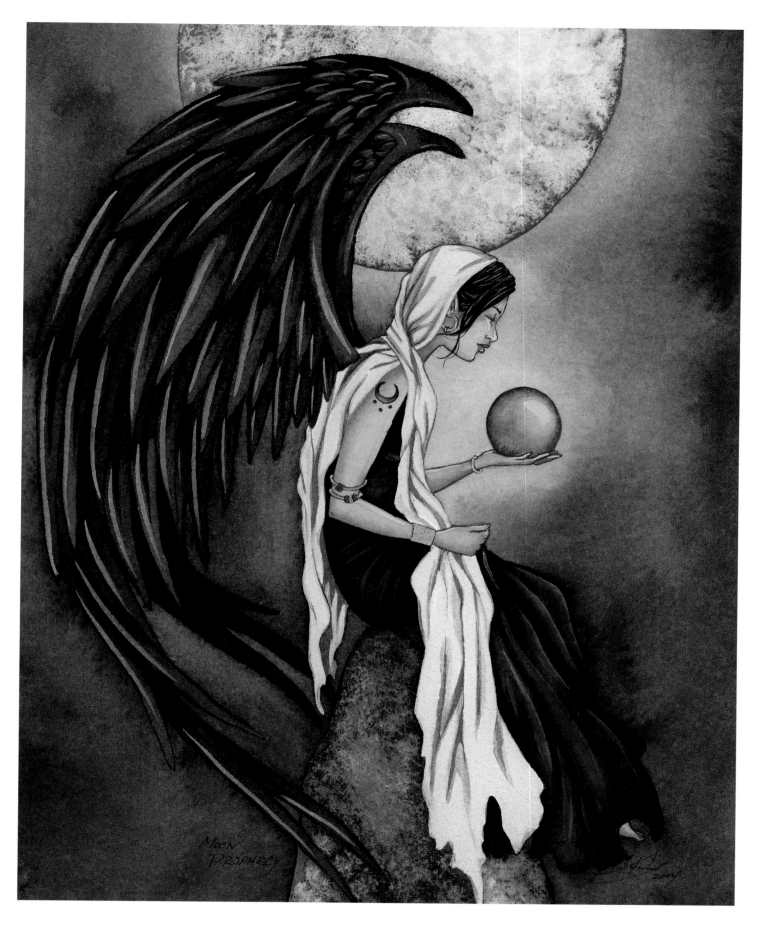

Moon Prophecy (2004)

In *Moon Prophecy*, I used the same pose that I used in *Dust Angel*. I liked the pose in *Dust Angel* so much that I wanted to recreate it with a different color scheme.

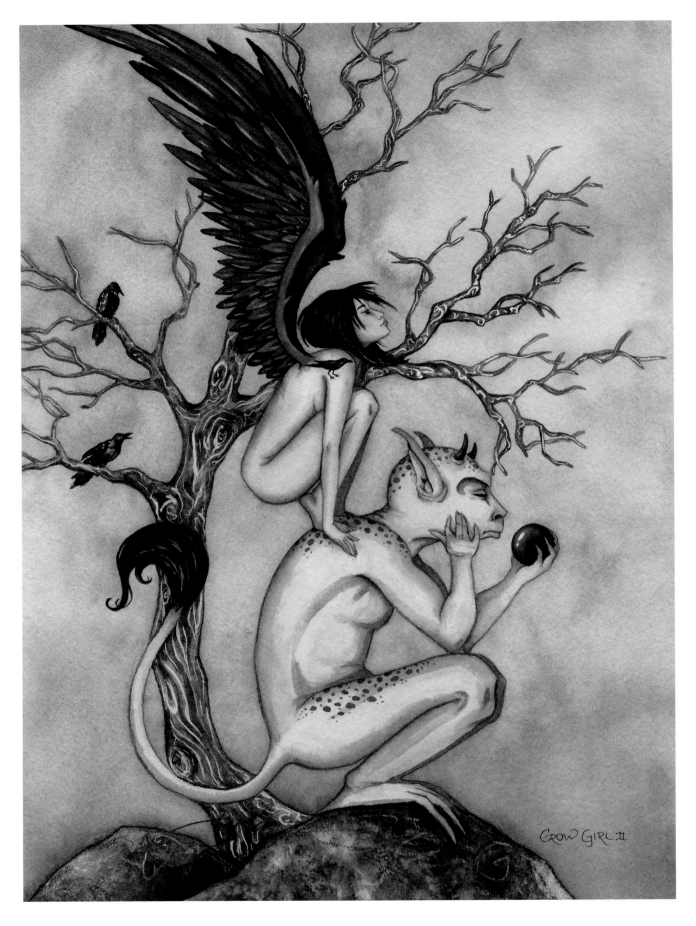

Crow Girl II (2002)

I'm not sure now how I came up with the idea for *Crow Girl II*. It's sort of an odd image, now that I look at it.

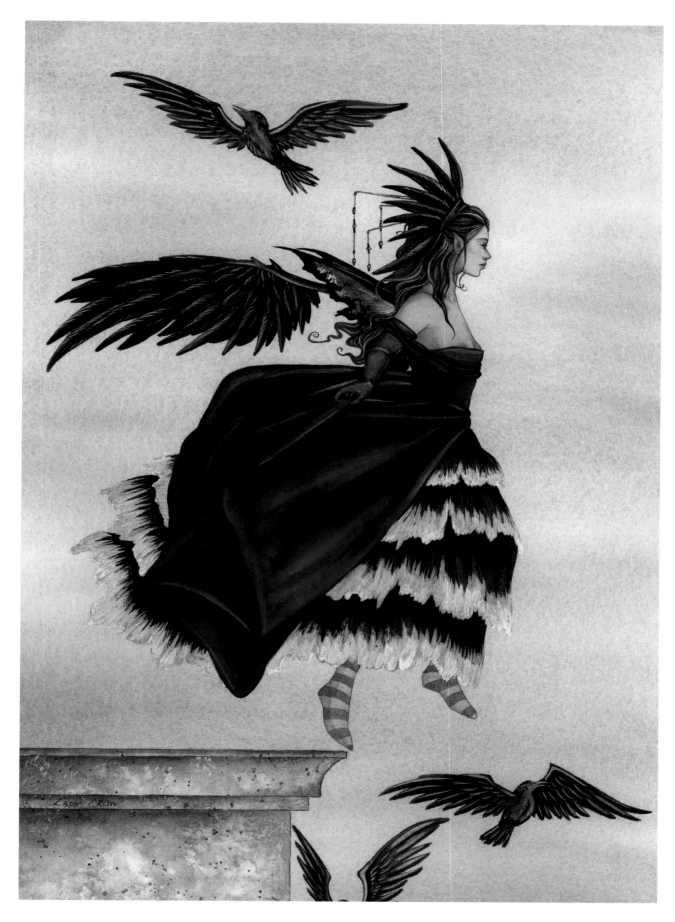

Lady Crow (2003)

Sometimes I get stuck on one idea. While painting *Lady Crow*, I said to myself, "Why do you keep painting women standing on ledges? Enough is enough." But of course, I will probably paint more images using that motif in the upcoming year.

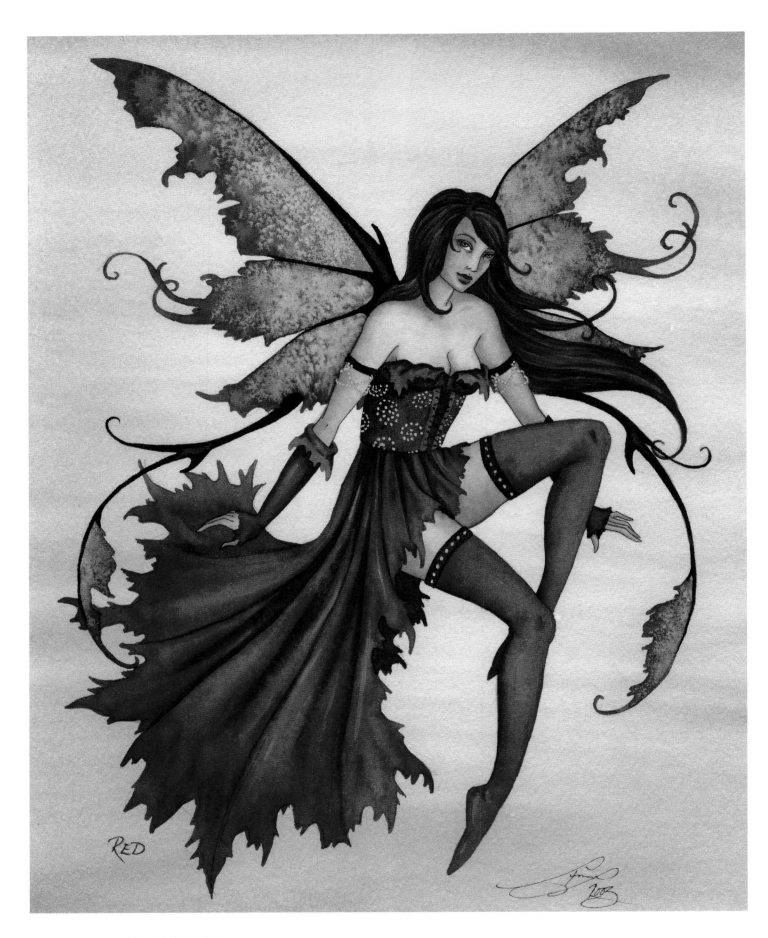

Red (2003)
My favorite color.

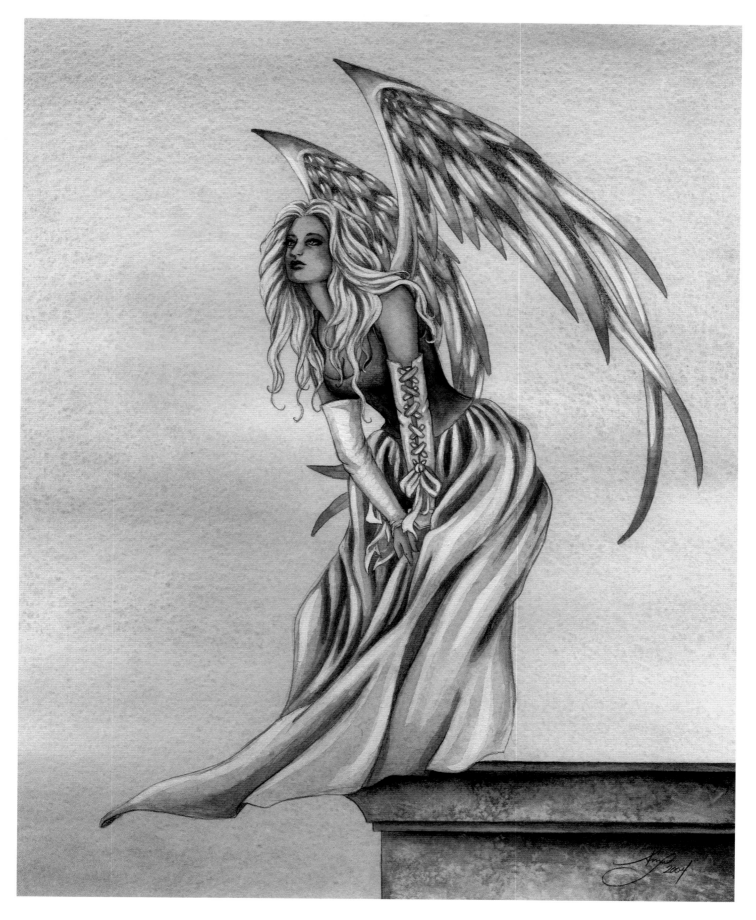

Rose Angel (2004)

Rose Angel was an experiment in monochromatic color. I relied heavily on white gouache to make the highlights pop and add life to the piece.

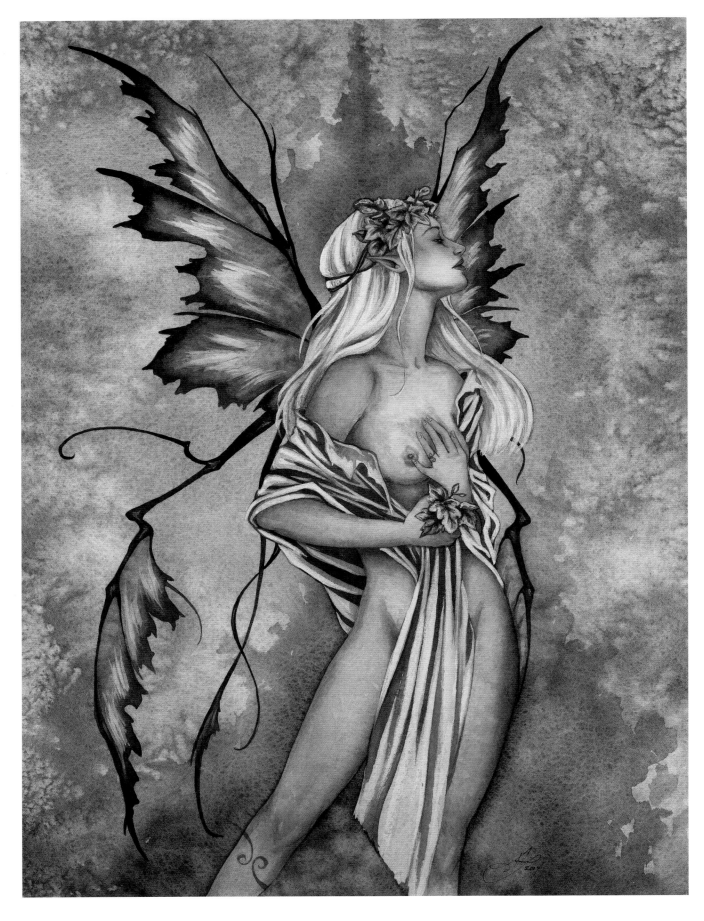

Silvane (2004)

For *Silvane*, I employed a version of the pose that I used in *Evening Whispers*. It's such a compelling pose I had to use it again.

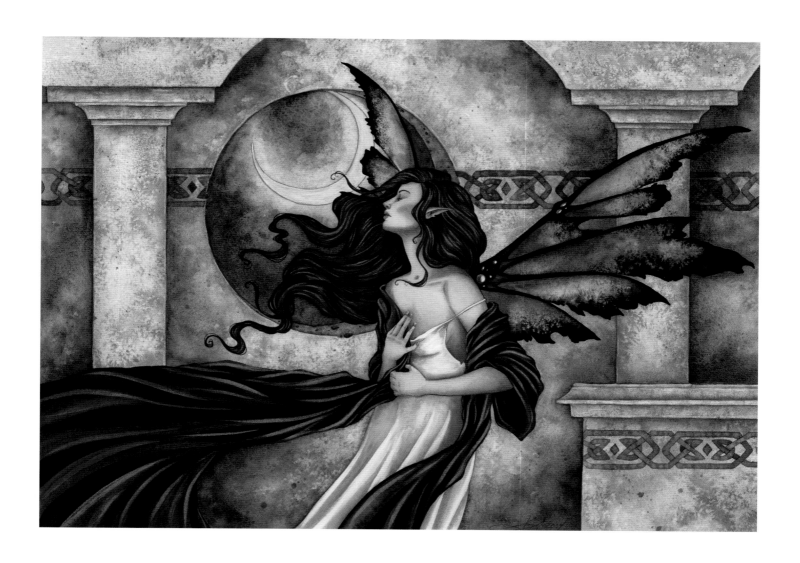

Evening Whispers (2004)

Evening Whispers is one of my favorite pieces. I was very pleased with the way the color came out, especially on the gown, the look of which was achieved by sheer accident. The water I was using to wet my brush had been tinted by the pigments I had used to paint the figure's hair (I was too lazy to change my water), and it left a slight pink stain on her clothing. The effect is lovely.

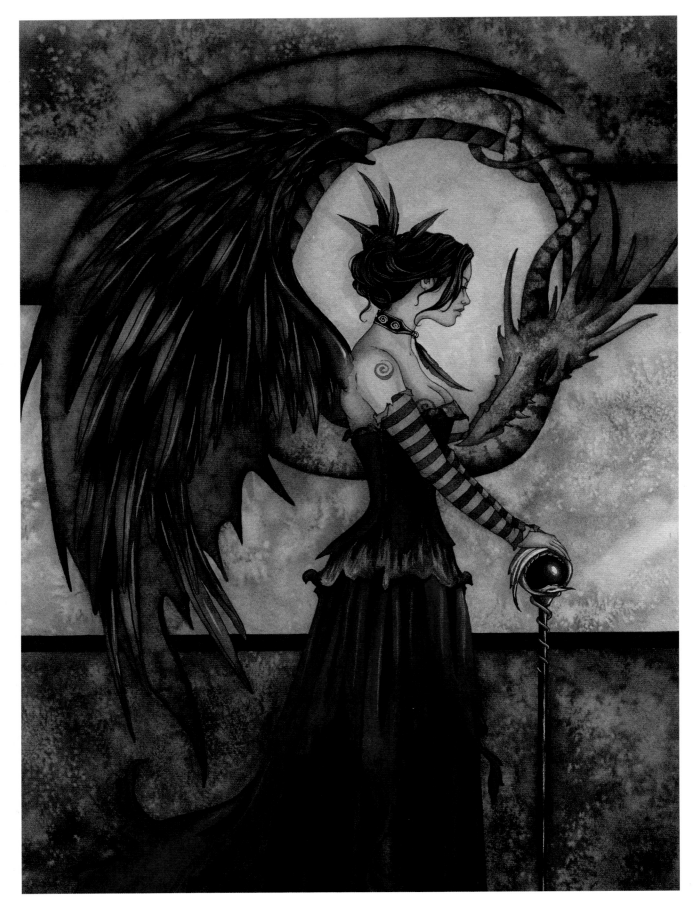

Court of the Dragon (2004)

The title *Court of the Dragon* refers to the name of the royal court that the woman in the painting belongs to. The image brings to mind a dark castle inhabited by strong and noble faery creatures.

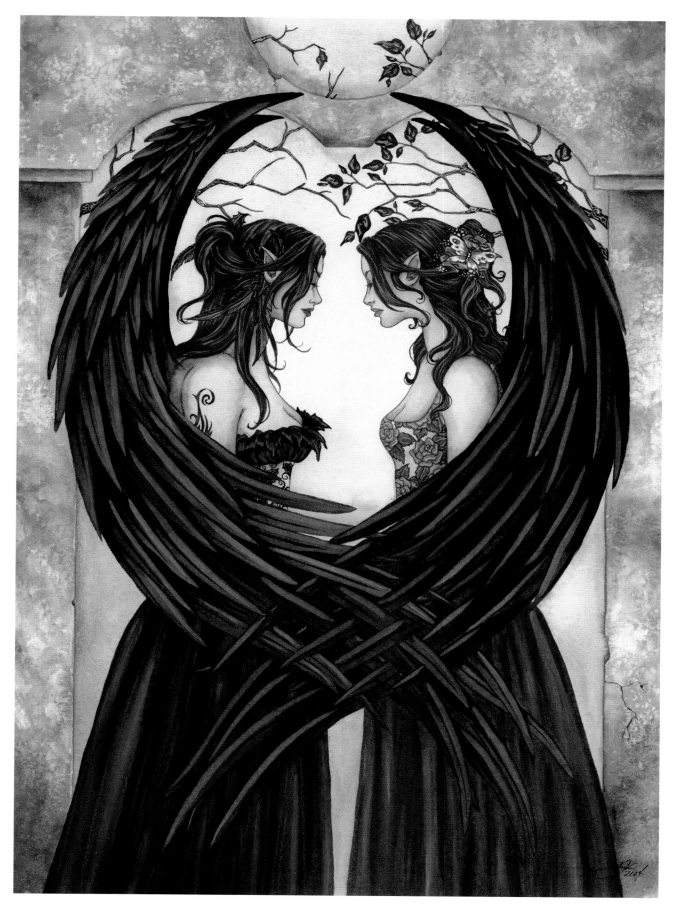

Sisters (2004)

I thought the idea for *Sisters* was very compelling. Each sister has a slightly different character.

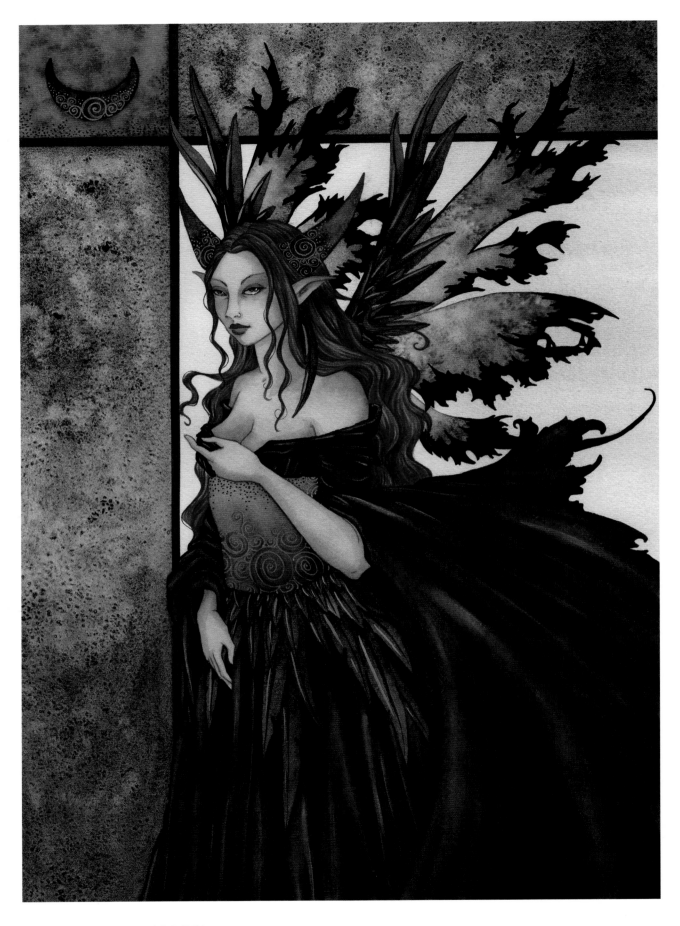

The Countess (2003)

Originally, I intended this piece to be named "Calliope and her minions." However, as I started drawing her minions, I felt I did not have the interest or patience needed to complete the piece, and I left them out.

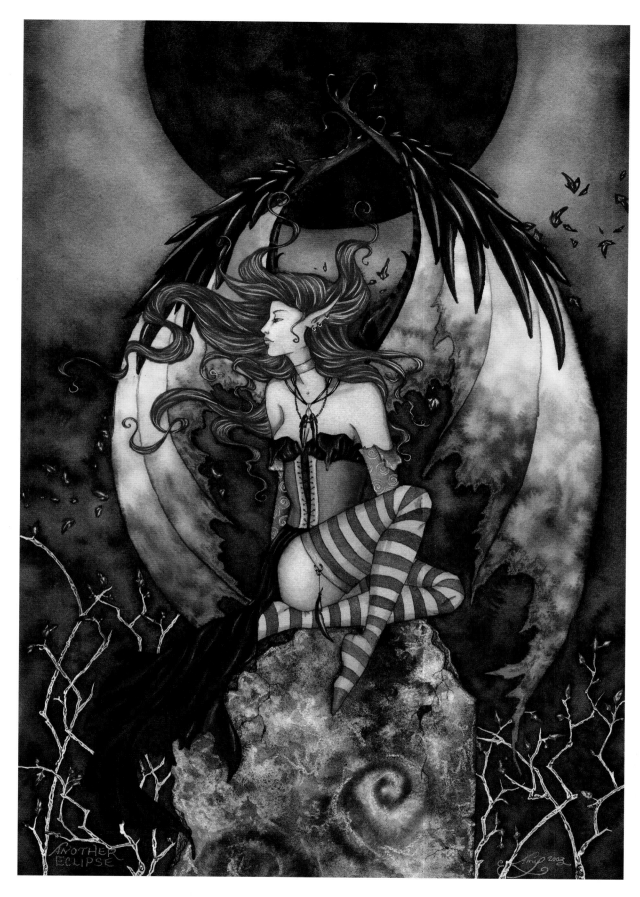

Another Eclipse (2003)

I occasionally like to experiment with very bright colors in paintings. They draw more attention to a piece and add drama.

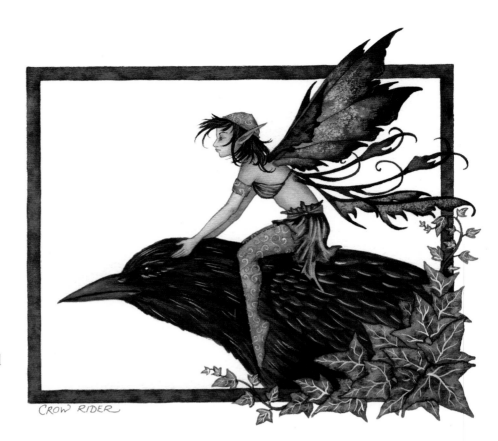

Crow Rider (2002)

The idea for this piece floated around in my head for years before I finally decided to paint it.

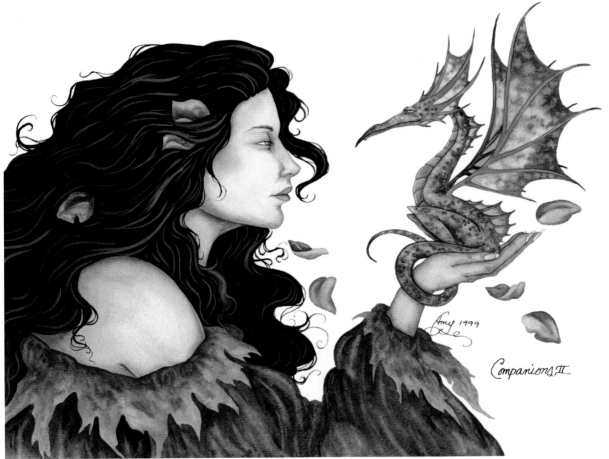

Companions II (1999)

As can be seen in several of my paintings, I like the idea of a human finding a small, magical treasure.

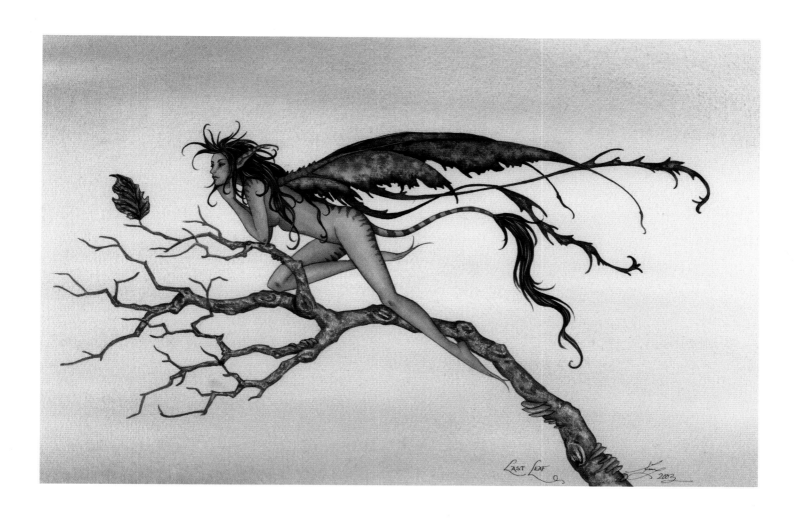

Last Leaf (2003)

The faery waits patiently for the last leaf of autumn to fall.

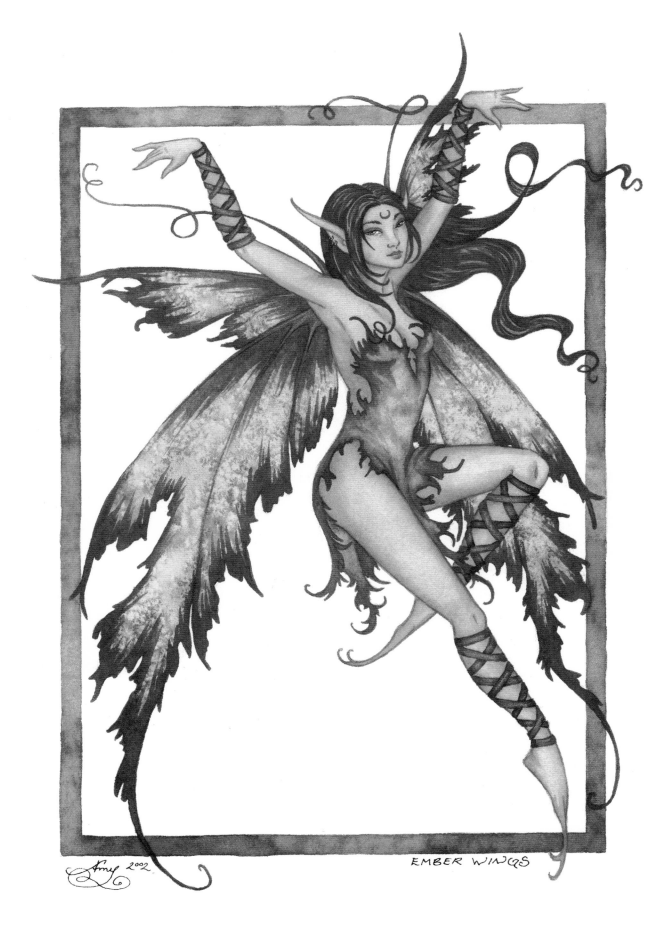

EMBER WINGS

Ember Wings (2002)

The success of my previous fire faery pieces has prompted me to continue to create a new fire faery every year, if my schedule permits. I love gold and red, so it's never a problem.

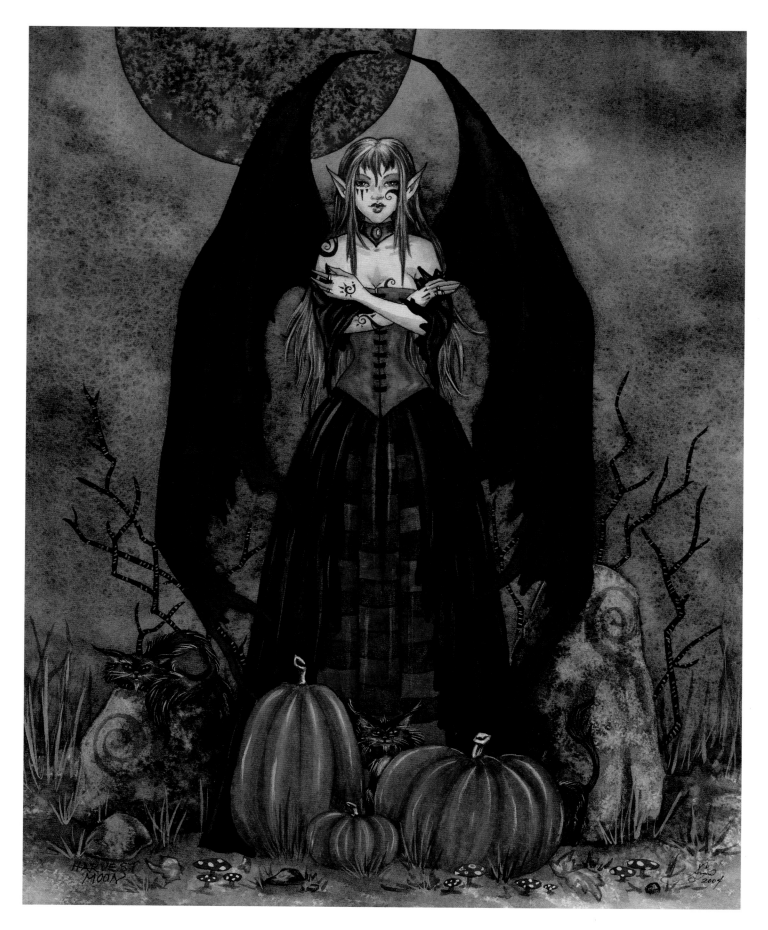

Harvest Moon (2004)

The original sketch for *Harvest Moon* was started around Halloween, 2003. However, I got distracted and didn't finish the piece until several months later. In the original sketch, the woman was accompanied by the Pumpkin King, but I felt the image was getting too busy and removed him.

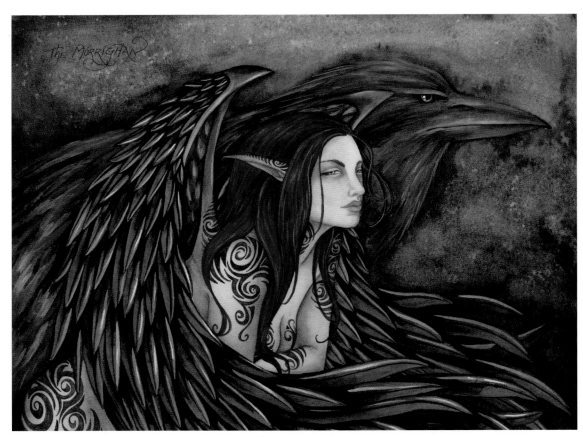

The Morrighan (2001)

I created this piece after reading about a goddess who had three "selves". One of the selves was the Morrighan. She was described as having red hair and could turn herself into a raven.

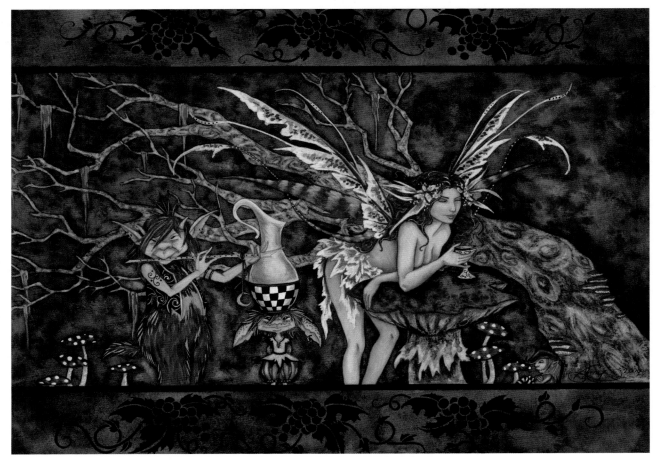

Dinner Music (2000)

The Pan character plays a soothing tune as the Faery is served a sweet wine.

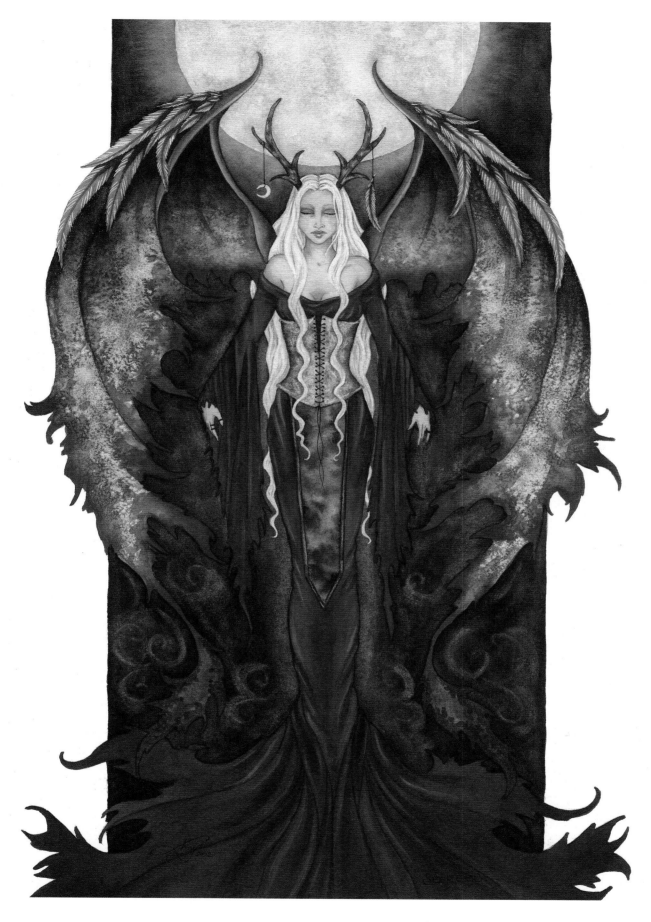

Seeress (2002)

I enjoy painting antlered women. They have a sense of mystery and strength.

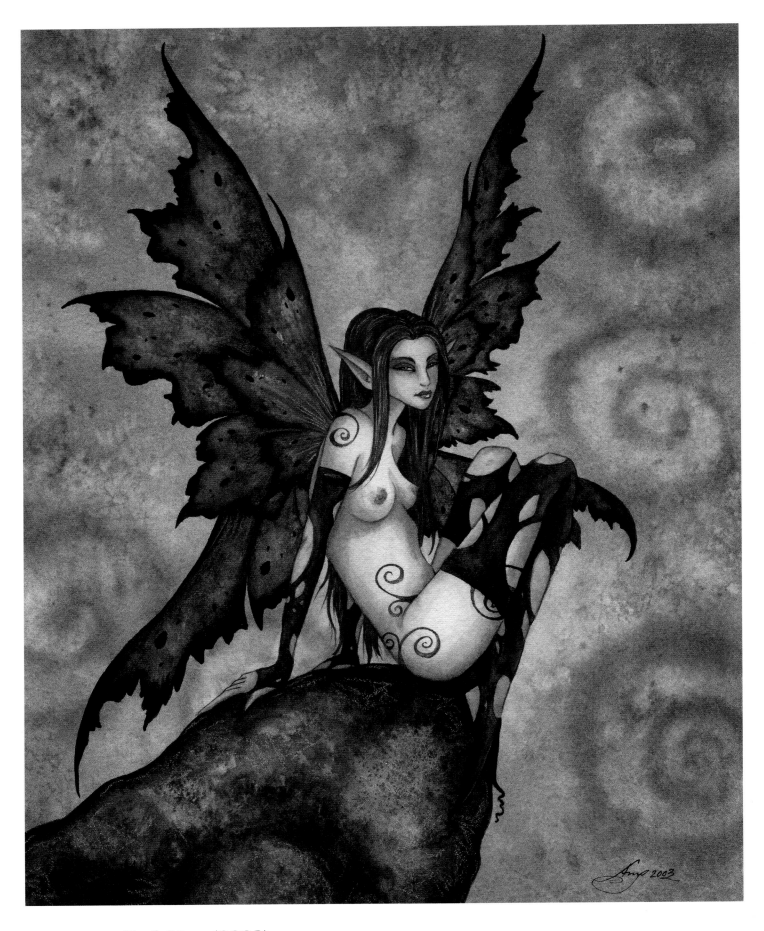

Dark Muse (2003)

The faery in this piece has a slightly different look from my usual faeries. She has a longer, pointier face and a longer body.

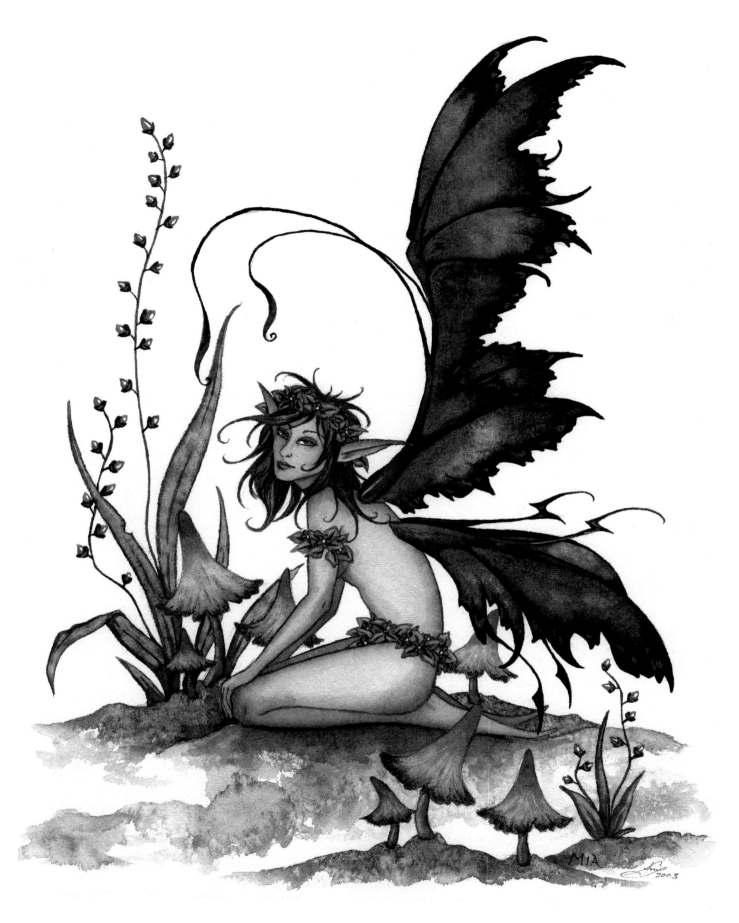

Mia **(2003)**

Mia is just a sweet little faery.

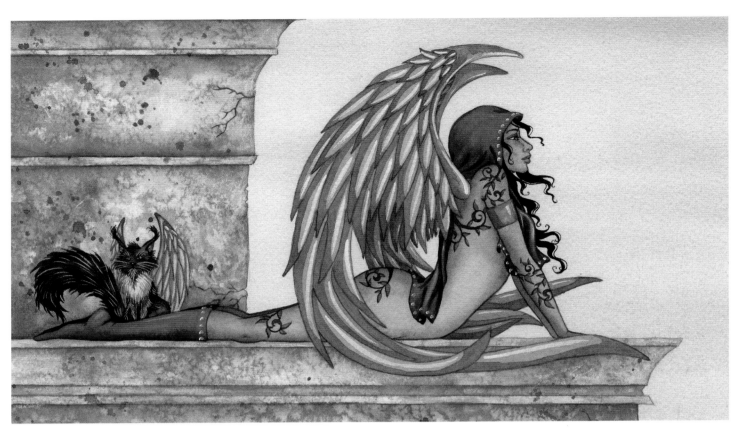

Golden (2003)
A dark skinned, golden winged angel basking in the sun.

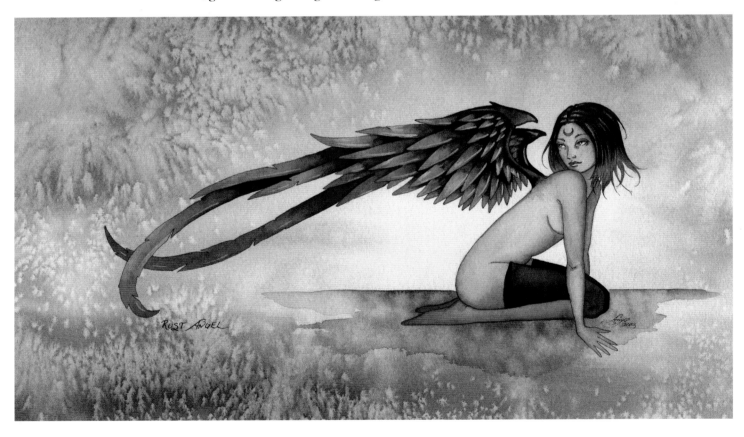

Rust Angel (2003)
In *Rust Angel*, I painted the tips of the angel's wings and hair as if they were rusting.

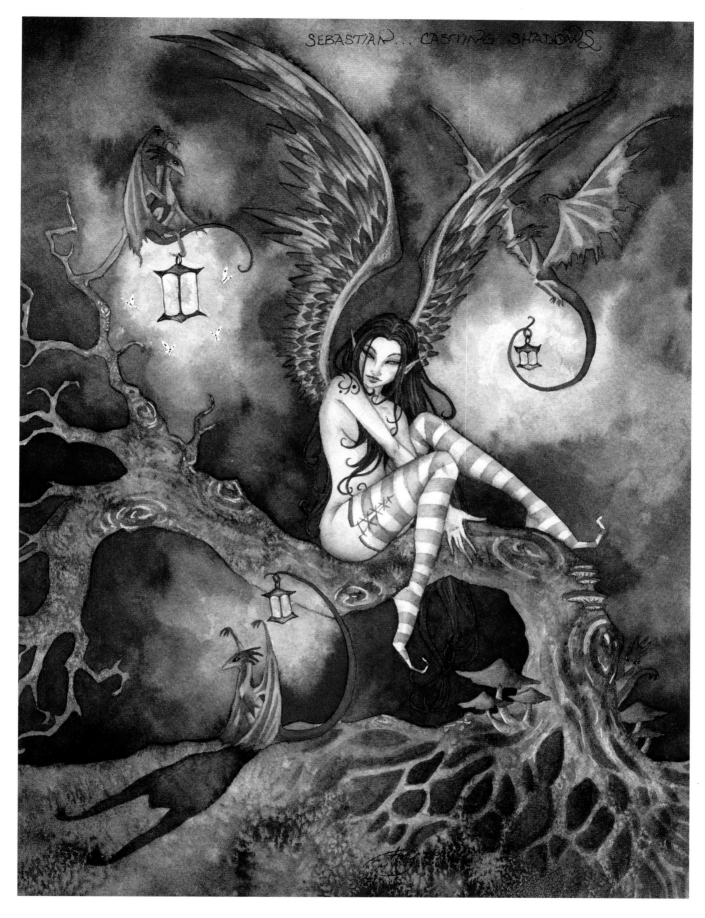

Sebastian Casting Shadows (2001)
Sebastian is playing with his lantern. He believes he looks quite fierce.

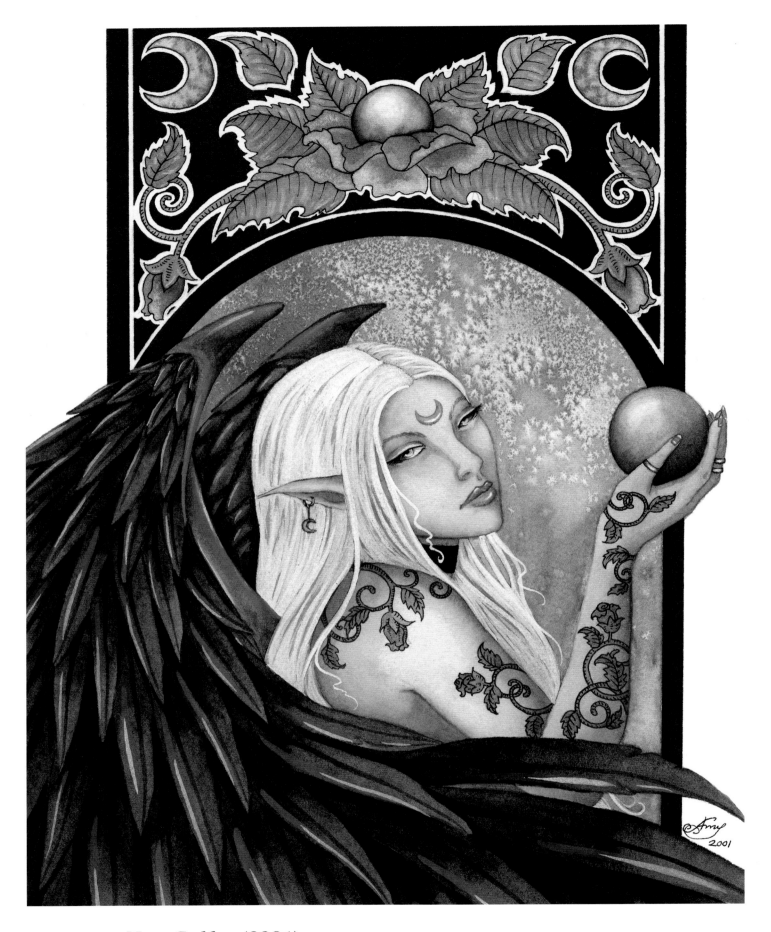

Moon Goddess (2001)
The background in *Moon Goddess* is loosely inspired by the work of Alphonse Mucha.

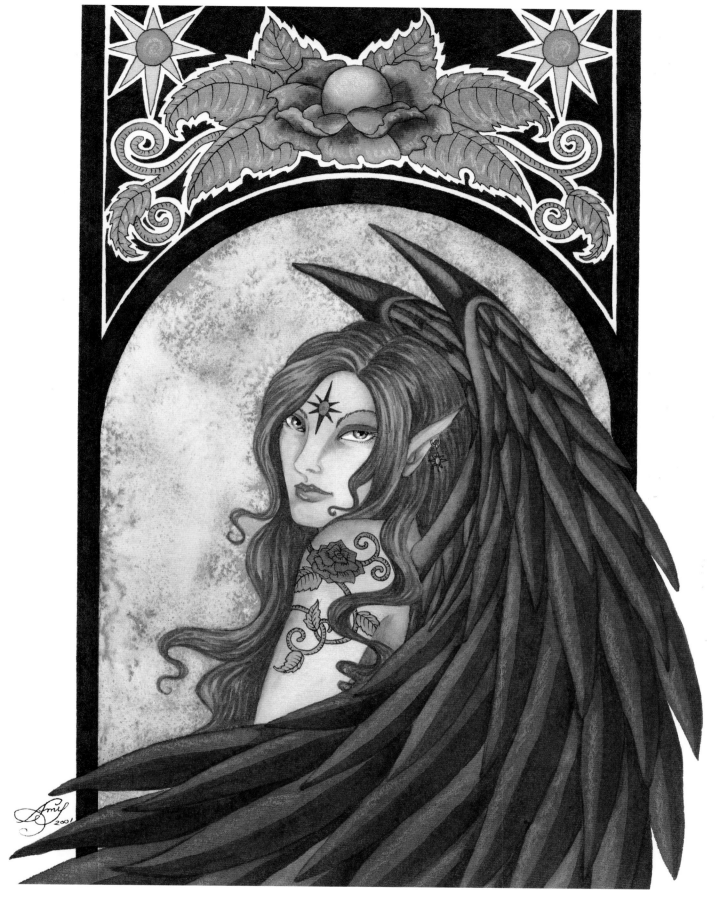

Sun Goddess (2001)
Sun Goddess is the companion piece to *Moon Goddess*. She also displays the influence of Alphonse Mucha.

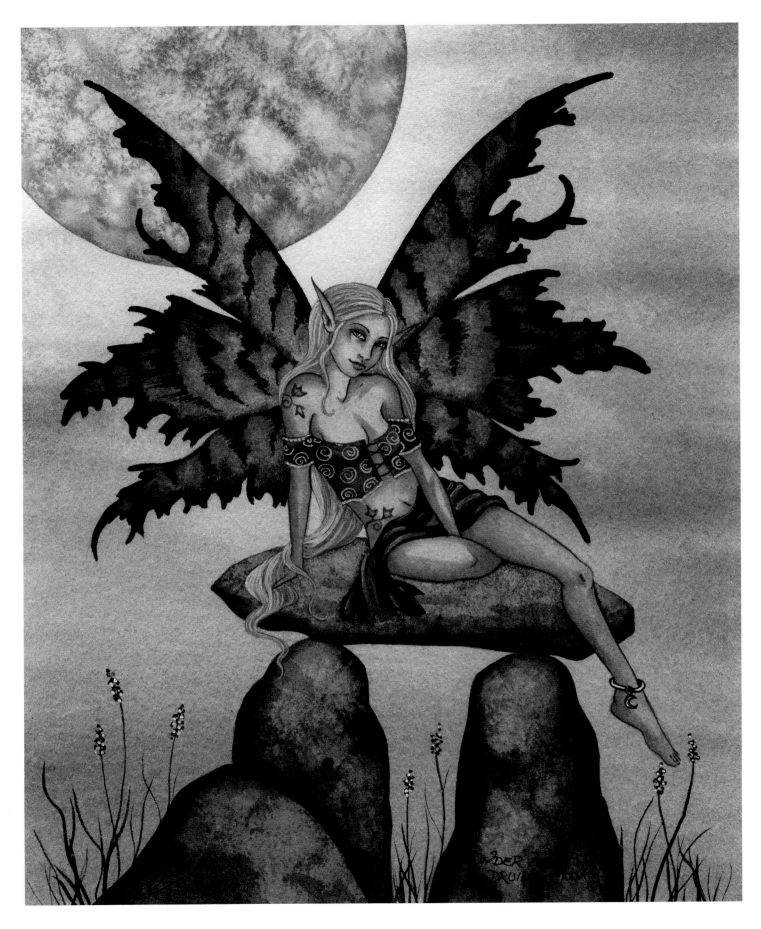

Under a Druid's Moon (2003)
I like the way this painting turned out. The faery looks just a little mischievous.

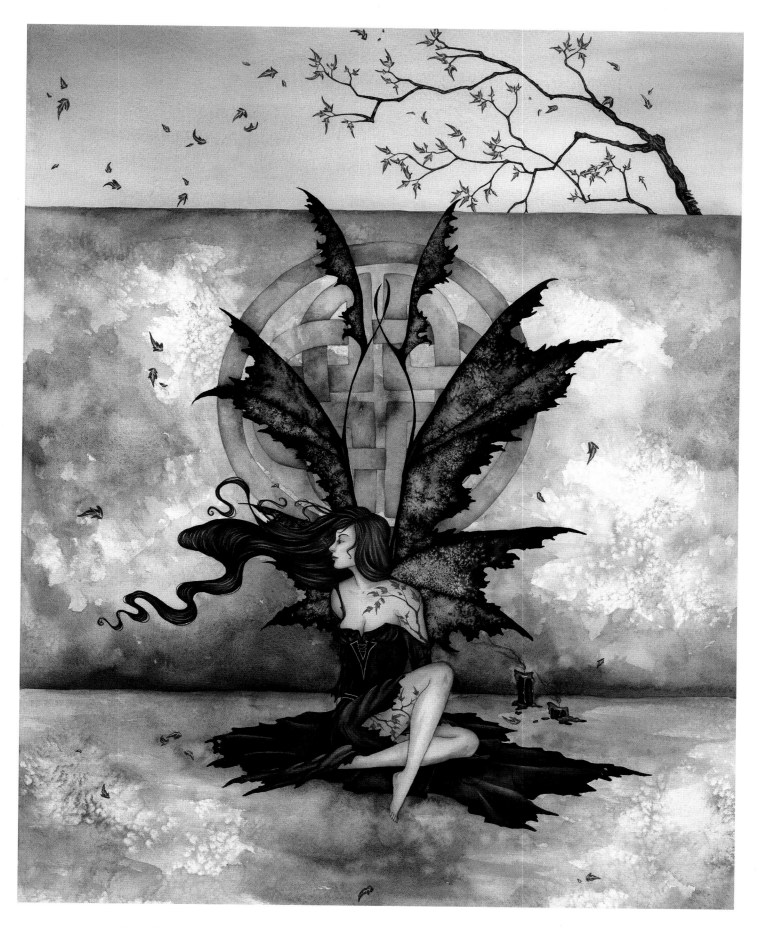

Sapphire (2004)

The original drawing for *Sapphire* sat in my closet for ages before I finally sat down and started painting it. I dressed the woman in dark shades and placed her on a very neutral background so that she grabs your attention.

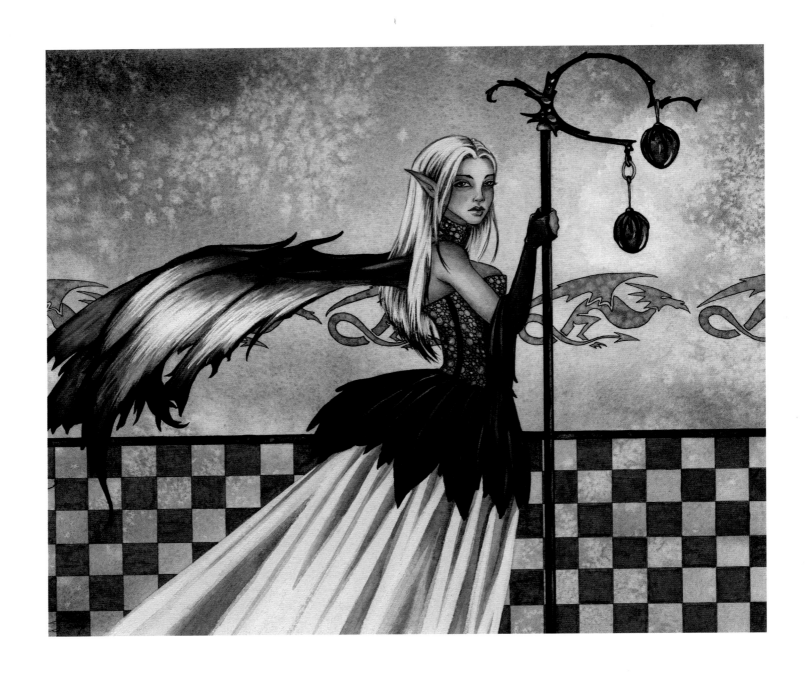

Eleanor (2004)
I enjoy painting images in drab colors, even though people usually respond better to brightly colored images.

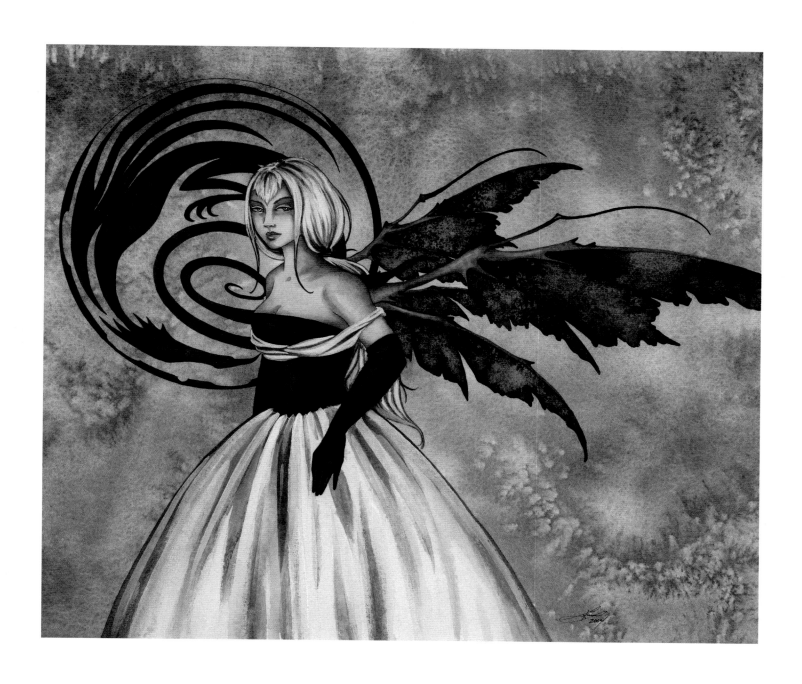

Empress of Whispers (2004)

After painting *Eleanor* in shades of gray, tan, and black, I began painting *Empress of Whispers*. I was so happy with the way *Eleanor* turned out that I had to continue to explore using a drab-color scheme.

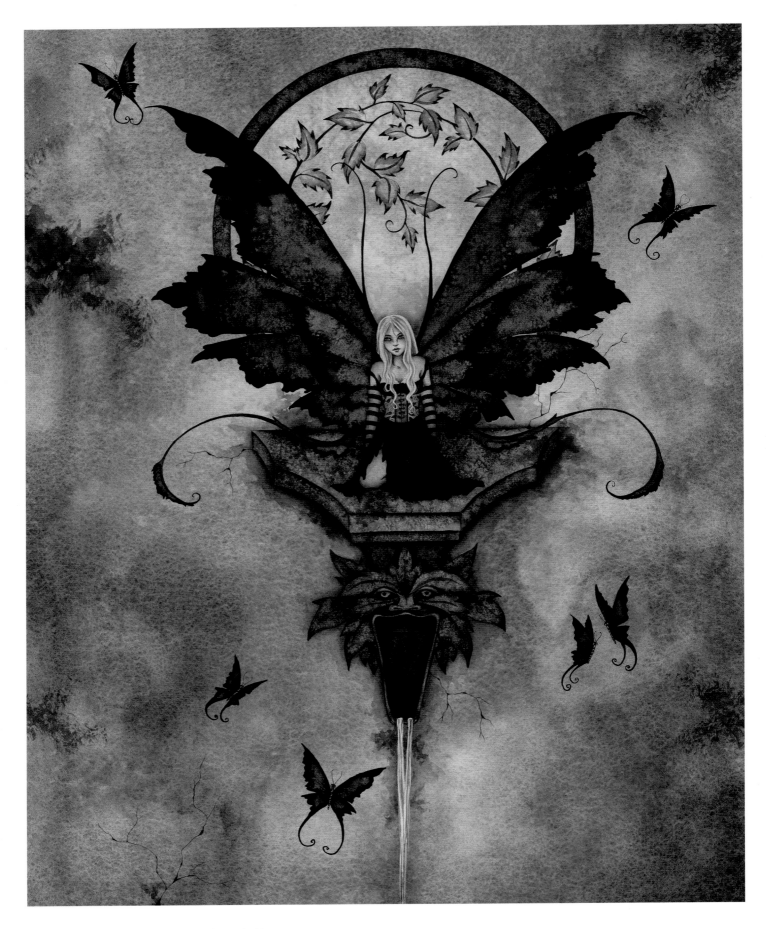

Sanctuary (2004)

The idea for *Sanctuary* came to me while I was watching the movie *Labyrinth*. I was thinking about oubliettes, and the image of a little faery sitting on a shelf in a dark place came to mind.

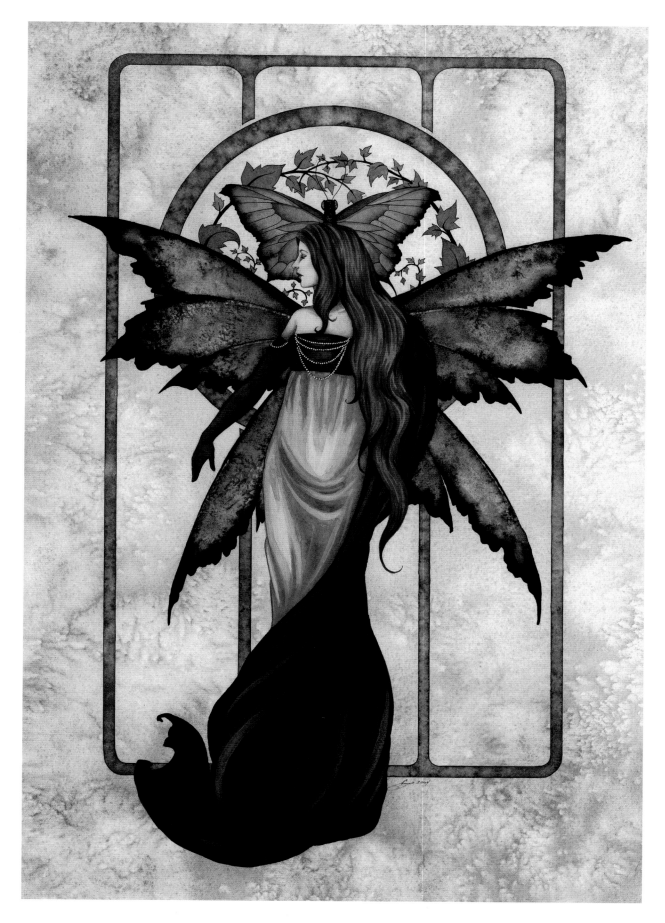

Elegance (2004)

Elegance is among my three favorite pieces. I love the green shades and the design of the figure's dress. The black accents on her wings help to create a dramatic effect.

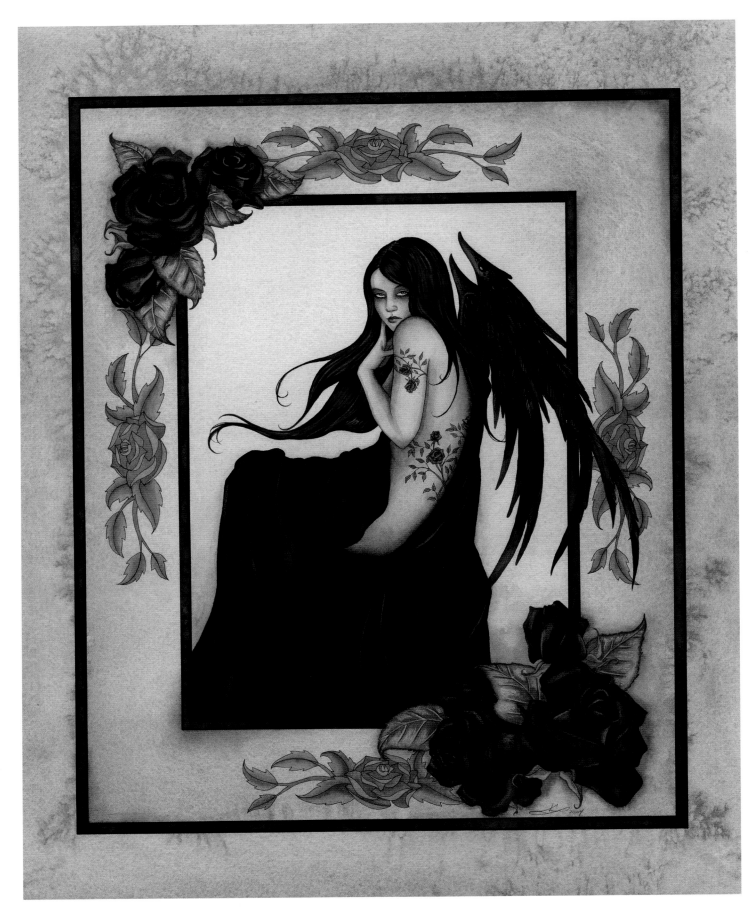

Little Rose (2004)

It took me an entire day just to paint the petals on the black roses. I am happy with the end result, but I hated them when I was working. I am used to spending no more than an hour or so on something like these roses.

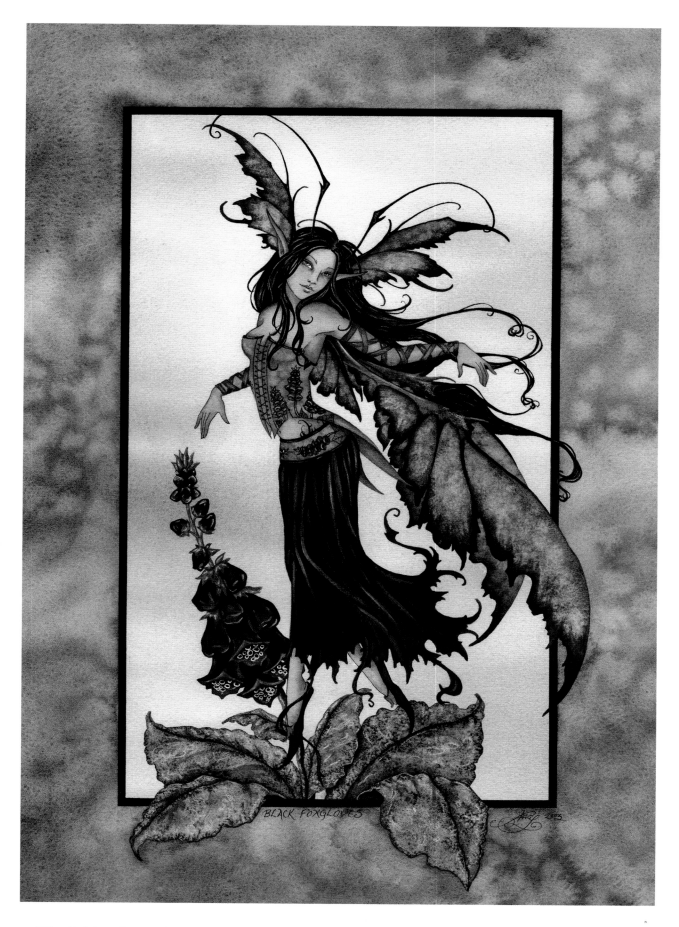

BLACK FOXGLOVES

Black Foxgloves (2003)

I love foxgloves; they are one of my favorite flowers. In this piece, I took the liberty of painting them in a new color. If only they did come in black.... What a magnificent sight it would be to see a field of black foxgloves.

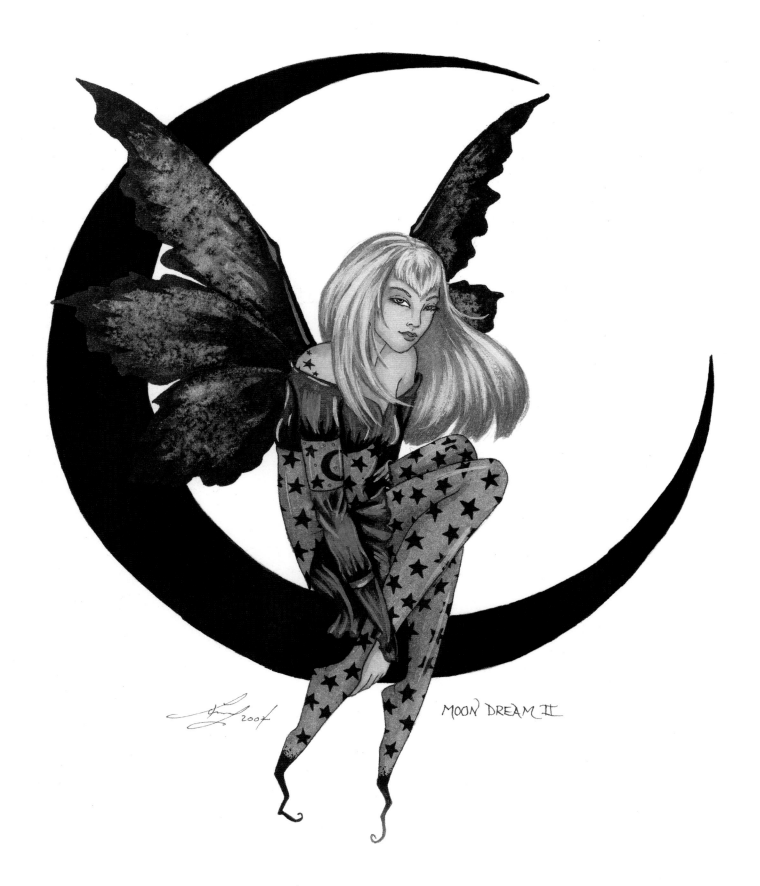

Moon Dream II (2004)

Moon Dream II is a simple piece, but I liked the way it came out. People never seem to get tired of the moon.

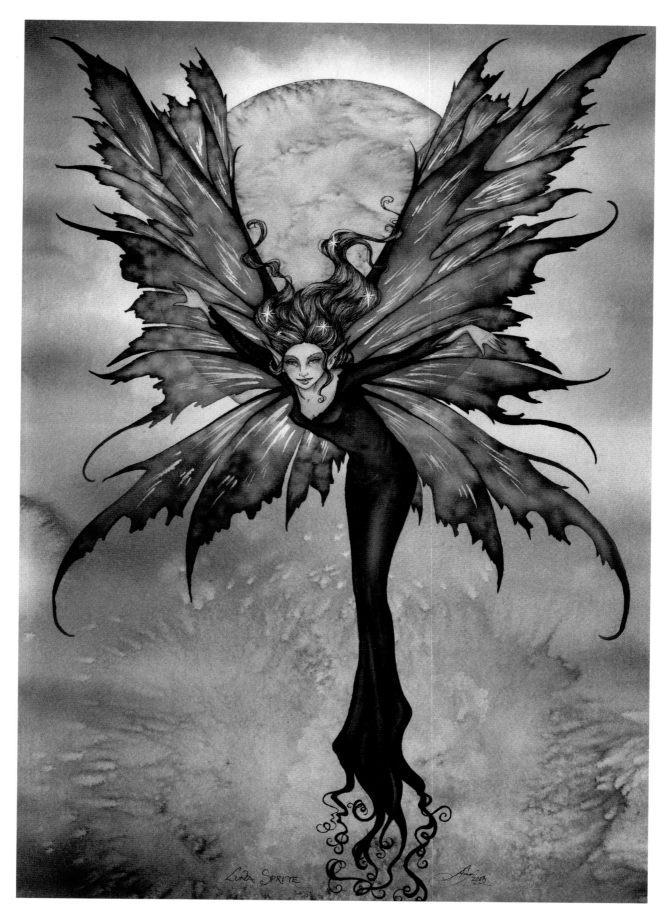

Luna Sprite (2003)

Luna Sprite was inspired by an earlier piece, *Cloak of Stars*. I wanted to revisit the color scheme. I also enjoyed painting the form-fitting black dress.

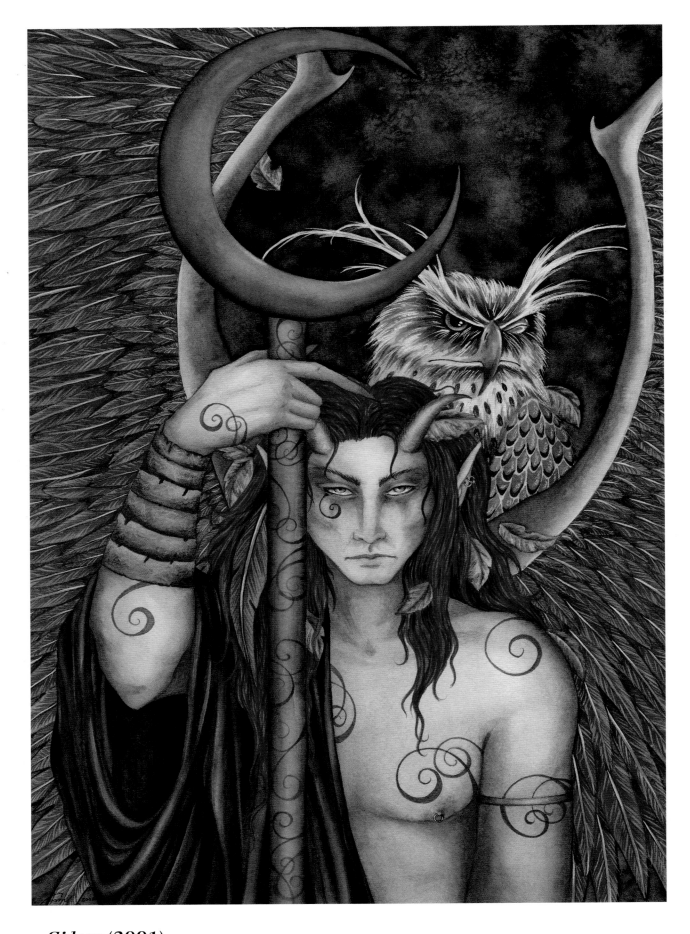

Gideon (2001)

Gideon is a character I designed for a story I would like to write some day. He is a wise man, a shaman among his kind.

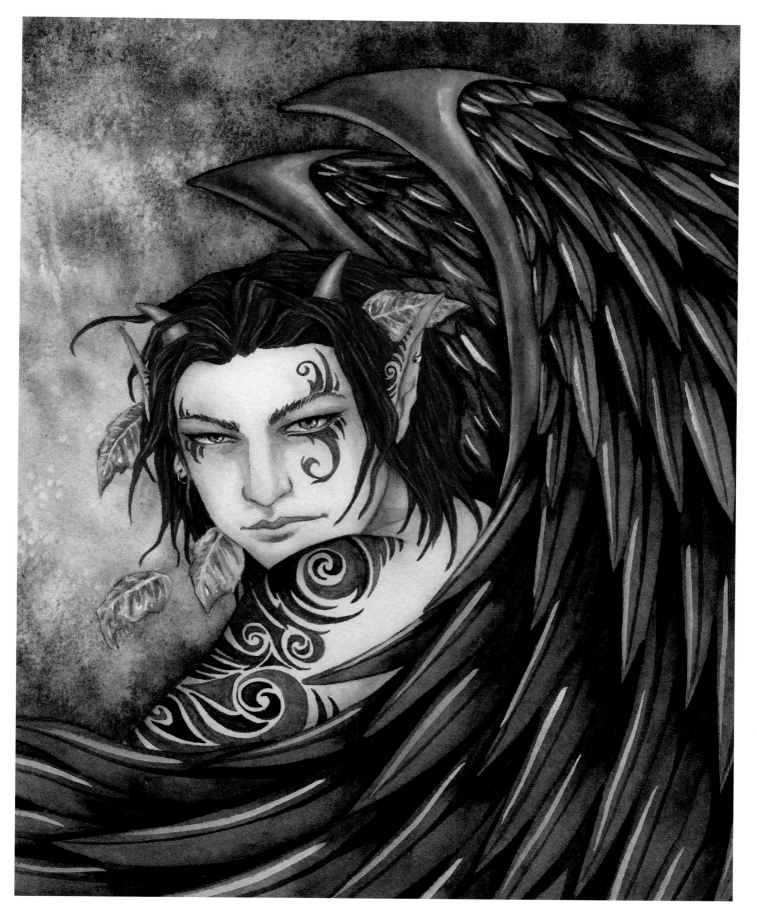

Jasper (2001)

Jasper is another character who I designed for a story I would like to write. He is young, mischievous, and exuberant.

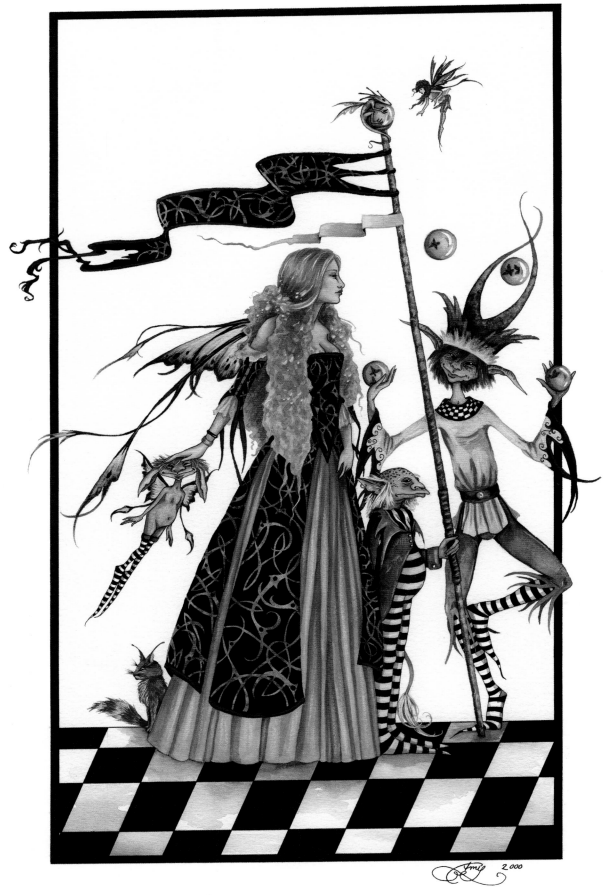

Lady of the Court (2000)

Lady of the Court was a fun piece to do. It allowed me to create some really unique and interesting characters. Inking in the checkerboard flooring, however, nearly drove me insane. (I can hear those of you who know me saying, "Nearly?".)

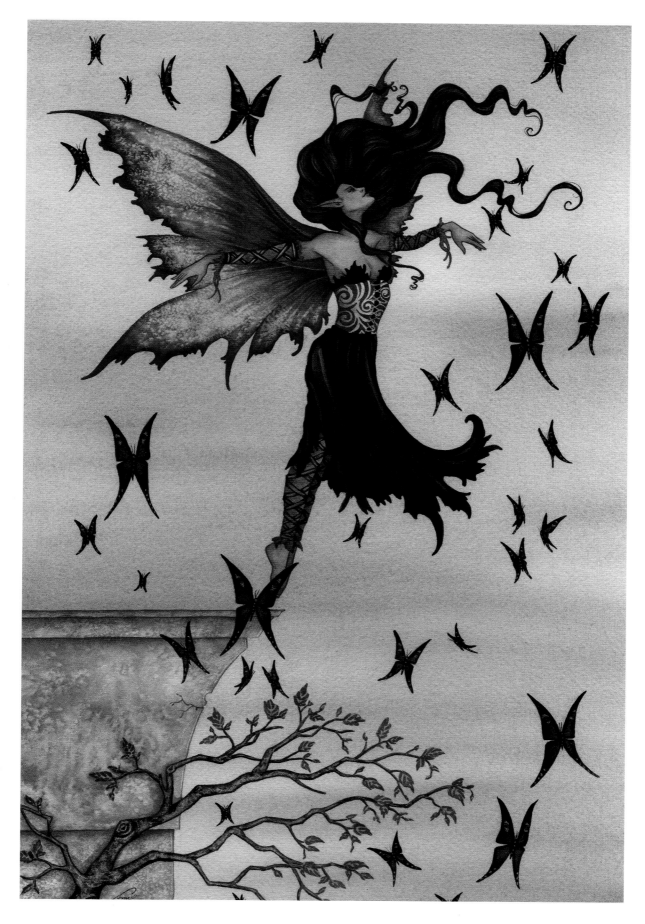

Euphoria (2002)

What a fun piece to do! I did not use any reference for this pose; it just seemed to pour out of the pencil. It is very different from my usual poses, and it was challenging to get the angle of the face just right.

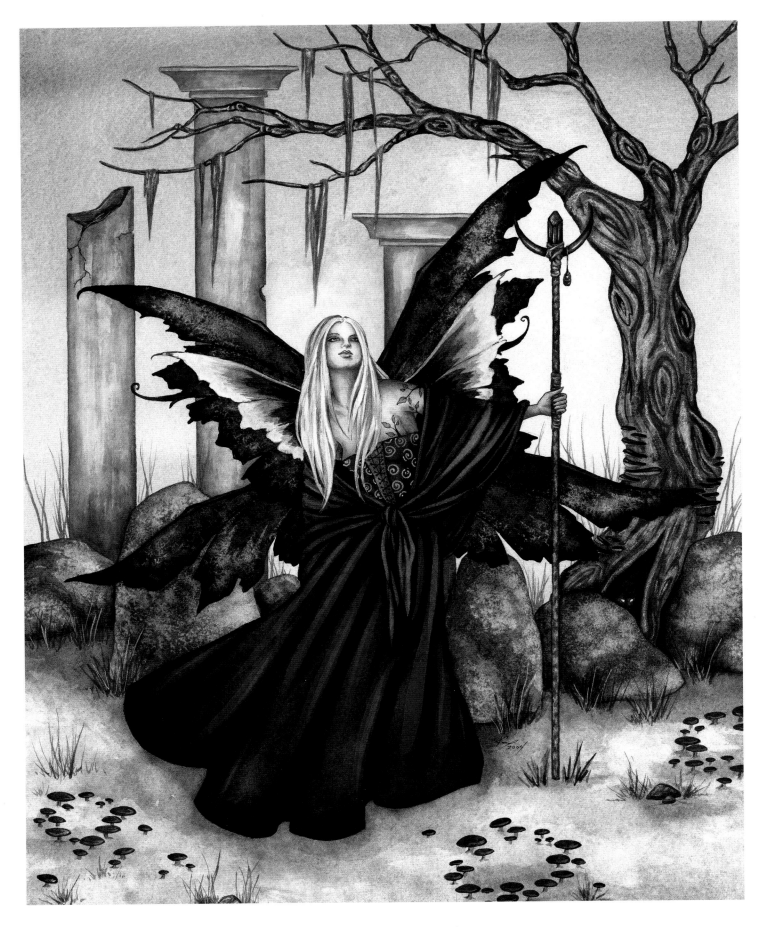

Twilight in the Temple of the Moon (2004)

Yet again, I have reused a pose. This pose was originally used for Deer Maiden, of which there is a sketch at the beginning of this book. The pose was also used in Stardust. Until I sat down to write these comments, I had not realized just how often I will paint a particular pose. Throughout this book, you will be able to find quite a few examples.

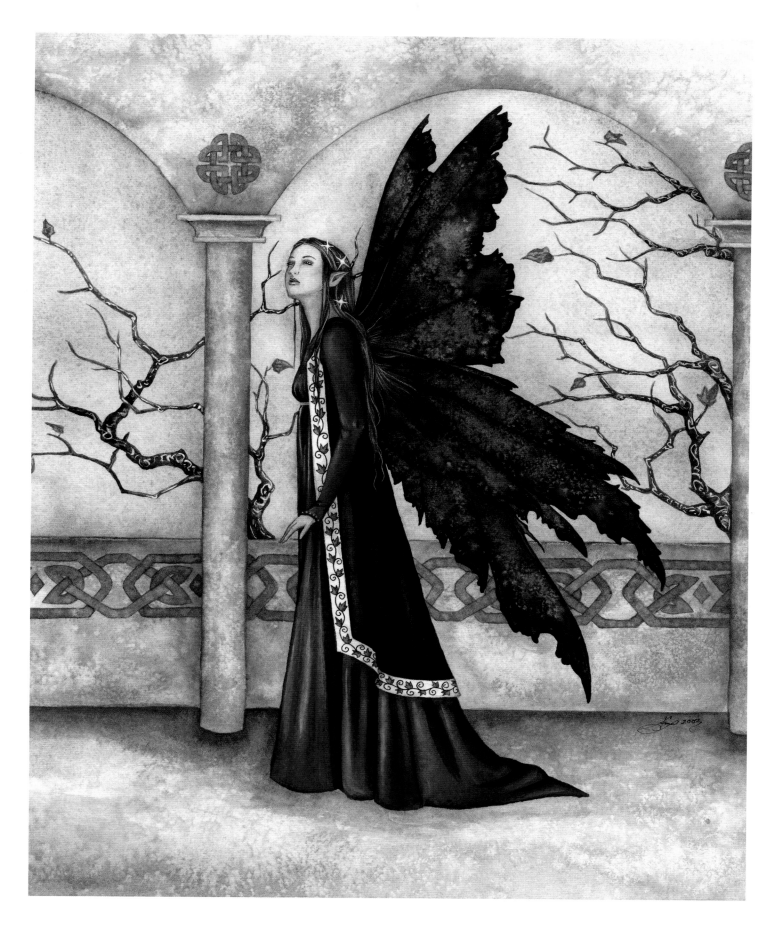

Hearing Voices (2003)

I had a hard time picking a title for this image. Then I noticed that the figure in it seemed to be listening to something—or someone.

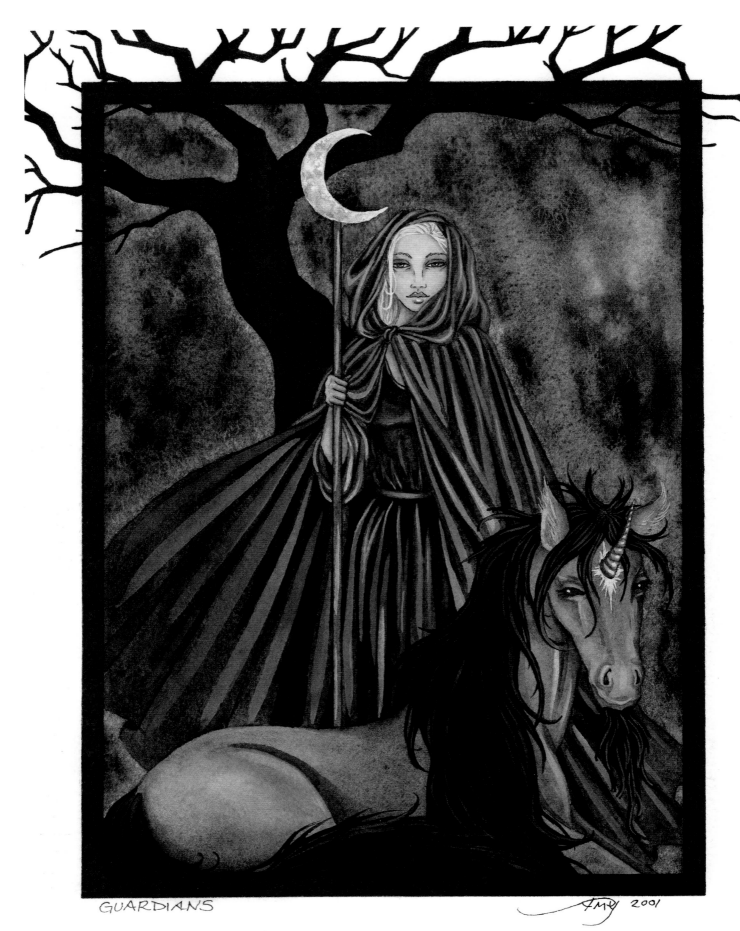

GUARDIANS

Amy 2001

Guardians (2001)

In *Guardians*, I was playing around with black tree silhouettes.

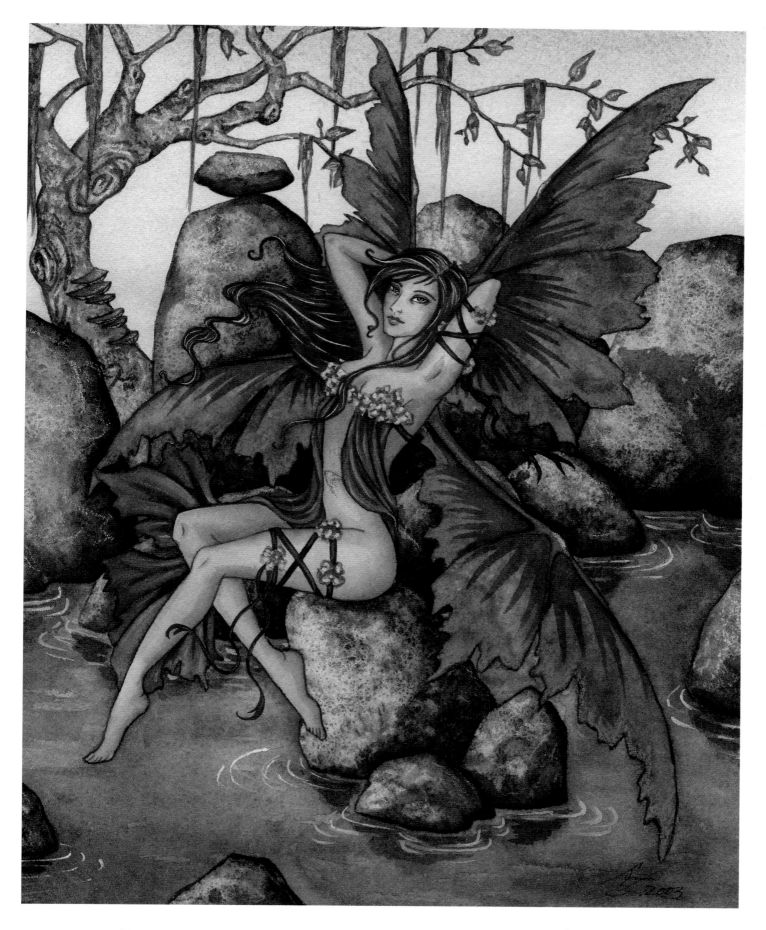

Temptress II (2003)

I had a hard time naming this piece. I finally decided on *Temptress II*, because the figure seems to be teasing the viewer.

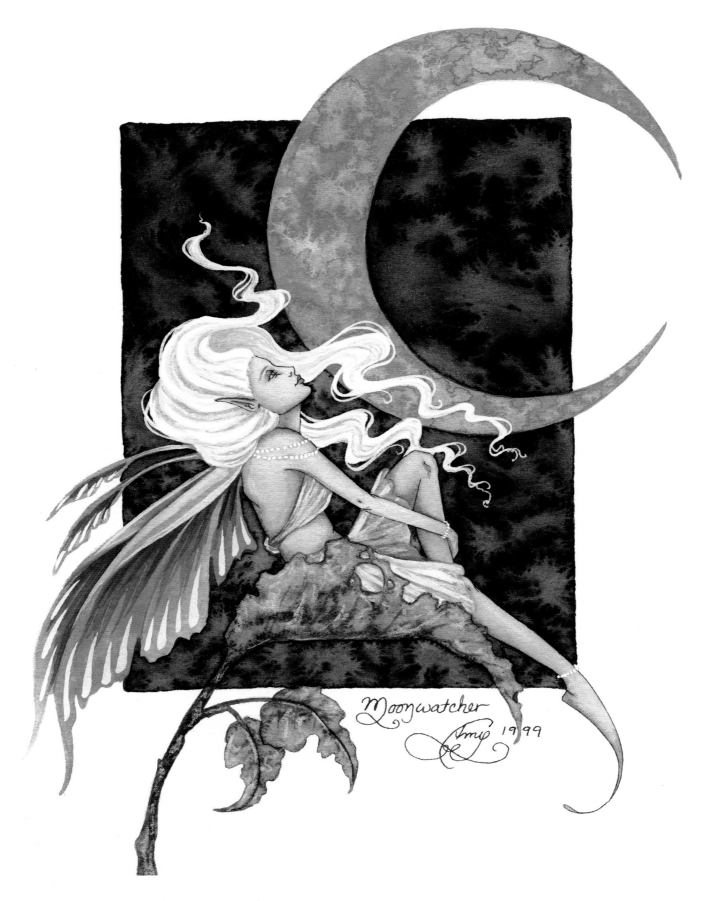

Moon Watcher (1999)

I love moons. My daughter also seems to be obsessed with them. There is something mysterious and wonderful about the moon.

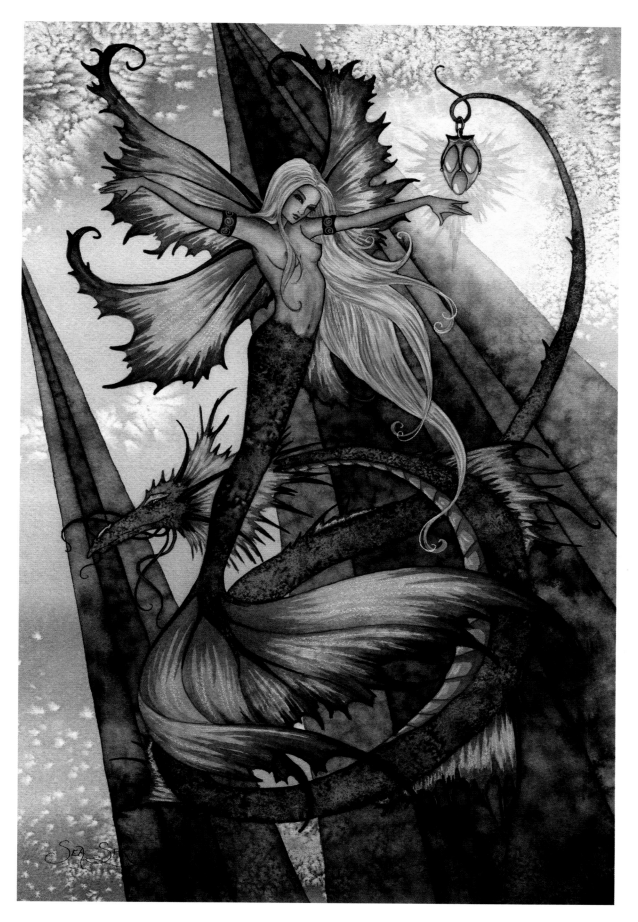

Sea Sprite (2003)

I needed to do a strong mermaid. I hadn't painted a mermaid in more than a year. I feel the sea serpent makes the image dramatic.

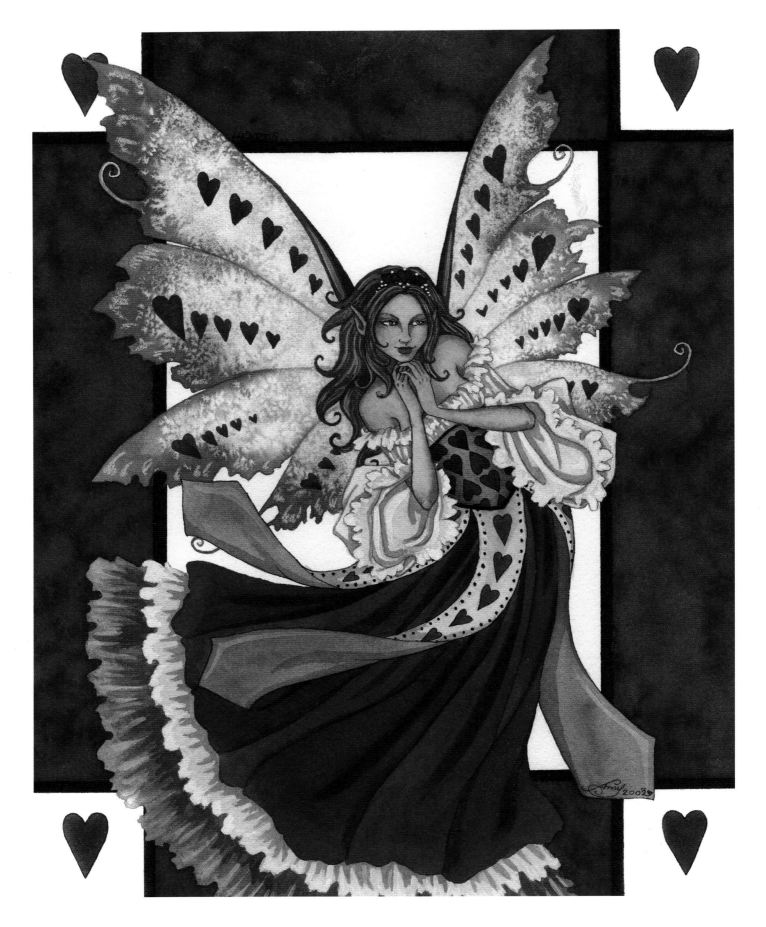

Hearts (2003)
Someone pestered me for a couple of years to do a Valentine Faery. Finally I gave in and created *Hearts*.

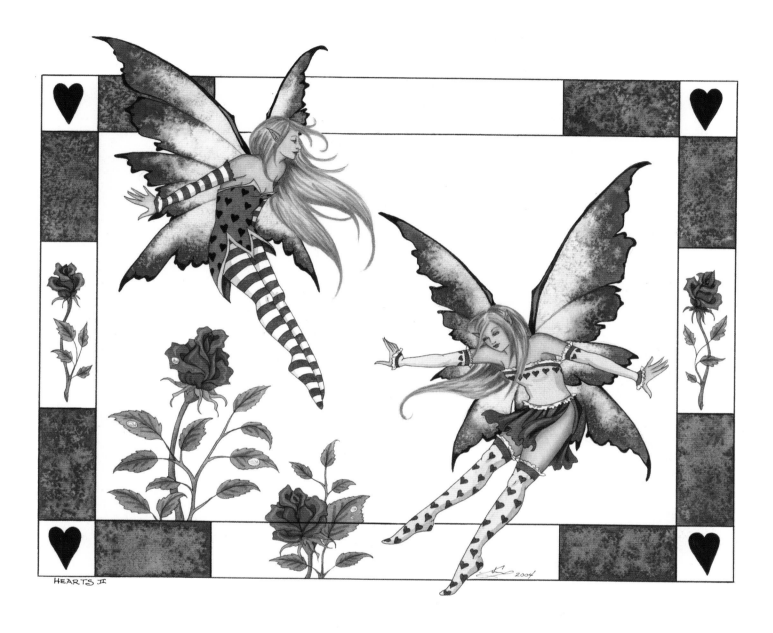

HEARTS II

Hearts II (2004)

I painted *Hearts II* because the original painting, *Hearts*, was a great success. I also like the clean and vibrant use of reds and white.

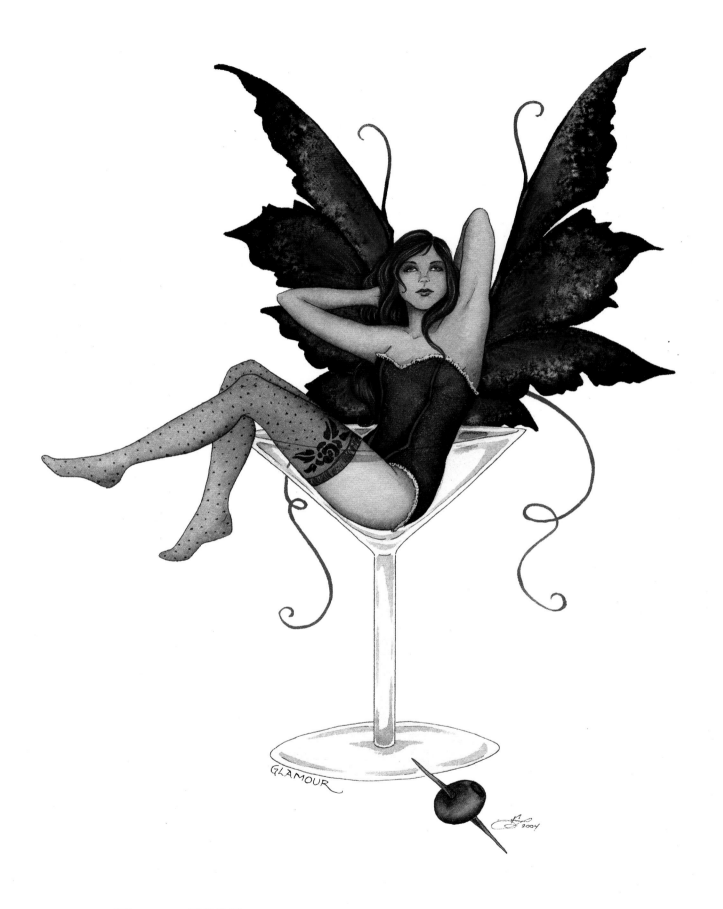

Glamour (2004)

Glamour was inspired by an old photograph of a woman sitting in a chair with her legs draped over the arm. I instantly saw the chair as a martini glass.

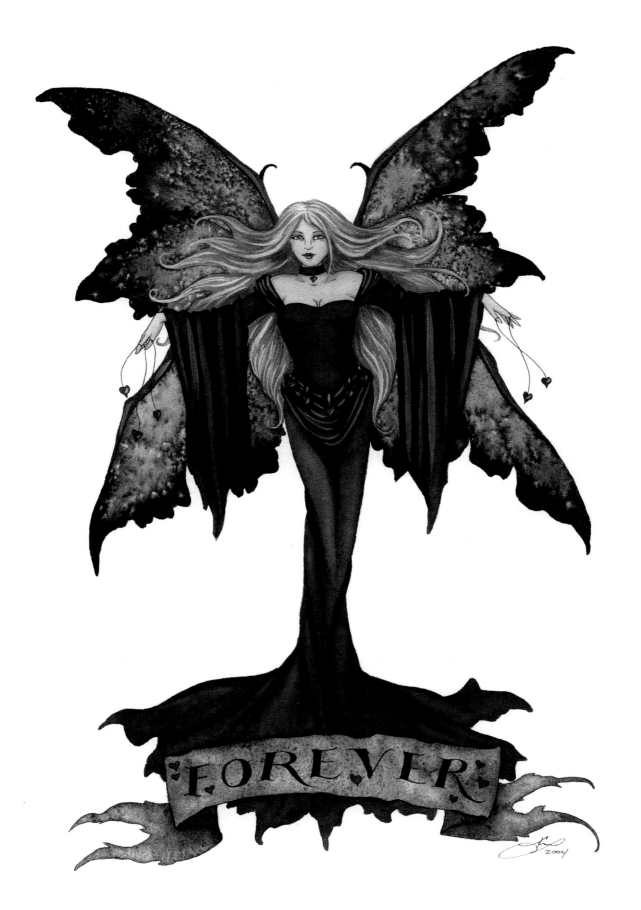

Forever (2004)

Forever is another piece that was inspired by an old photograph. The statuesque woman in the photo was wearing a gorgeous draping gown.

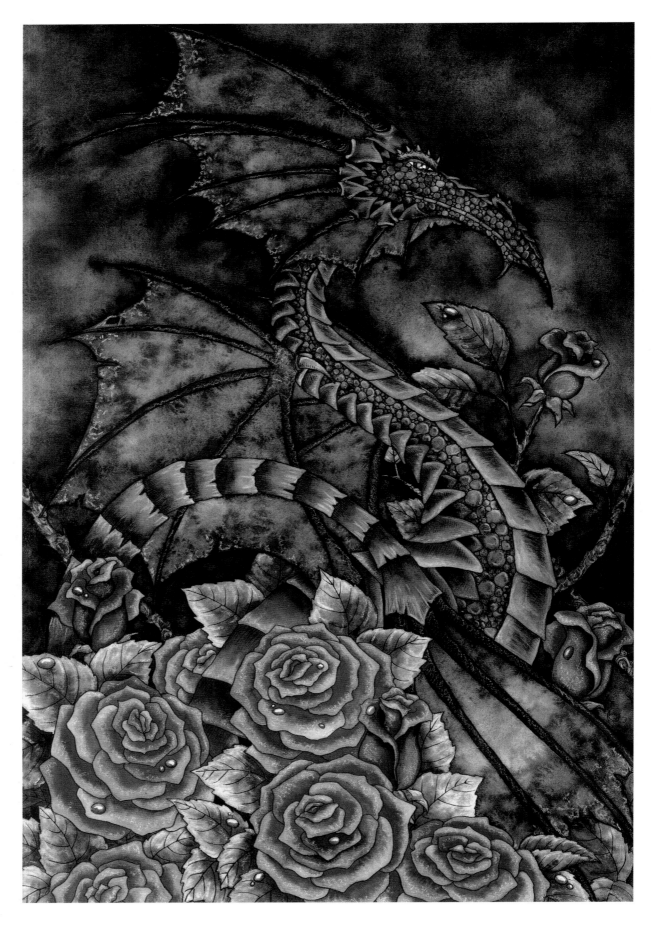

Beauty and the Beast (1998)

The dragon in *Beauty and the Beast* took me days to finish. I was not happy with it and kept adding more and more paint and colored pencil. Even weeks after I had thought it was finished, I went back and fiddled with the background wash.

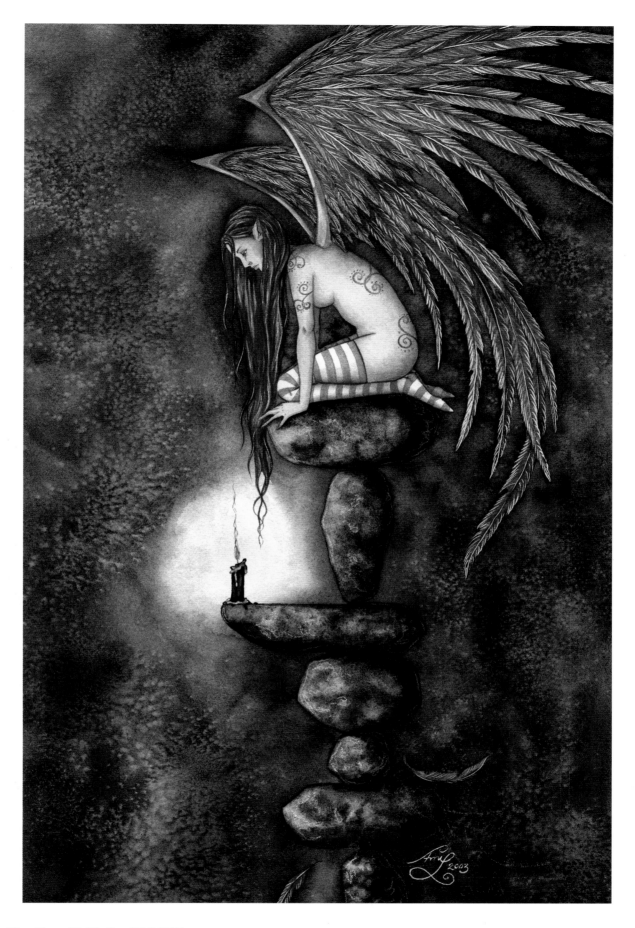

By Candlelight (2003)

By *Candlelight* is a piece I started working on several years ago, then abandoned temporarily. Before finishing it, I used the pose I had created for it in *Waiting Out Eternity*. A year or so later, I went back to *By Candlelight* and finished it.

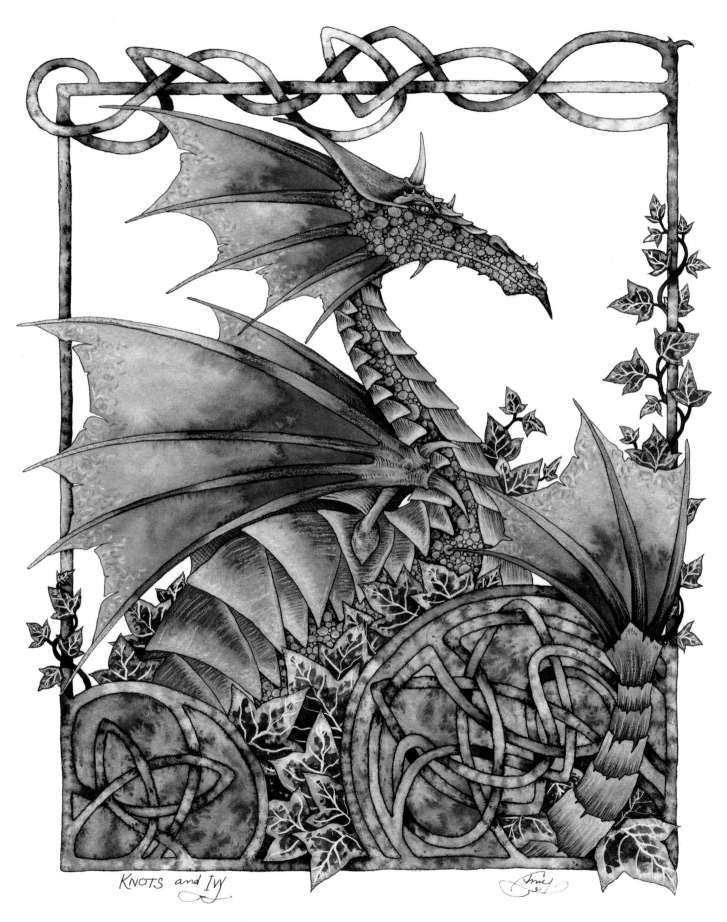

KNOTS and IVY

Knots & Ivy (1998)

Knots & Ivy is an old piece. At this point I cannot remember where the inspiration for it came from. Often I just sit down and start working with no real direction.

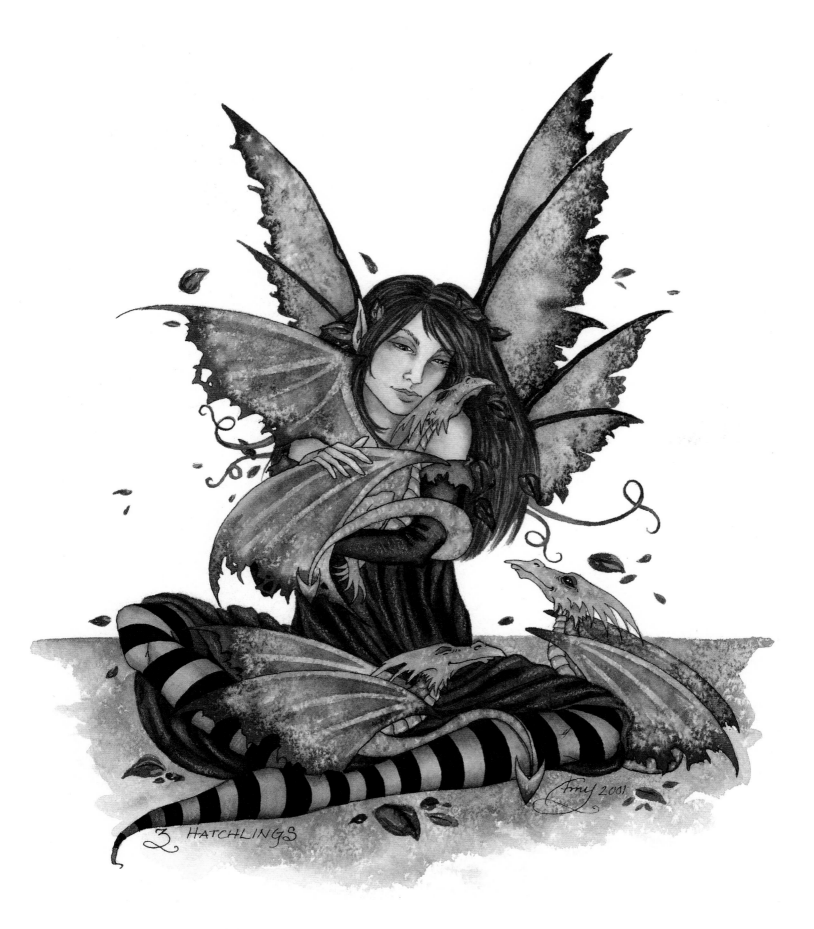

Three Hatchlings (2001)

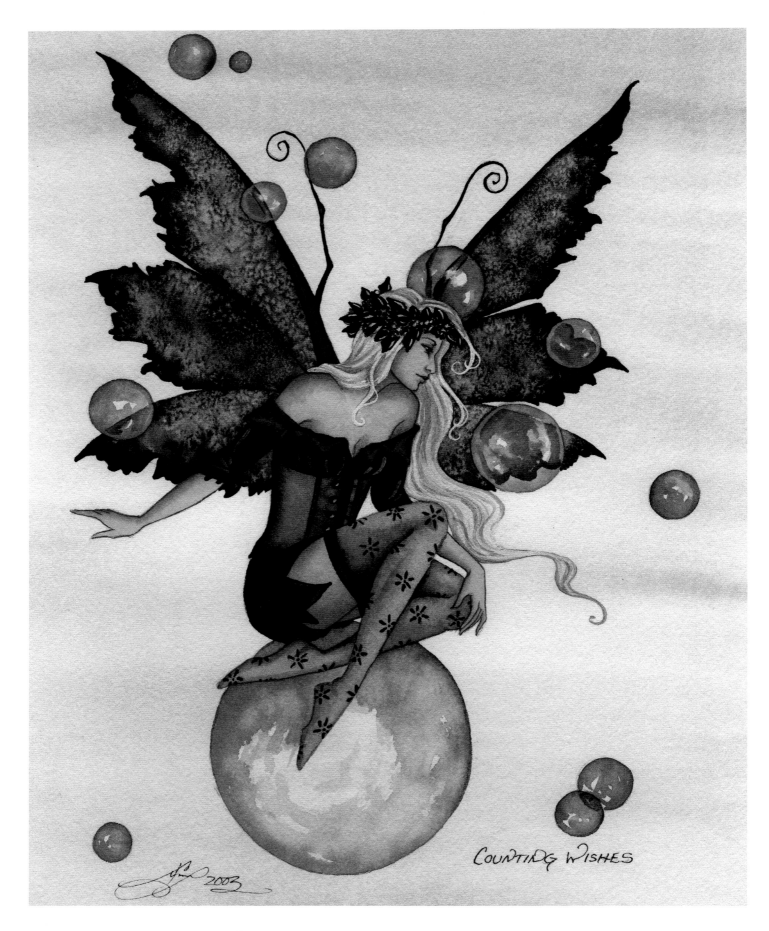

Counting Wishes (2003)
Each bubble holds a wish and the faery counts each one as it passes.

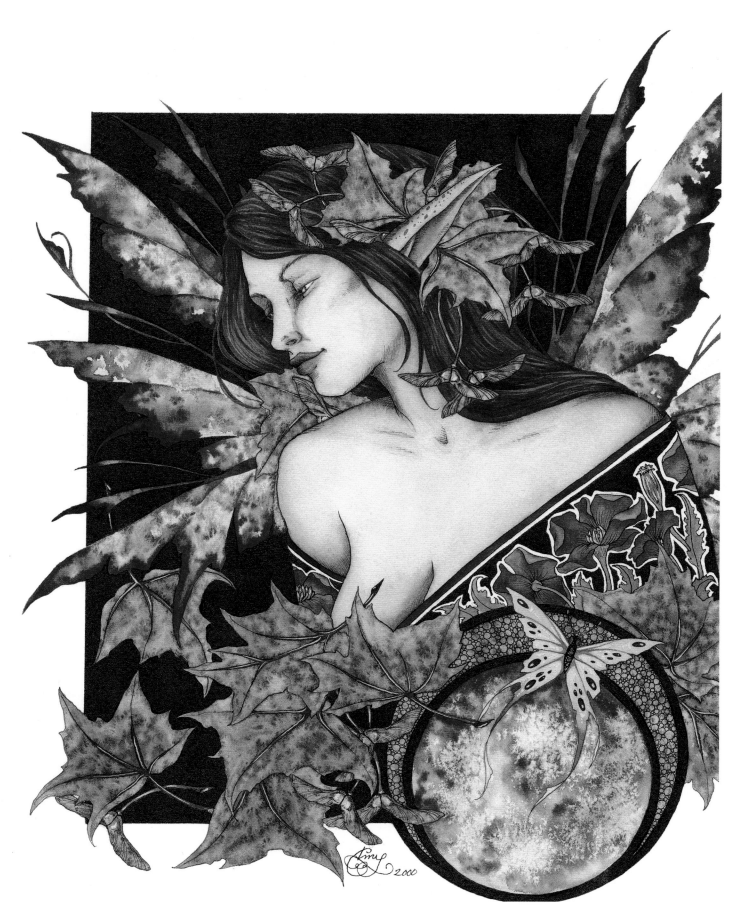

Ariana (2000)

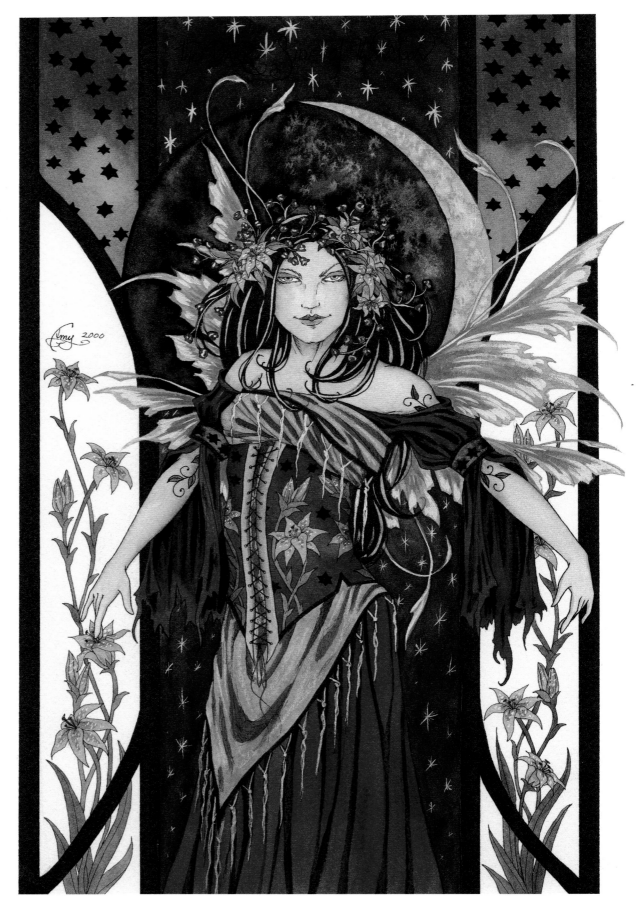

Dark Side of the Moon (2000)

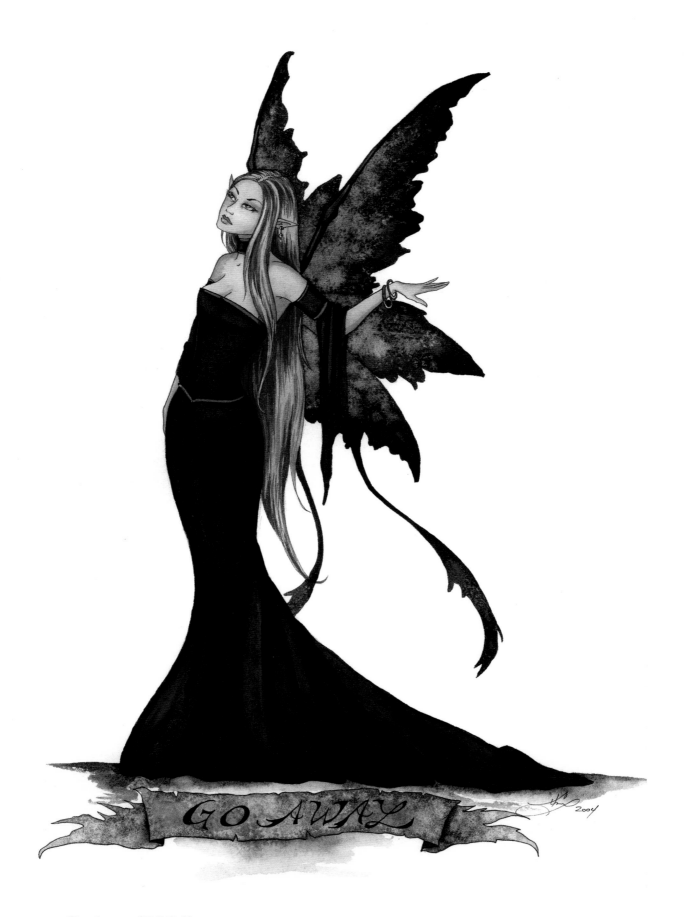

Go Away (2004)
I like to hang "Go Away" signs around my house. No one knows if I'm kidding or not.

INDEX